Impressionist Portraits

With 138 illustrations,

83 in colour

THAMES AND HUDSON

Impressionist Portraits

MELISSA McQUILLAN

To my parents

Printed and bound in Japan by Dai Nippon

Contents

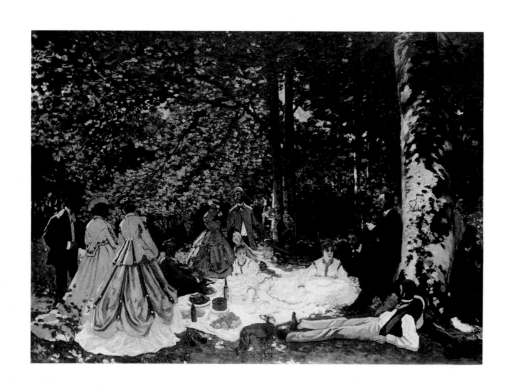

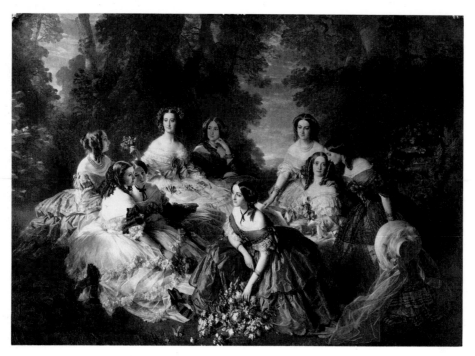

Introduction

It was a landscape, Monet's harbour scene *Impression, Sunrise*, 1873, which gave the name Impressionism to the work of a group of artists who first exhibited in 1874 under the more cumbersome name of Société anonyme des artistes peintres, sculpteurs, graveurs. Between 1874 and 1886 eight exhibitions were held, under various titles. The artists participating varied over the years, and the paintings shown never displayed a homogeneous style; however, the typical Impressionist painting came to be conceived as a scene painted out of doors ('en plein air'), rendering transient light and atmospheric effects, and comprising a paint surface made up of broken touches of fresh-hued pigment.

Because the achievements of Impressionism have since been so closely identified with landscape motifs, the fact that the Impressionists painted many portraits may come as a surprise. The accommodation of these images within predominant conceptions of Impressionism unsettles our assumptions and encourages us to question the usefulness of purely stylistic criteria.

Opposite, above
Claude Monet, Le Déjeuner sur l'herbe, *1866*
This picnic scene is a preparatory study for a much larger and more ambitious painting which Monet never finished and of which only fragments survive. Although apparently a plein air work, the composition was developed through the traditional means of preliminary sketches. The painter's mistress Camille Doncieux modelled for all the female figures, while Frédéric Bazille posed for at least four of the men.

Opposite, below
Franz-Xaver Winterhalter, The Empress Eugénie Surrounded by her Maids of Honour, *1855*
One of the most popular portraitists of the mid nineteenth century, Winterhalter was favoured by the royalty of several countries. His depiction of the Empress Eugénie and her maids of honour against a landscape contrasts in its lighting, its attention to detail and the artifice of its composition with Monet's Déjeuner sur l'herbe.

Right
Claude Monet, Impression, Sunrise, *1873*
Monet painted two similar views of the harbour at Le Havre at this time. This one, the better known, is generally considered to be the work whose title gave rise to the term Impressionism.

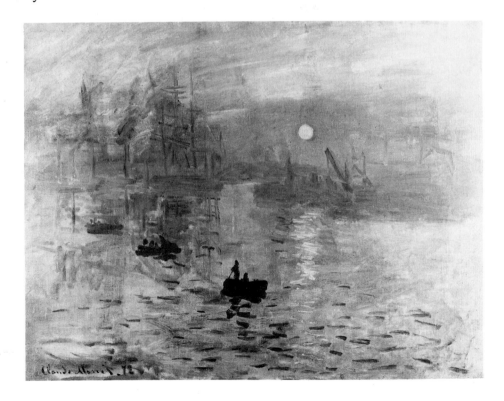

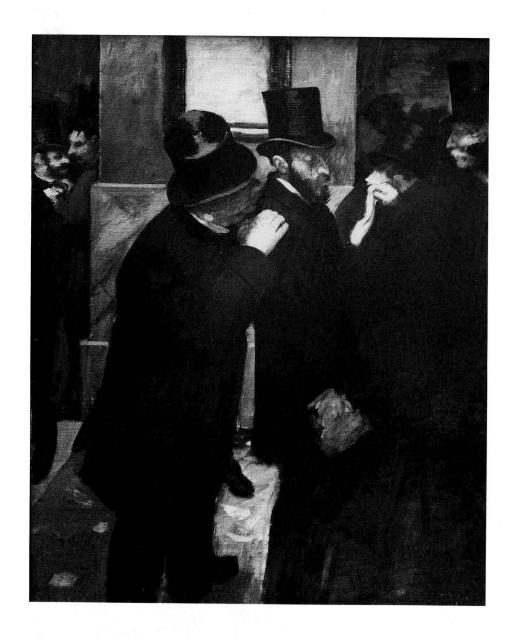

Edgar Degas, The Stock Exchange, c. 1879
*The man upon whom Degas has focused his attention
is the banker and art collector Ernest May. He is
attending to a private word from his friend M. Bolâtre.*

Although the individual exhibitors were drawn together by common personal, theoretical and artistic interests, the bonds did not add up to a cohesive stylistic programme. In the formative decade before the first show in 1874, and in the dozen years during which the exhibitions took place, the work of each painter underwent its own shifts, frequently, but not consistently, responding to the work of colleagues. Thus, both in terms of the development of each painter in relation to the others or in that of temporal stylistic development, Impressionism resists a fixed identity.

The name Impressionism is often, and misleadingly, taken to imply the insubstantial or incomplete resolution of an image. In a great number of Impressionist paintings, both motif and handling ('facture') contribute to an appearance of spontaneous, momentary vision. Often, however, the work by leading participants in the Impressionist circle embraced contradictory experiences, allying the concrete with the elusive and fugitive. Examples range from Monet's crusty surfaces embodying sunlit leisure scenes to Degas' more precisely delineated depictions of urban life.

Opposite
Claude Monet, L'Hôtel des Roches Noires,
Trouville, *1870*
*In addition to the suburbs of Paris, fashionable seaside
resorts such as Trouville provided Monet with plein air
settings and motifs of leisure activity. Loaded
brushstrokes freely block in the figures and the striking
contrasts of light and shade.*

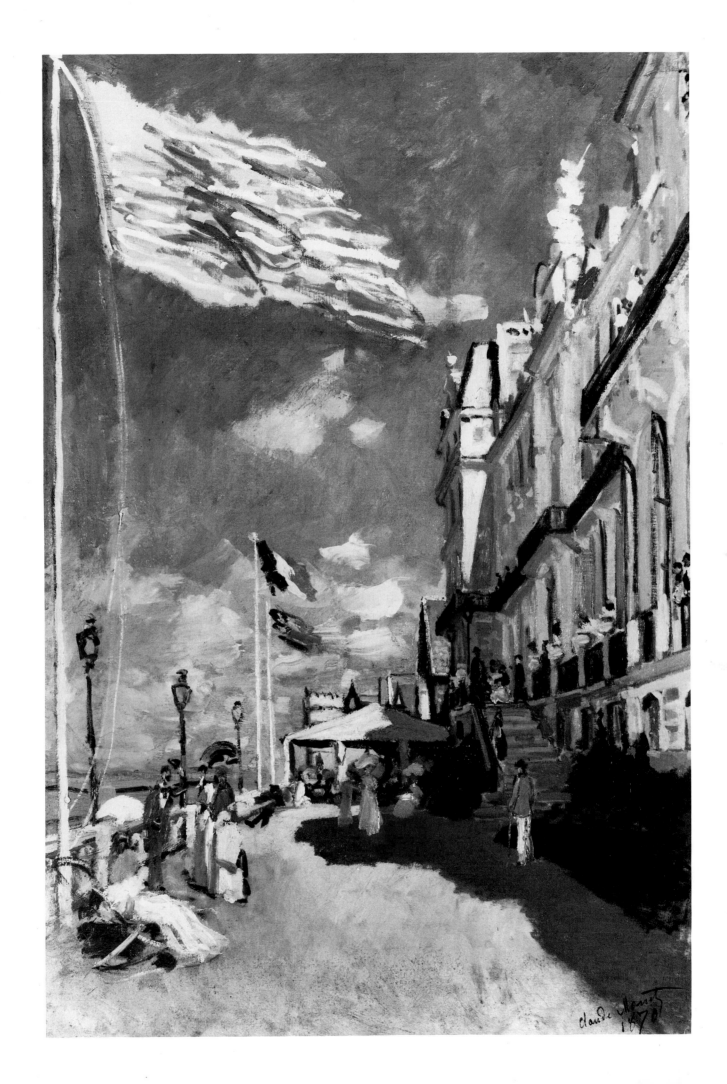

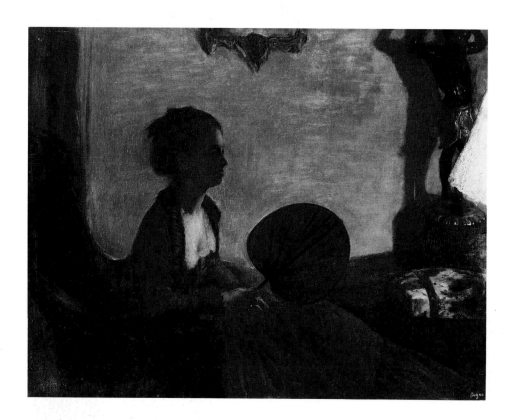

Left
Edgar Degas, Mme Camus, *1870*
A hidden light source silhouettes Mme Camus, who was a friend of both Degas and Manet. She was a talented musician, and had earlier posed for Degas in front of her piano.

Below
Pierre-Auguste Renoir, Lise with a Parasol, *1867*
Lise Tréhot, who was Renoir's mistress from 1866 to 1871, was among the first of his many models to pose in a light-dappled atmosphere. The pockets of shade and the reflections unite her with her landscape surroundings.

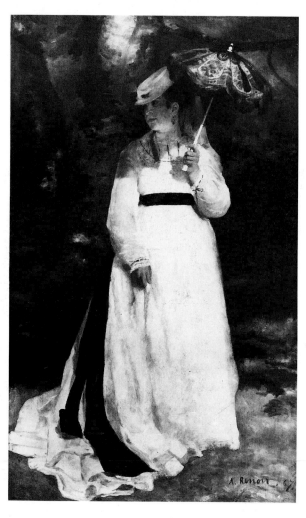

Is it that the title *Impression: Sunrise* still stimulates assumptions about Impressionist subject-matter? Is it really because landscape motifs predominate that we have perhaps a restricted view of Impressionism? Or does the *apparently* less loaded subject-matter of landscape make the work of these artists more accessible and less troublesome for wider audiences? Does landscape painting's contribution to the breakdown of nineteenth-century academic conventions confirm the Impressionists' position as ancestors in the genealogy of the avant-garde? An account of the identification of Impressionism with landscape remains to be worked out, but in displacing landscape's significance to Impressionism, be it ever so slightly, complex questions are opened up, and Impressionism is shown to formulate many different images of modern life during the years of the late Second Empire and early Third Republic.

Even though landscape remains a prominent motif within the Impressionist achievement, the depiction of the human form and visage occupies an equally significant position among the paintings of members of the Impressionist circle. Indeed, Degas and Cassatt focused almost exclusively on the human figure (mostly set in an interior environment and often seen under conditions of artificial light). Renoir devoted the large part of his oeuvre to images of people, especially women, depicted both

Opposite
Mary Cassatt, Two Young Ladies in a Loge, *1882*
The theatre served Cassatt as an occasional setting. Unlike her friend Degas, she concentrated not on the stage spectacle (see p. 122) but on the poised and self-possessed young women who formed part of the audience.

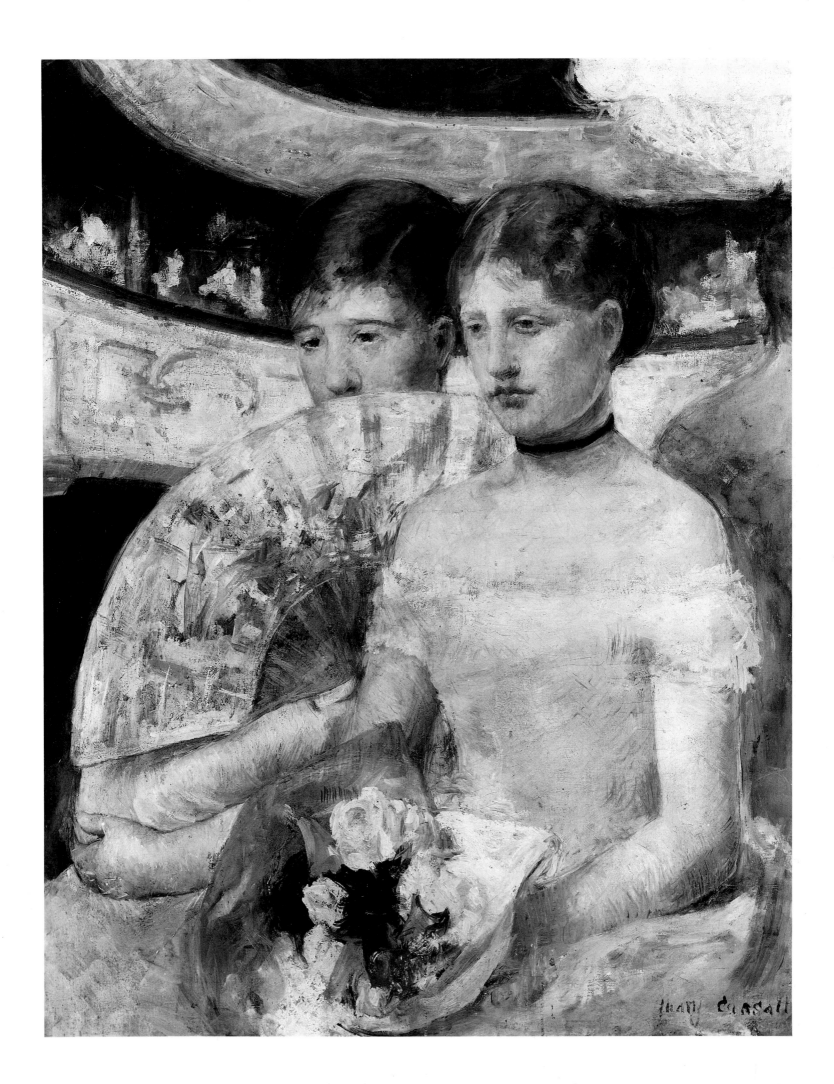

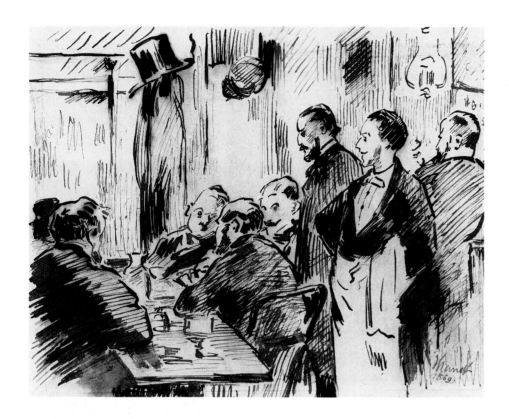

Edouard Manet, At the Café, *1869*
Neither the venue nor the personalities are identifiable, but it is likely that Manet's lively drawing depicts the Café Guerbois.

indoors and as natural inhabitants of landscape. Friends, relatives and acquaintances populate numerous canvases by Monet, Pissarro, Morisot, Cézanne and Gauguin. Even the less well-known Impressionists such as Caillebotte and Guillaumin produced arresting portrayals of themselves and colleagues. Among the core of Impressionists, Sisley alone showed almost no interest in the human figure or face — an early painting of an interior occupied by his two children being the only work that could be considered a portrait.

Two artists who did not exhibit with the group feature prominently in the wider Impressionist circle. Although Manet declined invitations to participate in the Impressionist exhibitions, he was an early inspiration for many of those who did actively show. His work evinces shared ambitions, and he remained close to his colleagues. Bazille, an intimate associate of the group who frequented the Café Guerbois in the Batignolles quarter of Paris when it served as the meeting place for the exchange of ideas, died in the Franco-Prussian War, before the inception of the Impressionist exhibitions. He was, however, accorded posthumous inclusion in 1876. Images of people were central to the enterprises of both painters.

The depiction of people, even the draughting of recognizable features, does not necessarily secure a painting as portraiture. While our notions of Impressionism are complicated by portraiture as a genre, Impressionist portraiture itself also raises many questions.

The pictorial representation of modern life and of contemporary, immediate experience pervades the paintings of the Impressionist circle. During the seminal years of the 1860s Realism and naturalism were central concerns for ambitious artists working their way out of worn artistic

Opposite
Armand Guillaumin, Pissarro's Friend Martinez in Guillaumin's Studio, *1878*
Guillaumin's portrait of Martinez presents an image as complex and captivating as works by his better known colleagues. This portrait bears comparison with Degas' Portrait of the Painter James Tissot *(p. 60).*

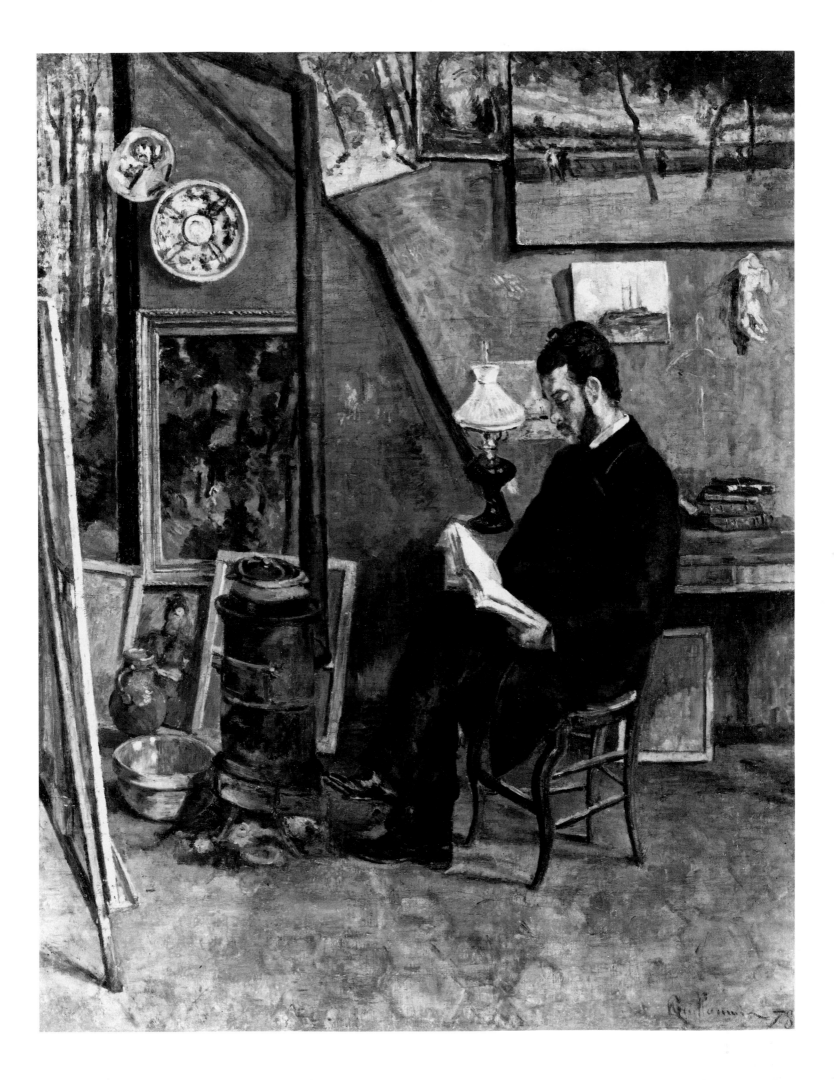

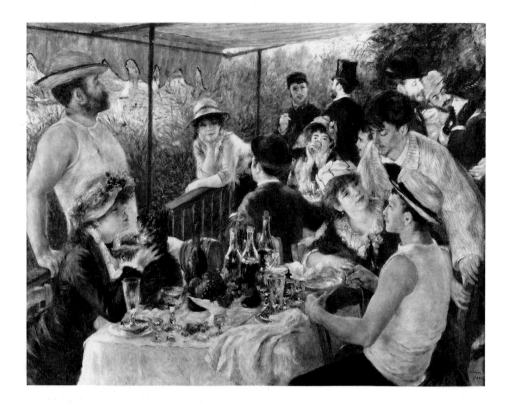

Pierre-Auguste Renoir, The Boating Party, *1880–81*
Among the models are Aline Charigot (seated left), soon to become Renoir's wife; Alphonse Fournaise, fils (standing left), son of the proprietor of the Restaurant Fournaise where the scene is sited (see also p. 108); Caillebotte (seated right); the art historian and banker Charles Ephrussi (background, in top hat); and possibly the actress Ellen Andrée (seated right), who was also a model for Degas' L'Absinthe (p. 20). Most of the other figures have been identified as friends of Renoir.

conventions. Realism, a literary and artistic movement, carried with it the political implications such as those set forth by Courbet in his Realist manifesto of 1855, while naturalism concerned itself with 'scientific' description of the observed world.

A figure, once it attains a certain scale within an Impressionist painting, almost inevitably presents a likeness of its model. While painters in the earlier nineteenth century idealized or generalized the physiognomic idiosyncracies of their models, especially in history and genre paintings – an approach which was still taught to the student Impressionists – in Impressionist paintings almost every description of the human face asks at least to be considered as a portrait. Such a rendering of appearance, often closely focused, may insist upon an unexpected literalness which contrasts with the stereotype of the scintillating Impressionist landscape.

While not all the human figures who populate and animate canvases by Impressionist painters are given enough individuality to enable us to identify the sitters, most bear features of particular models, even when the painting itself opens a discourse upon a broader theme. Sitters can be recognized in works whose titles or whose compositions invest them with fleeting vestiges of narrative. Readings of Renoir's *Boating Party*, 1880–81, fluctuate between its general image of a certain kind of leisure activity and its depiction of Renoir's friends and acquaintances enjoying themselves on such an occasion.

This destabilization of traditional readings of imagery occurred at the same time as the breakdown of the category of portraiture. Portraiture was often differentiated from 'serious' painting; well into the nineteenth century academic hierarchies ranked portraiture below the most ambitious

Opposite, above
Emile Auguste Carolus-Duran, The Woman with the Glove: Mme Carolus-Duran, *1869*
The elegance and cool glamour of this portrayal attest to Carolus-Duran's skill – a skill which made him one of the most popular portraitists of his day.

Opposite, below
Claude Monet, Woman in the Green Dress (Camille), *1866*
Monet's portrait of his wife Camille in a green dress begs comparison with the fashionable portrait of Mme Carolus-Duran by her husband. Although not so slick in execution, and more spontaneous in treatment, it refers to a common tradition of full-length female portraiture.

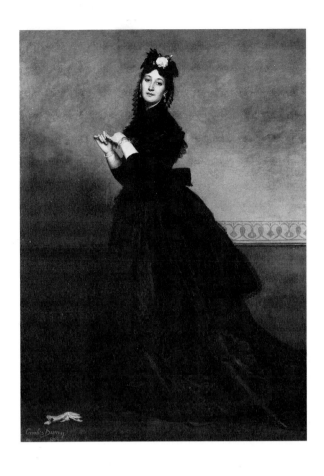

types of painting, which depicted historical and religious subjects. Although all categories of painting had their conventions, the demands of portraiture were regarded both as artistically constricting and as less challenging. The grip of academic theory relaxed during the nineteenth century, but portraiture was still disdained by ambitious painters, both by adherents of official taste and by those who were more rebellious. Degas and Cassatt, for example, like their illustrious early-nineteenth-century predecessor Ingres, resisted early encouragements to devote themselves to portraiture.

Historically, most portraits had resulted from commissions. Even in the early nineteenth century when painters were already producing more work for an open market, portraiture still depended upon the initiative of a patron. It constructed images of power and authority, the social position of the sitter being as fundamental to the configuration upon the canvas as personal appearance. The sitter needed to possess not only the financial means with which to pay the artist but also a status which could be asserted in visual signs. Portraiture served the interests of the commissioner.

By the early nineteenth century images began to accumulate which, at least retrospectively, appear to undermine portraiture's traditional preoccupations. These included Goya's unflinching portrayals of weak-minded or anxious-looking sitters and Géricault's arresting depictions of insane people. Nevertheless, portraiture continued to concentrate upon status, both hereditary and achieved. Royalty, financiers, industrialists and landowners all patronized Ingres, arguably the foremost portraitist of the first half of the nineteenth century.

In contrast, relatively few portraits were undertaken by the Impressionist artists as the result of commissions. The unconventional Impressionist facture, combined with the artists' dubious reputations, attracted only the most adventurous patronage. Although all these artists submitted to the official Salons at points in their careers, juries and critics tended to regard their work as marginal or oppositional. When they banded together for their first exhibition, they had agreed not to send work to the Salon, in effect acknowledging a divorce from establishment values. Such a rejection of the Salons restricted the artists' exposure to potential patrons. What critical attention they received characterized them as unorthodox, hardly a quality sought by patrons desiring assurance of their social prestige (which was for many an attainment of relatively recent vintage).

Although the market for portraiture was expanding with the growth of the bourgeoisie, most businessmen, bankers and magistrates sought pictorial affirmation of their arrival through formulae sanctioned by tradition. Chaplin, Carolus-Duran and Winterhalter were among the artists they chose, names with narrow currency today.

Of the Impressionist circle, Manet and Degas most often depicted sitters from the ranks of notable contemporary political and social figures, but, as Manet experienced when at his own request he portrayed the radical

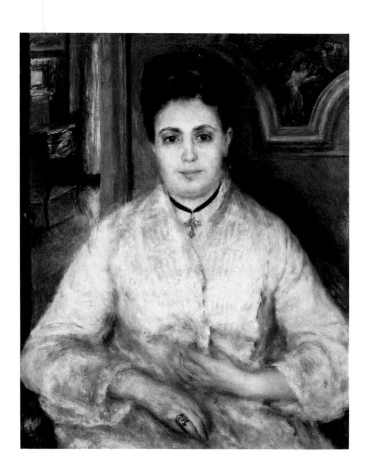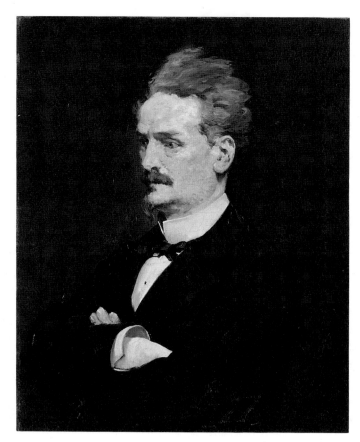

politican Henri Rochefort, the results often failed to obtain a grateful reception from the sitters. Degas may have had aspirations to paint bankers and industrialists, but only his family and associates from his school days requested or acquiesced to his scrutiny. It is important to realize that both painters' social and urban backgrounds were those of their *haut-bourgeois* models.

It might be that Impressionism's commitment to authentic, immediate experience distanced those painters who came from shopkeeper and artisan families from the very different world of their potential patrons – and it was photography that made personal imagery available to a wider public for whom the painted portrait had never been a serious option. There are a few exceptions – both Monet and Renoir received occasional commissions from wealthy merchants and entrepreneurs – but such patrons were among a handful of enthusiasts, who enterprisingly appreciated art not admired by the establishment, and who often befriended the artists they supported.

If portraiture was a specific, though disintegrating, category of painting and not necessarily synonymous with likeness, how does one come to terms with the vast number of likenesses in the collective oeuvres of the Impressionists? The sitter still plays a key role, but may no longer be the putative reason for the work's existence. If not commissioned, who were these images for? In some instances they were indeed *for* their models on a primary level. Manet's portrait of Zola, 1868, was undertaken in gratitude

Above left
Pierre-Auguste Renoir, Mme Chocquet, *1875*
Although not especially wealthy, Victor Chocquet was a discerning patron. He commissioned this portrait of his wife from Renoir, and it was soon joined by a companion portrait of himself (p. 140).

Above right
Edouard Manet, Portrait of Henri Rochefort, *1881*
After his return from exile in 1880, Rochefort had grudgingly acquiesced to Manet's request to paint his portrait. His traditional artistic tastes led him to reject Manet's offer of the finished work as a gift. However, the portrait, together with that of M. Pertuiset (p. 164) did earn Manet a Salon medal.

Opposite
Edouard Manet, Portrait of Zola, *1868*
Zola's pamphlet on Manet, published in 1867, features prominently among the papers on his desk. The complex imagery of the painting acknowledges the importance to Manet of Japanese art (the folding screen to the left and the print by Kuniaki II on the wall) and of the 17th-century Spanish painter Velásquez, represented by a print after his Los borrachos. *A photograph of a print after Manet's own* Olympia *appears to gaze at Zola, who had defended the painting as Manet's masterpiece.*

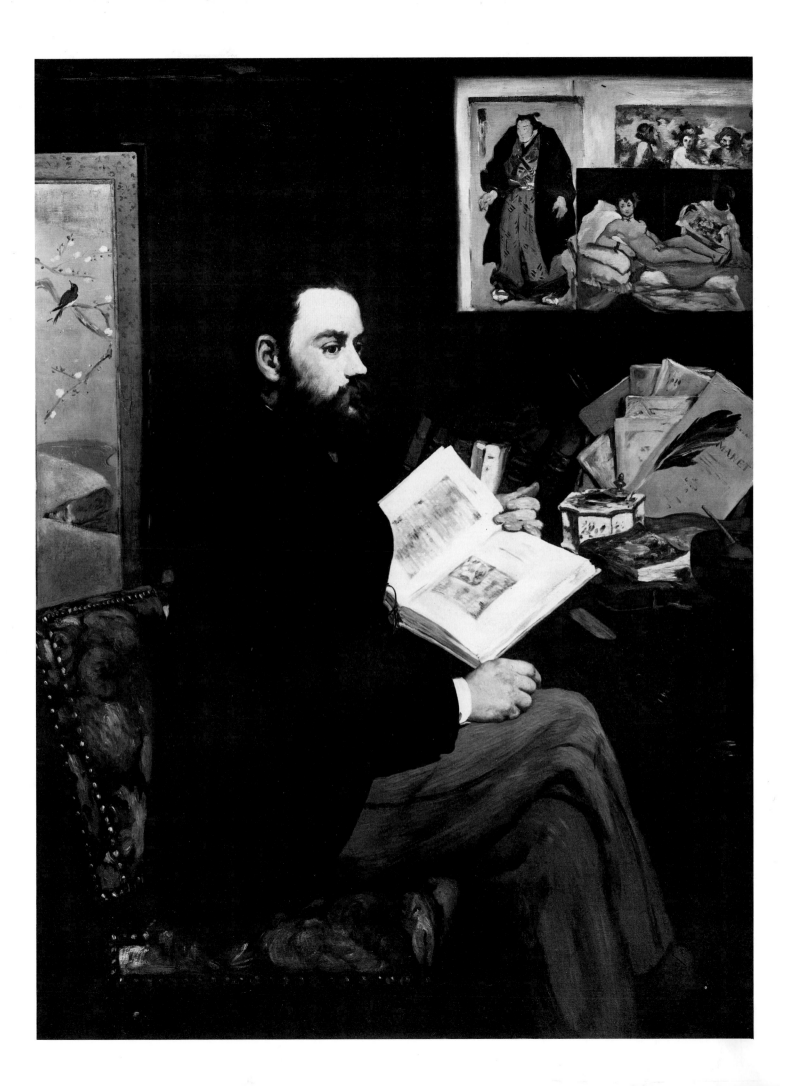

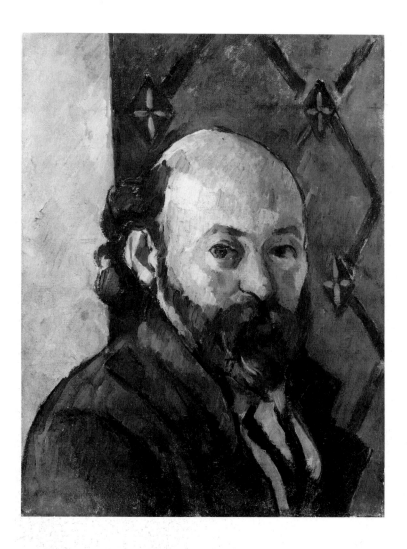

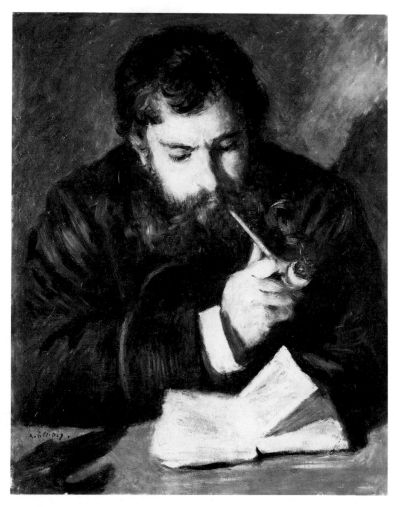

for Zola's critical support. A friendship such as that between Bazille and Edmond Maître, who was intensely interested in music and literature, occasioned a portrait which went to the sitter as a token of the relationship. At another level these images reach out beyond the private moments: Zola's portrait was sent to the Salon and was therefore also intended for a wider audience.

Painters painted each other, but such portraits were not necessarily made as a gift to the sitter — it was Manet who acquired Renoir's portrait of Bazille. In some of these canvases a colleague appears simply to have been a willing and available model whose features were already familiar to the artist; thus Renoir depicted Monet smoking a pipe, in 1872. In a large number of cases, however, portraits of artist colleagues, like the majority of self-portraits, appear to make a statement about 'The Artist', to engage in a dialogue about artistic life and the enterprise of painting, and to formulate an artistic persona. In withdrawing from the standard structures of artistic life and identity, the Impressionists had, in a sense, to reformulate their positions as artists. A sharpened intensity enters these images of painter colleagues. Interestingly, a number of the self-portraits were executed at signal moments of the painter's career, often when success in a more conventional sense seemed attainable.

Above left
Paul Cézanne, Self-Portrait, *1879–82*
Cézanne, the most prolific self-portraitist among the Impressionists, did not need a special occasion to scrutinize his features. The lozenge pattern round his head in this self-portrait suggests a vestigial halo, likening his artistic dedication to religious devotion.

Above right
Pierre-Auguste Renoir, Claude Monet Smoking his Pipe, *1872*
Renoir captured his friend Monet in moments of intimacy as well as at work. This is one of several portraits of Monet reading and smoking his pipe.

Opposite
Frédéric Bazille, Portrait of Edmond Maître, *1869*
Although Bazille shared a studio and living quarters with Renoir and Monet, his closest friend was Edmond Maître, with whom he shared an enthusiasm for music and literature.

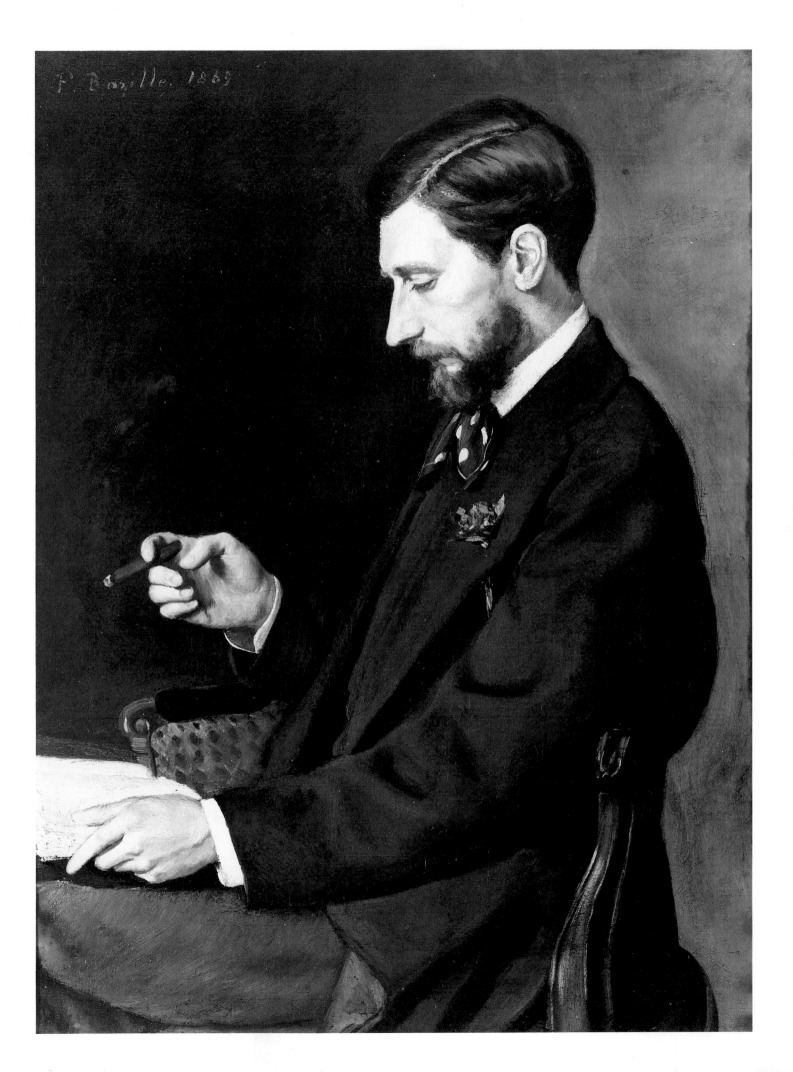

A cursory examination of the professions of the sitters reveals a high proportion of members of other artistic professions: writers, musicians and performing artists. Some, but not all, of these portraits were commissioned. Writers, especially, mingled in the Impressionist circle, meeting in the same cafés. They took up art criticism as part of the journalistic activity which supported and made possible their other writing. They were fellow creative artists and often honorary patrons.

The society in which Manet and Degas grew up brought them into association with musicians and the world of the Paris Opéra. Their absorption in urban haunts acquainted them with performers at more popular entertainments as well. Bazille and Renoir, too, indulged an enthusiasm for music, which invests some of their portrayals. At a time when Wagnerism was extending its impact upon all the arts, Renoir alone among the

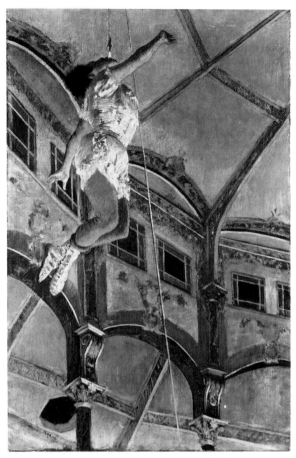

Edgar Degas, Mlle La La at the Cirque Fernando, 1879
Mlle La La's trapeze acts were great attractions at the Cirque Fernando. Degas' dramatic view depicts her whirling in space.

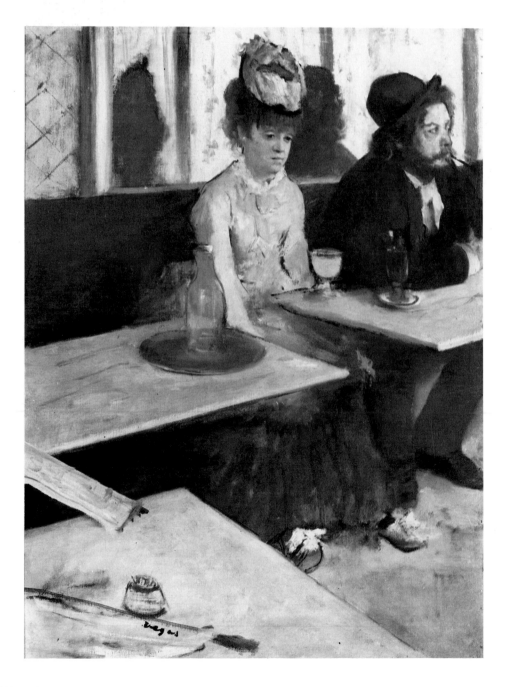

Left
Edgar Degas, L'Absinthe, 1876
The actress Ellen Andrée and the painter Marcellin Desboutin posed here as absinthe drinkers for Degas. Andrée also modelled for Renoir's Boating Party *(p. 14), and Desboutin appears in Manet's* The Artist *(p. 104).*

Opposite
Edgar Degas, Carriage at the Races, 1871–72
The Valpinçon family, friends of Degas, form the domestic grouping in the foreground carriage. Degas' enthusiasm for horse-racing motifs had begun during an earlier visit to the Valpinçon country estate in Normandy, and he again spent time there during the Paris Commune in 1871, a likely date for this painting and several others of the family (see also p. 78).

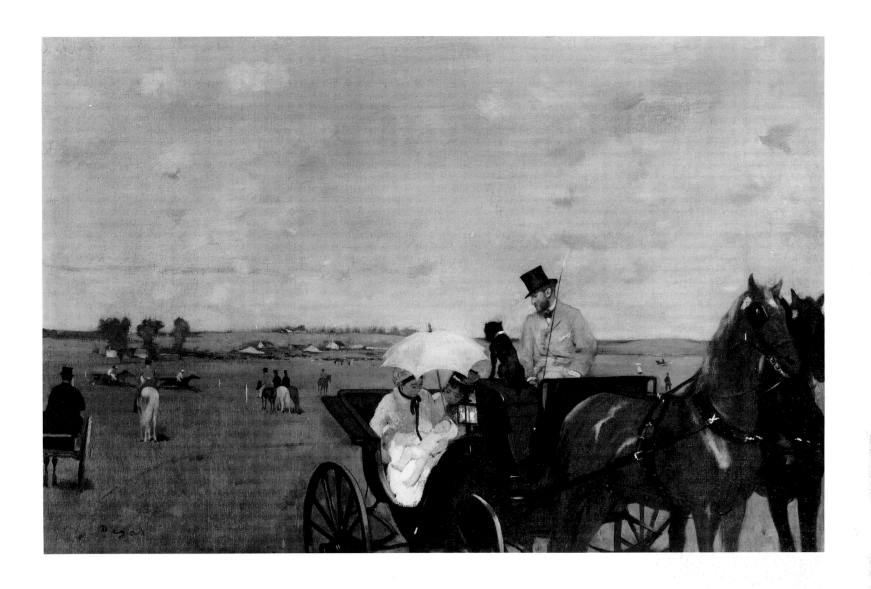

Impressionists sought out the composer: the result, a rather unfortunate and unresolved portrait. Like the images of artists, many of these portrayals of literary, musical and theatrical figures construct a professional image.

These self-portraits and portraits of professionals in the several arts do not depict portraiture's traditional subjects (the embodiments of power); however, the Impressionist images nevertheless have a genealogy traceable back to the Renaissance. They belong to a continuing discourse on the position of the arts, the stature of artists, and the nature and value of creativity. Never a fixed category, the identity of 'The Artist' was naturally of immediate concern to painters, but the pictorial constructions of the artists' identities reach out beyond the personal realm to assert themselves upon the wider audiences of art.

Equally venerable traditions provide precedents for depictions of artists' families, but prior to the Impressionist generation such portraits remained relatively minor. For the Impressionists, however, parents, siblings, wives, husbands, children and mistresses became the category of sitter most frequently portrayed. Friends and relatives also served as models for

compositions whose broader theme happened to incorporate individual likenesses. Even if we set aside these more generic works, a vast number of more straightforward images remain to be understood. For example, Monet's wife Camille appears as herself in canvases by Renoir and Manet as well as by Monet himself.

The sheer quantity of such paintings refutes a strictly private function. Although some were intended as gifts for their sitters or for other family members, the majority raise questions as to their intended viewers or potential purchasers. A portrait of someone else's family has a different kind of meaning and desirability to a portrait of one's own. In what kind of context did spectators locate such paintings? Are they works set adrift, homeless? Did the sitter's identity subside beneath a more general reading? Did the spectator find these works attractive for formal reasons rather than for their subjects? Needless to say, family members were the most ready, captive and inexpensive models when a human figure was needed, but expediency seems an unsatisfactory, and at best partial, explanation. These family images taken as a group must attest to shifting functions and meanings for paintings of the human likeness. An examination of the institution of the family, its changes in the nineteenth century, and the development of the concept of the ideal bourgeois nuclear family might further elucidate this unprecedented insertion of the artist's most intimate personal realm into pictorial subject-matter.

The people depicted by the Impressionists are concentrated around certain professional or family groupings, but overall they embrace a broad span of bourgeois experience. The few sitters from the upper classes

Above left
Pierre-Auguste Renoir, Mme Monet and her Son in their Garden at Argenteuil, *1874*
Camille Monet and Jean are shown in virtually the same poses in a painting by Manet, which also includes the figure of Monet himself (Metropolitan Museum of Art, New York)

Above right
Claude Monet, Alice Hoschedé, *1878*
Alice Hoschedé and her children came to live with the Monet family in 1878, the year before the death of Camille, Monet's first wife. Monet and Alice Hoschedé married in 1892. This portrait has sometimes been identified as Alice's daughter Blanche.

Opposite
Claude Monet, The Luncheon, *1873*
The artist's son Jean plays alone in the foreground, while Camille and an unidentified female companion appear strolling in the distance. In the mid 1870s Monet painted numerous garden scenes occupied by Camille and Jean, often suggesting alienation or distance between mother and child (see also p. 100).

emerge in altered guise from traditional, formal depictions. The urban and rural working classes appear only occasionally as identified and named visages. The fact that a peasant or a seamstress could not afford (and might not conceive a want for) a portrait seems hardly pertinent, since the greater number of Impressionist portraits were not commissions. Impinging upon the cognizance of the Impressionists, urban workers found a place in the imagery of Manet's and Degas' paintings — as did rural workers in Pissarro's, Cézanne's and Gauguin's work — but on the whole the models have either been reduced to types or their names have vanished from record. In the case of Caillebotte's *Père Magloire* (p. 186), the model was for years misidentified as Monet.

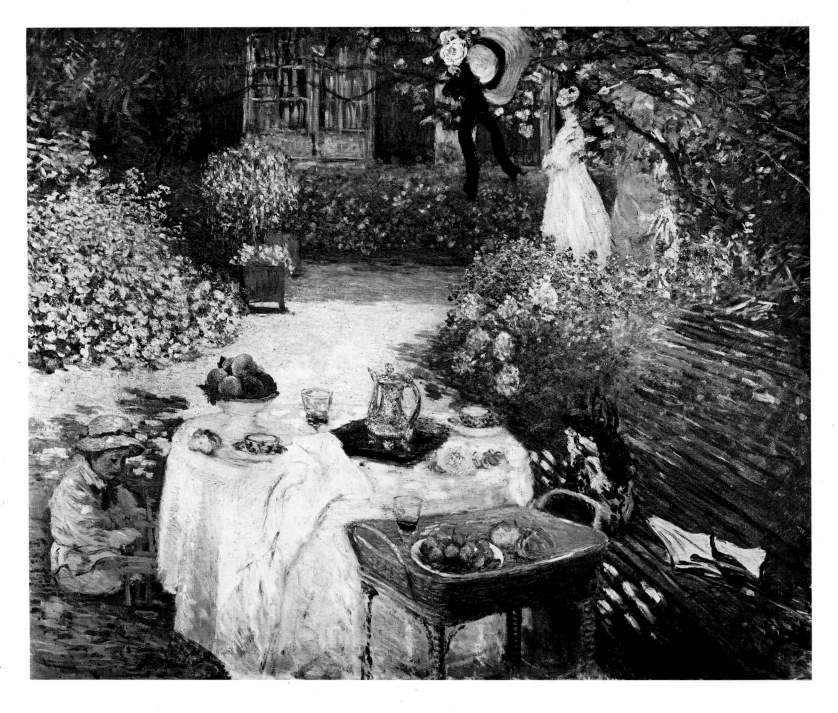

I suggested earlier that the social and environmental background of the artist might have a bearing – though not a fixedly determinate one – upon the selection of sitters and their presentation in the painting. Gender experience also entered the work of the two women painters who participated in the Impressionist exhibitions, Morisot and Cassatt. On the one hand, gender restricted their choice of sitters: some potential models were outside the bounds of propriety, others might disdain to sit for a woman. On the other hand it afforded these artists subtle shifts from the traditional male perspective, especially in their representations of women and of distinctly female experience.

In the 1860s, 1870s and 1880s rapid transformations exposed contradictions in established social orders and positions. Some of the portraits by the Impressionist circle make the resultant tensions explicit, while others reinforce dominant attitudes beneath the novel guise of spontaneous handling, for example in the portraiture of women.

Although the Impressionists have often been characterized as avant-garde rebels, the majority of their portraits remain within the framework of traditional visual formats. Whether they are presented as busts, seated or standing figures, however, intimacy predominates over formality. Some sitters appear just to pose, either self-consciously or in a relaxed posture. Sometimes they appear engaged in social pursuits – Impressionist painting developed an imagery of leisure pastimes. Others read or sew, or appear to have been momentarily interrupted from these activities. Occasionally, the models are portrayed in the context of their professional occupations, which are identifiable by their clothing or elements of their environment.

The dappled light effects, atmospheric conditions, complementary colours and broken paint texture of the Impressionist style may seem antithetical to the solid volume and contained form of the human figure; however, such stylistic features frequently appear. On the other hand, so does linear drawing and shaded modelling, local colour and broader swathes of paint. The paintings collected here reveal the variety and diversity of style and facture practised by this group of painters, all associated in a common enterprise.

Despite the fact that painters such as Manet, Degas, Cassatt, Cézanne and Gauguin tended to imbue their motifs with more enduring or extra-temporal qualities, Impressionism is still associated with the world of instantaneous, fleeting appearances. A person's physical appearance at any particular moment, however, can be only a starting point for these portraits. The transformation of appearance into a painting – and into the even more limited and problematic category of portraiture – involves the mediation of the artist working through the conventions of the medium and the accepted social groupings of gender, age, class and profession. Although Impressionist painters emphasized perceptual qualities in formulating their images of immediacy and modernity, their portraits construct an image of the sitter that comprehends both the interaction between the artist and model and prevailing codes of social behaviour.

Berthe Morisot, The Cradle, *1872*
Morisot's sister Edma Pontillon, a frequent model, posed for this maternal image after the birth of her second child.

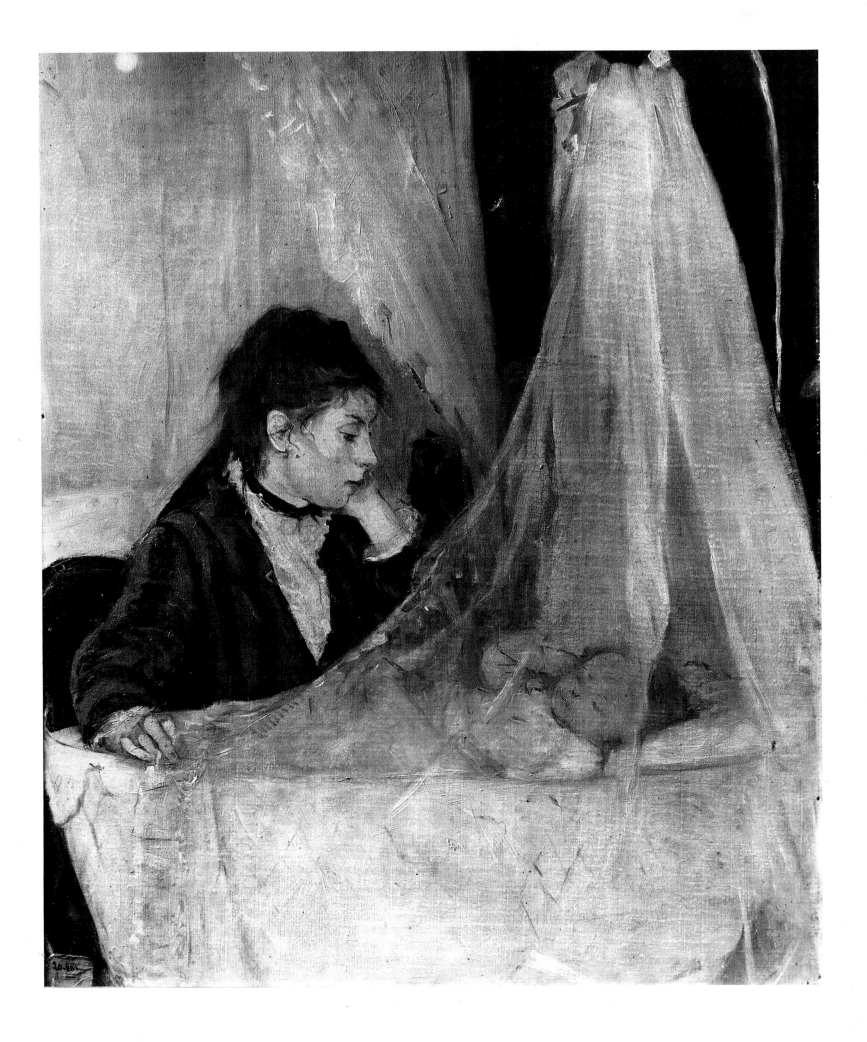

The preceding discussion has broached questions about the conditions of portraiture in relation to a large number of the paintings included in this book – works whose status as portraits may hardly seem arguable today. The fact that for a modern audience they can read as portraits indicates how much they themselves have contributed to the reformulation of portraiture.

Replacing some of the no longer viable older conventions, the Impressionists' portraits endow personality with greater status. This is not to say that personality was not previously important, but in portraits by the Impressionist circle personality, and its distancing, becomes a heightened issue. If the conveying of the sitter's personality now seems a norm of portraiture, an aspect which may strike the present-day viewer before office, rank or status, then Impressionist portraiture bears a great responsibility for this situation. In isolating the individuality of a sitter's personality, in exposing the interaction between sitter and painter, in emphasizing immediacy of personal confrontation, such works disguise the fact that they are still conventional. That so many of these portraits initially seem natural rather than constructed indicates just how powerful was the Impressionist achievement.

The apparent success of the French Third Republic seemed to confirm bourgeois ideals of individualism. Portraits by the Impressionist generation spotlight the individual. They might be seen as the last relatively confident-looking depictions of the human form and visage before such representation itself became problematic.

Edouard Manet, Portrait of Clemenceau, *1879–80*
Manet made several portraits of Georges Clemenceau early in his political career. Since Clemenceau posed only a few times for him, Manet probably had to make use of photographs, but the result presents a forceful, determined image.

Opposite
Pierre-Auguste Renoir, Portrait of Mme Georges Charpentier, *1876–77*
The publisher Georges Charpentier and his wife were among Renoir's earliest important patrons. After this small portrait Renoir went on to execute the large painting of Mme Charpentier and her children on p. 136.

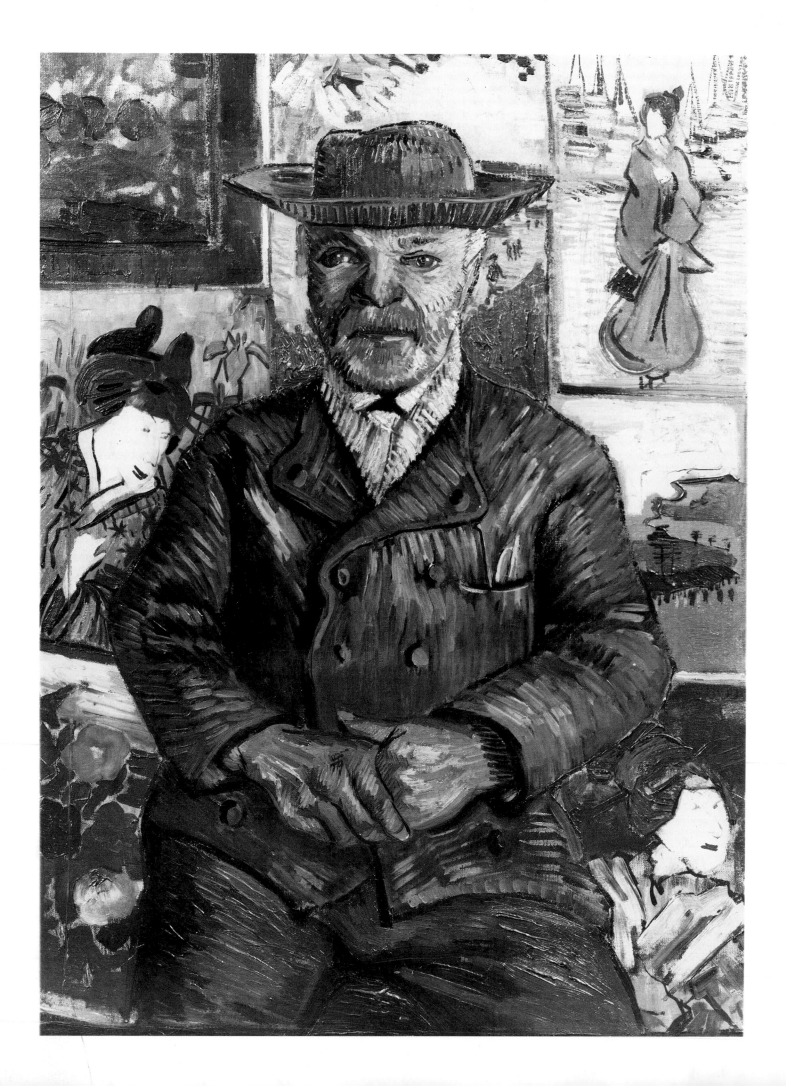

Note on Selection

The works and artists presented here, apart from Manet and Bazille, have been restricted to the exhibiting Impressionists. Although not exhaustive, this representation encompasses virtually all the major participants as well as a selection of those whose reputations are less well known. Impressionism has therefore been taken as an artistic affiliation rather than as a more rigorous stylistic grouping. The time-span has been confined to the decade leading up to the first exhibition of 1874 and the ensuing twelve years during which the remaining exhibitions were held. My intention has been to set parameters for opening up rather than restricting issues, but, inevitably, interesting works have had to be excluded — portraits by Van Gogh, for example (who did not exhibit with the Impressionists).

Attention has been given to presenting the range and variety of sitters, and towards a balanced representation of types of sitter as well as of artists. Undoubtedly, my own personal interests have influenced the selection, but I hope that the final assemblage includes both familiar images and new and unfamiliar ones.

My intention has been to propose as positive features uncertainty, ambiguity and contradiction. Therefore, the paintings range from unquestionable portraits, commissioned by their sitters, to works where the recognizability of the model seems a result of pictorial practice rather than a specific intention to paint a portrait. It is hoped that these images reveal the complicated and never static nature of both Impressionism and portraiture, and that they raise questions and elude fixed readings.

Vincent van Gogh, Père Tanguy, *1887*
Van Gogh never exhibited with the Impressionists, but his paintings executed during his years in Paris evince an individual response to Impressionist facture. He painted at least three portraits of Père Tanguy, who was an artists' materials merchant. The walls of Tanguy's shop were hung with Japanese prints and works by the Impressionists and younger artists which he often accepted as payment.

Plates
and
Commentaries

I

The Early Years
1864–74

Frédéric Bazille

Self-portrait 1865

Although he had decided on a painting career by the time he left school, Frédéric Bazille (1841–70) took his father's advice and enrolled in his local medical faculty in Montpellier. Arriving in Paris in the autumn of 1862, he combined his medical studies with art, entering Gleyre's studio where he met Monet, Renoir and Sisley. Failure to pass his medical exams enabled him to devote himself to his painting.

Bazille's background had prepared him for his eventual profession. His family belonged to the high Huguenot bourgeoisie, and he had helped his uncle Louis to assemble a collection of paintings and prints. Family support later enabled him not only to carry on with his own art but also to assist his more needy friends. Both Renoir and Monet were to share his studios.

This self-portrait already shows him to be an accomplished painter, and Salon acceptances were to follow over the next few years. While he joined his colleagues in painting plein air landscapes, he retained the more traditional practice of making preparatory drawings and composing works in the studio. Thus, although associated with proto-Impressionist developments, his form of naturalism retained a draughtsmanly quality and self-conscious arrangements of figures at a time when the work of his closest contemporaries was moving towards a sketchier, more casual appearance. He enlisted at the outbreak of the Franco-Prussian War in 1870, and his untimely death at Beaune-la-Rolande curtailed a potentially individual engagement with Impressionism.

Bazille presents himself as an artist, prominently displaying his palette, which provides a localized spectrum of hues against the dominant light-dark patterns. His three-quarter-length pose shows his body turned away, his head glancing over his shoulder as if checking his features in a mirror. This somewhat unusual arrangement was adopted later by Guillaumin (p. 130). Rather than assertively confronting the viewer, it suggests privacy, although the upturned palette forecloses retreat into the darkened background. The cup fastened to the palette's edge brings out the deliberate artifice of this display of his painter's tools; at such an angle any medium would spill out. Although Bazille's left hand here holds the brush, Renoir's portrait (p. 38) shows that he was in fact right handed, and that Bazille has here set down his mirror image.

The interplay of black, white and the varied range of greys, together with the brightly illuminated features, evince Bazille's artistic kinship with Manet. It was Manet who painted Bazille's portrait in the latter's painting of his studio (p. 73).

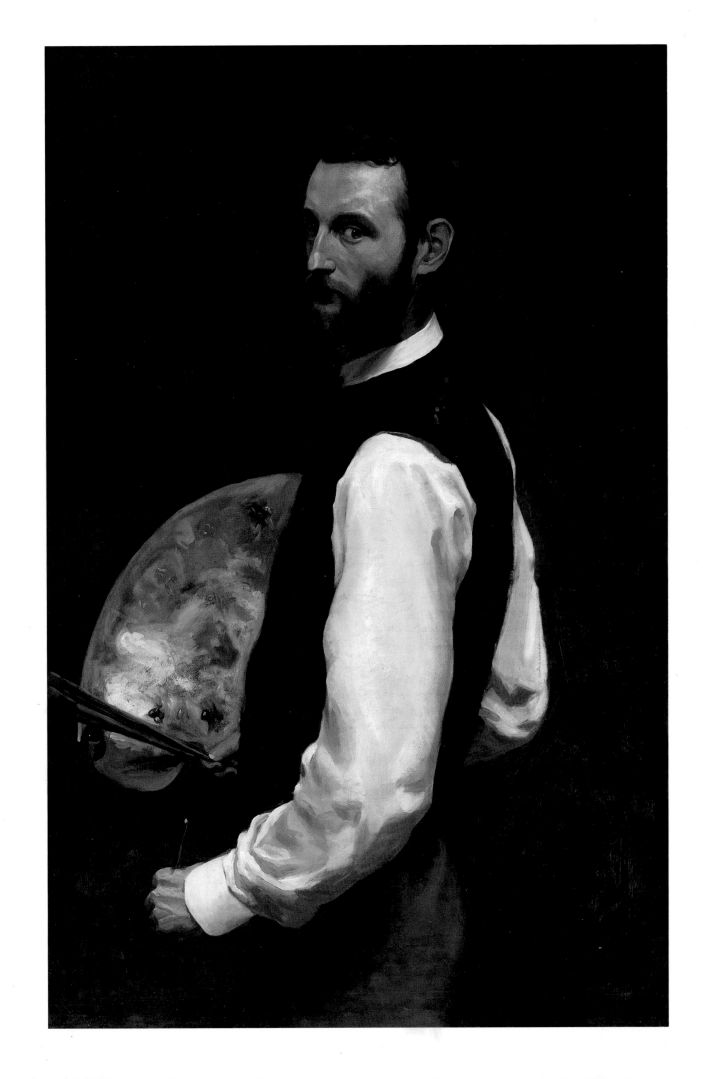

Frédéric Bazille

Family Reunion 1867

Bazille's large family portrait is one of the most ambitious of the multi-figure compositions attempted by the young plein air painters in the late 1860s. Unlike the more casual picnic and leisure scenes of his colleagues, it shows virtually every figure posing with an awareness of being looked at and giving back an equally determined scrutinizing stare. The multiple gazes, rendered with an overall draughtsmanly precision and clarity, produce disturbing psychological reverberations. No one within the painting attends to anyone else, although they are associated in poses, juxtapositions and colouring.

Bazille's extended family is assembled on the terrace of the family property at Méric near Montpellier. An earlier, more relaxed family group painted in the same setting appears in the corner of his painting of his Paris studio (p. 73). Next to Bazille on the extreme left stands his cousin M. des Hours. Mme des Hours sits at the table opposite their daughter Thérèse. Their other daughter Camille, in matching blue polka-dotted dress, sits on the parapet to the far right. Bazille père and mère sit on the bench to the left. Only the paterfamilias refuses to face forward, instead scanning his domain. He was an agronomist and wine grower. The couple standing at the back, whose sidelong glances alleviate the collective stare, are two more cousins M. and Mme Teulon, while on the parapet Bazille's brother Marc crouches behind his wife Suzanne.

The umbrella of the tree shades the group. Behind, light glares on the open landscape vista and casts brilliant dapples on the terrace. The shadowed atmosphere combines with numerous items of clothing in a pervasive blue tonality. The indirect but lucid illumination results in few pockets of shadow and only a slight modelling of features. Despite the spatially scattered grouping, the figures seem locked in a kind of wide-angle focus frieze.

Although united in their almost unbroken acknowledgment of the viewer, the faces exhibit a variety of expression and reaction ranging from intensity to irony, from hostility to blankness and dreaminess. The sewing on the table and the foreground still-life of hat, parasol and flowers suggest an interruption of occupation for at least some of the sitters.

When the painting was exhibited in the Salon of 1868, Zola commented on its 'keen love of truth', but the truth is one of precision in separate details. The whole looks artificially staged, more a collective portrait than a group portrait. What Bazille has assembled here are separate individuals, each representing a variation on the common experience of viewing and being viewed.

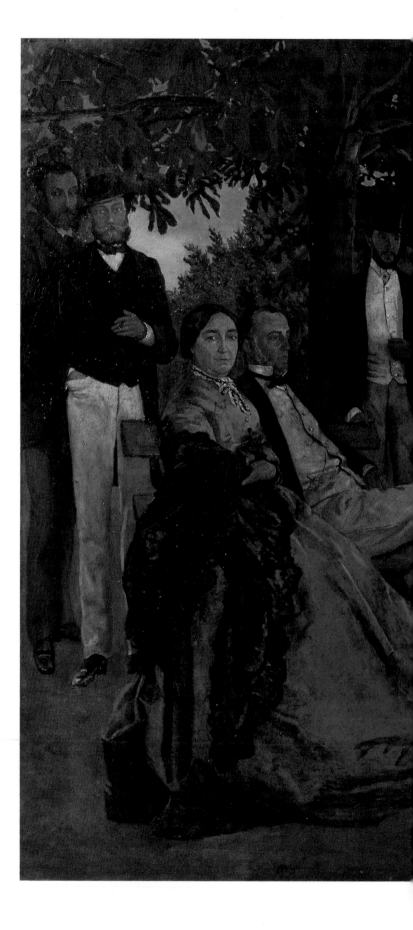

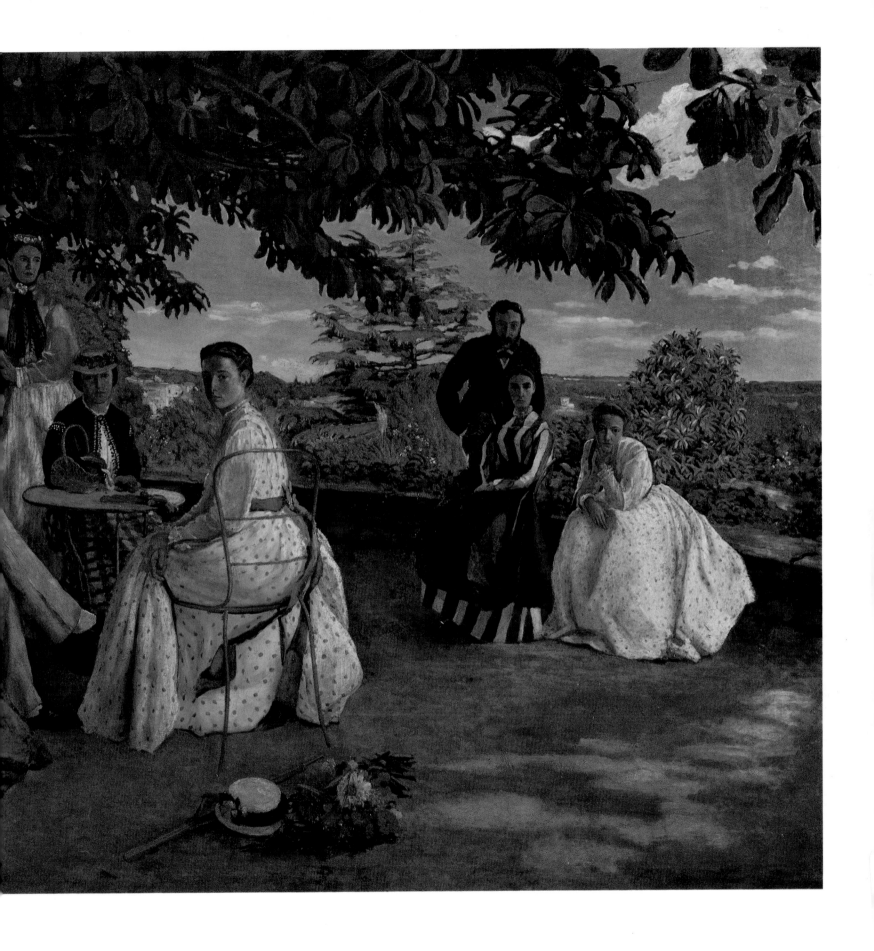

Frédéric Bazille

Portrait of Renoir 1867

Bazille's reciprocal portrait of Renoir, painted in the same year that Renoir had depicted Bazille at his easel (p. 38), portrays its sitter more informally. It gives no hint of Renoir's profession. Instead, he is perched rather unconventionally on his chair, his legs folded back beneath his clasped arms, allowing his feet to dangle. Such a pose surely could not be held comfortably for long periods, but it has the asset of appearing casual and temporary.

Bazille exploits the contrast of the zig-zagging shape of the legs and the almost rectilinear form of the near arm against the curves of the chair. Even Renoir's hairline echoes the angularity of his body. The hands, while loosely painted, form a concentrated knot. Renoir's face, nearly in profile, combines reflective relaxation with an alert concentration, brought out in the eye capped by the sloping dash of his brow.

The frontal lighting tends to flatten the facial features and black- and grey-clothed limbs. Shading is reduced to linear drawing, especially along the edges of forms. This flattening emphasizes a certain anatomical awkwardness. Renoir's upper right arm seems overstretched, and the foreshortening of the forearm not quite convincing, but as a pictorial shape this arm mirrors the jutting left shoulder.

The cooler blue-grey background lightly covers the surface of the canvas, cancelling out the vestige of some darker form to the lower right, while blackened pigment fingers its way up the left side. In its present state this darker area works as a kind of cast shadow, but it may indicate intended revision to the tonal scheme. Only the blue touch of Renoir's necktie, drawing attention to the face above, provides a definite hue among the more neutral colours.

The fresh brushwork, the ambitious pose – even with its awkwardness – and the subtle variety of tonalities provide a vital personal image of Renoir. The work seems evocative as much of behaviour as of appearance. A restlessness and tension pervade the interlocked stasis of the figure. The two men knew each other well, sharing Bazille's studio in the rue Visconti, during the autumn of 1867, where they were joined by Monet. Bazille wrote to his sisters, 'Monet has fallen upon me from the skies. . . . Counting Renoir, that makes two hardworking painters I'm housing. . . . I'm delighted.'

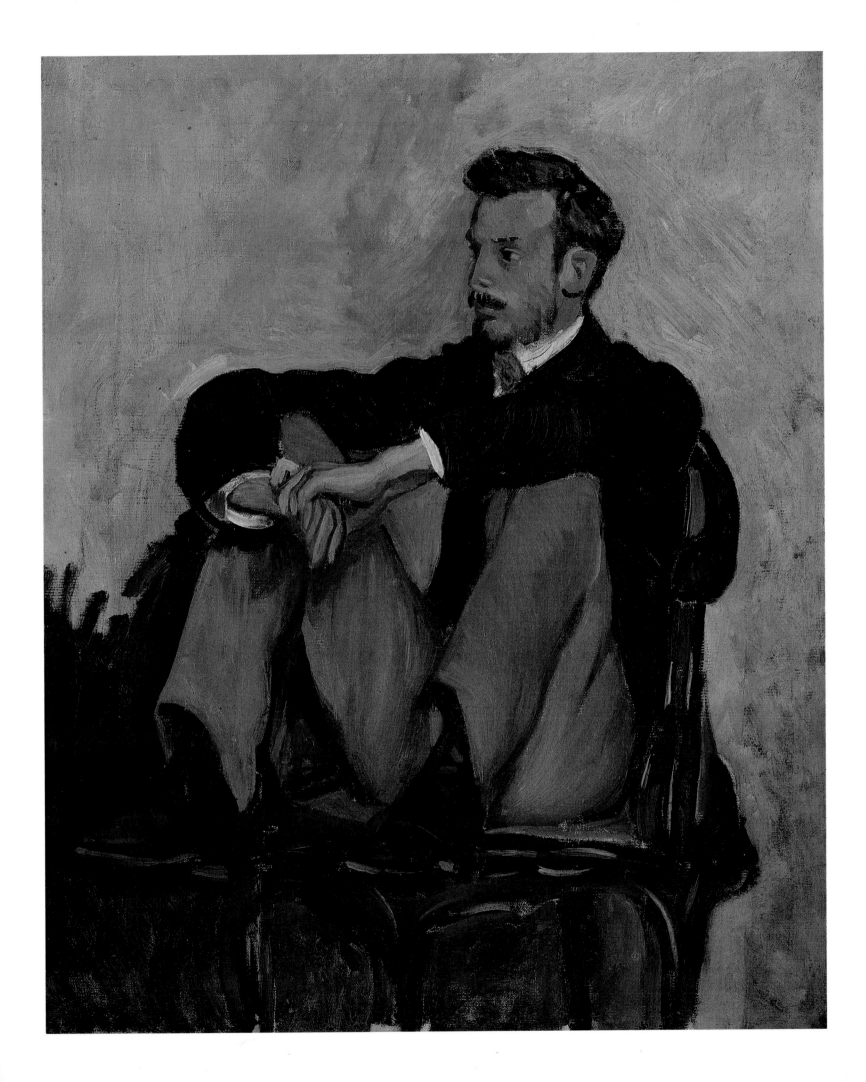

Pierre-Auguste Renoir

Portrait of Frédéric Bazille 1867

During the late 1860s Bazille and Renoir shared several studios, joined at times by Monet. Sisley, too, lived in the same house on the rue Visconti where this portrait was painted. A group of paintings stand as testament to these close friendships. Bazille and Renoir painted each other (see also p. 36) and Sisley painted the same still-life composition here preoccupying Bazille. Bazille's still-life *The Heron* survives as a striking, naturalist observation of dead birds.

Renoir and Bazille had met while students in Gleyre's studio in 1862. With his family income Bazille was able to support his friend through this period of financial stress. Renoir portrayed his colleague practising his profession, in contrast to Bazille's image of Renoir in a more relaxed, meditative pose. The arrangement of the seated figure with his brushes and palette bears comparison with Manet's somewhat later portrait of Eva Gonzalès (p. 74). Manet indeed owned and admired Renoir's painting. Whereas Manet's work intrigues in the artifice of its presentation, Renoir's portrait conveys a natural intimacy. The casual footwear adds an informal element. Bazille appears absorbed in his work without showing self-consciousness at being observed.

The portrait summarizes the artistic practice of young naturalist painters of the period. Although the setting is a studio interior, plein air landscape painting was taking on an increasingly significant position, attested by the unframed landscape behind Bazille's head. His small palette is also of the type usually included in portable paint boxes. A fragment of a framed picture is inserted between Bazille's still-life and the landscape, while several canvases are stacked against the wall, showing both stretcher structure and primed surface. Bazille's long, finely pointed brushes are suited to the more sharply focused rendering which he maintained through the late 1860s, while his colleagues were moving towards the broader effects of the direct sketch.

Aside from the red ribbons on the left foot and the pigments on the palette, this painting confines itself to a greyish tonal range. The profile pose keeps parallel to the wall behind, but ambiguity appears in the seemingly shallow space. The join of the wall and floor is concealed, while the easel, its painting, the jutting plane of the palette and the cast shadows undermine the perspective implied by their diagonals.

The landscape on the wall depicts Monet's snowscape *Honfleur*, 1867. Bazille hung works by his friends as well as his own paintings in his studio, and it is tempting to imagine this work as a token of Monet's familiar presence in the studio.

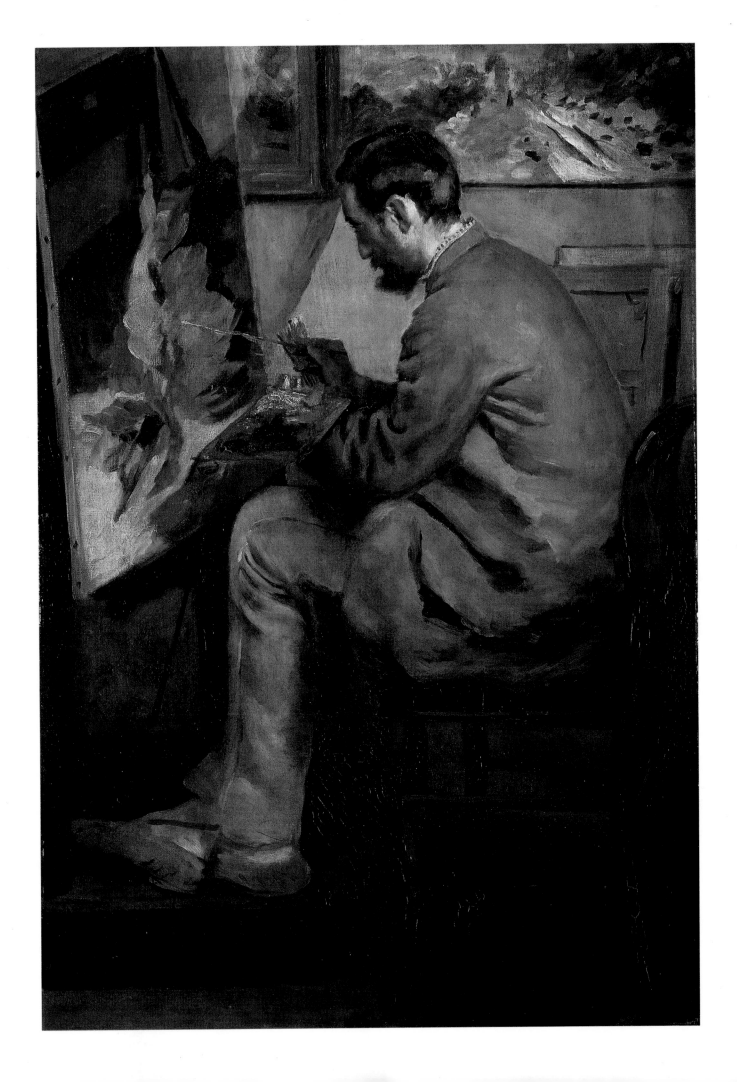

Edgar Degas

Woman with Chrysanthemums 1858–65

Degas' *Woman with Chrysanthemums* apparently began simply as a floral still-life, one which may have been inspired by several of Delacroix's bouquets. The painting is signed and dated twice, and technical examination indicates that the woman's figure was a later addition. Her insertion necessitated overpainting and several spatial readjustments.

The figure's arrival decentred a conventionally balanced composition. The abundant, colourful still-life and the smaller, more muted sitter compete as focuses of interest. She looks off to the right, the direction of her glance further dispersing compositional conventions. The first occurrence in Degas' work of such asymmetry, this painting stands as his first major construction of pictorial modernity. Such a siting of a figure at or near the framing edge recalls photographic images and Japanese prints, both of which attracted Degas' avid interest.

A floral pattern in the wallpaper and a garden scene visible through the open window flank the bouquet of cut flowers, representing degrees of artifice and naturalness. Despite the juxtaposition of flowers and a female figure, the familiar analogy here appears to be undermined. While the single pom-pom-like blossom extending over her upper arm finds visual echoes in the white ruffle of her hat and the small button accent of her earring, the handling of the variegated and textured blooms is unlike the general colouring, drawing and paint application of her figure. Thin applications of delicately modulated flesh tones, more like Ingres than Delacroix, build up her face. In the area of her dress the paint barely covers the canvas, and sketchy overdrawing indicates the presence of fabric folds and ruffles on her sleeve and bodice. In contrast to the flowers, which employ the palette's entire chromatic range, the woman's hues seem introverted: sepias, russets, black and white.

Her hand gesture, too, appears designed for concealment. Related poses had occurred in Degas' own self-portrait (p. 46) and in family portraits (p. 64) but the sitter here was not so intimately known to the artist. She has traditionally, although not conclusively, been identified as Mme Hertel, about whom almost nothing is known apart from her Montmartre and Rome addresses written in one of Degas' notebooks. An exquisitely drawn study of the head and upper torso presents a more individual portrait, but does not assist in confirming her identity.

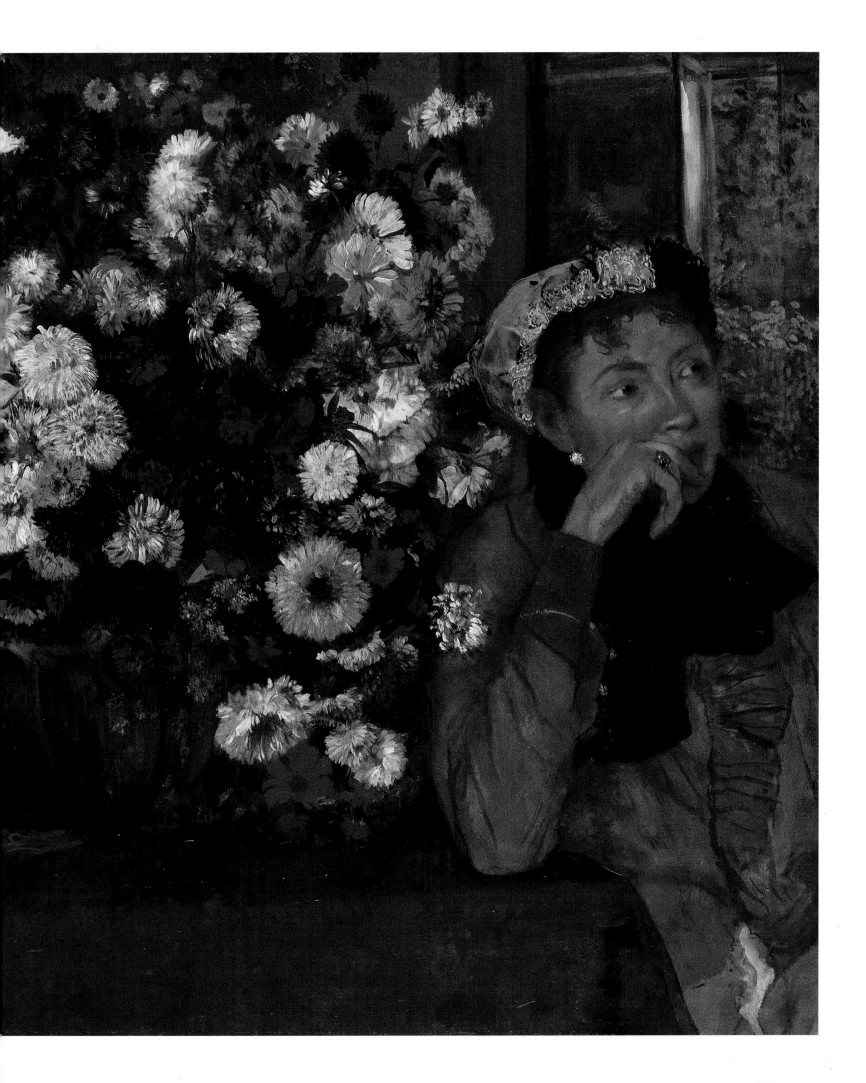

Claude Monet

The Luncheon 1868

Monet's *The Luncheon* can be interpreted as a domestic version of Renoir's *Cabaret of Mère Antony* (p. 44). An interior with figures at a table, a standing observer, a maidservant, a still-life of food, even a newspaper are elements shared by both works. The doll cast down on the foreground floor in *The Luncheon* might even be taken as a counterpart to the dog Toto in Renoir's work. Both are large, ambitious paintings displaying a relatively high degree of finish. But while Renoir fashioned an image of a serious moment in bohemian life, Monet constructed a vision of a bourgeois family idyll.

The mother and child present a linked unit, while the placement of the newspaper by the unoccupied setting suggests that the vacant chair awaits the paterfamilias. The maid hovers attentively. Only the female visitor on the periphery disturbs the enclosed tranquillity. Is her intrusion the vestige of a genre scene? Is she removing or putting on her gloves, arriving or departing . . . or simply observing?

Although Monet depicted his mistress Camille Doncieux and their son Jean at the table, he did not record an actual scene, for the facial features of the guest are also those of Camille. He described the painting to Bazille as 'an interior with a baby and two women'. Perhaps he meant two models, perhaps one figure came later, or perhaps the maid did not count.

Spatially, the work is more elaborate and more convincing than Renoir's interior two years earlier. The corner of the room may be crowded, but it comfortably accommodates the furniture and its personages who are all set in the middle distance and background. Two foreground chairs turned inwards and the dining table cordon off the occupants, although the steeply sloping floor suggests the intimate proximity of the picture space to the viewer. Directional lighting from the window supplies a range of full illumination, shadow, and contre-jour effects.

The patronage of M. Gaudibert, for whom Monet had painted several large portraits (p. 52), enabled Monet to enjoy a brief, relatively unstressful period of work in Le Havre together with Camille and Jean. The still-life on the table, while not elaborate, suggests the comforts of abundant food, while the presence of the servant implies a level of social achievement.

Monet planned to submit this painting to the Salon, and it evinces more precise drawing, a darker palette, and a more elaborate composition than a number of his contemporary works on a smaller scale. In the event, the Salon jury of 1870 rejected it. He still considered it an important work in 1874 when he included it among his entries to the first Impressionist exhibition, although by then his painting had moved away from the Manet-like self-consciousness of such an artificially staged composition.

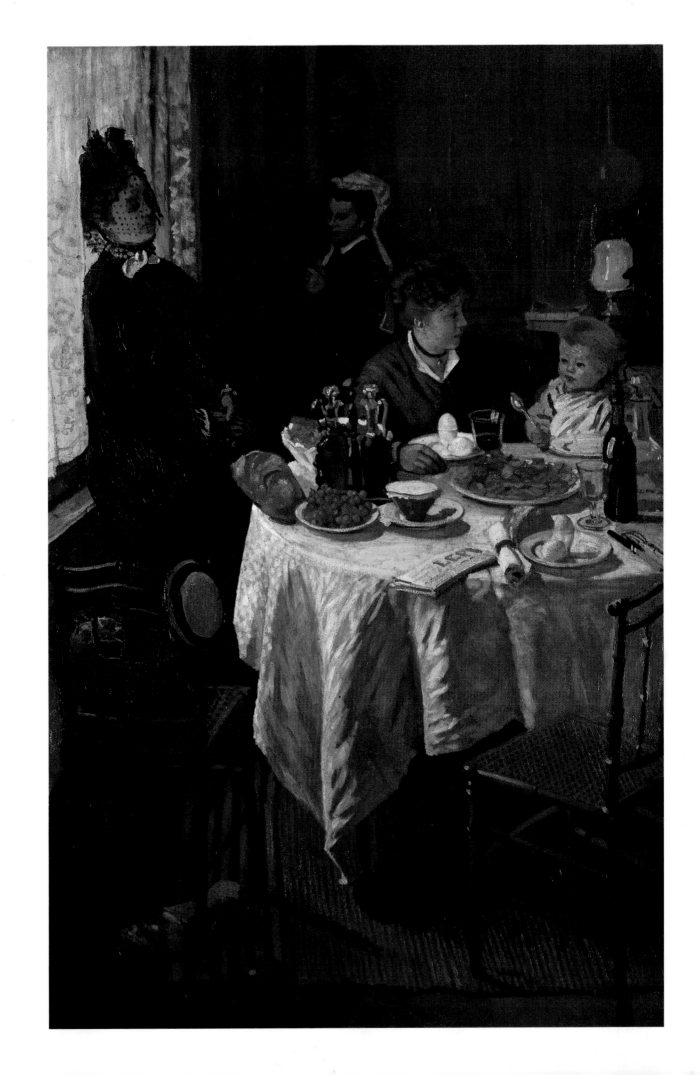

Pierre-Auguste Renoir

Cabaret of Mère Antony 1866

Renoir's first large-scale composition commemorates the *Vie Bohème* camaraderie of a group of artists in the late 1860s. The scene is set in the inn of Mère Antony at Marlotte in the Forest of Fontainebleau. 'It was a real village inn!' Renoir later remarked. The walls were decorated with caricatures of Henri Mürger – author of the novel *Scènes de la Vie Bohème* – later to be replaced by this very painting. Renoir himself had sketched the image of Mürger in the upper left.

The black, white and grey sobriety, the industry of the waitress and the attentive conversation among the male figures contradict the Goncourt brothers' characterization of the inn as harbouring 'wretched painters, along with Mürger's disgraceful phalanstery and wretched harem.' Mère Antony in a headscarf turns her back on the gathering. Crushed against the background, her presence seems to be inserted among the graffiti on the wall. The waitress, Nana, clears the table, while the three men engage in discussion round the newspaper *L'Evénement*, which had recently appointed Zola as a critic. It was in *L'Evénement* that Zola published his defence of Manet in 1866. Thus, the prominent display of the paper is far from gratuitous.

The men have been variously identified. Renoir mentioned Sisley and Jules Le Coeur (1832–82). In 1866 Renoir was especially close to these two artists, one a future Impressionist and the other a wealthy landscape painter, who occasionally lent Renoir financial assistance. Little is known of Le Coeur's work. He gave up architecture to pursue painting, and although he exhibited in the 1873 Salon des Refusés, he did not join the Impressionist exhibitions. Le Coeur, standing, fills his pipe, while Sisley, whose features are lost in his profil perdu, gesticulates towards the other listener, a clean-shaven man whose identity has not been discovered despite his carefully depicted features. The white poodle, Toto, belonged to the establishment. He, too, was something of an individual character, being the possessor of a wooden leg, and Renoir has rendered his portrayal as sharply as those of the humans.

The precision of each detail, the awkward space and scale, and the almost doll-like poses, lend a certain ingenuousness to the contrived staging. Symbols of the establishment – dog, waitress, proprietress and murals – encase the three men. The gestures of the hands ascending diagonally across the newspaper, echoed by the three heads, suggest a moment pregnant with meaning.

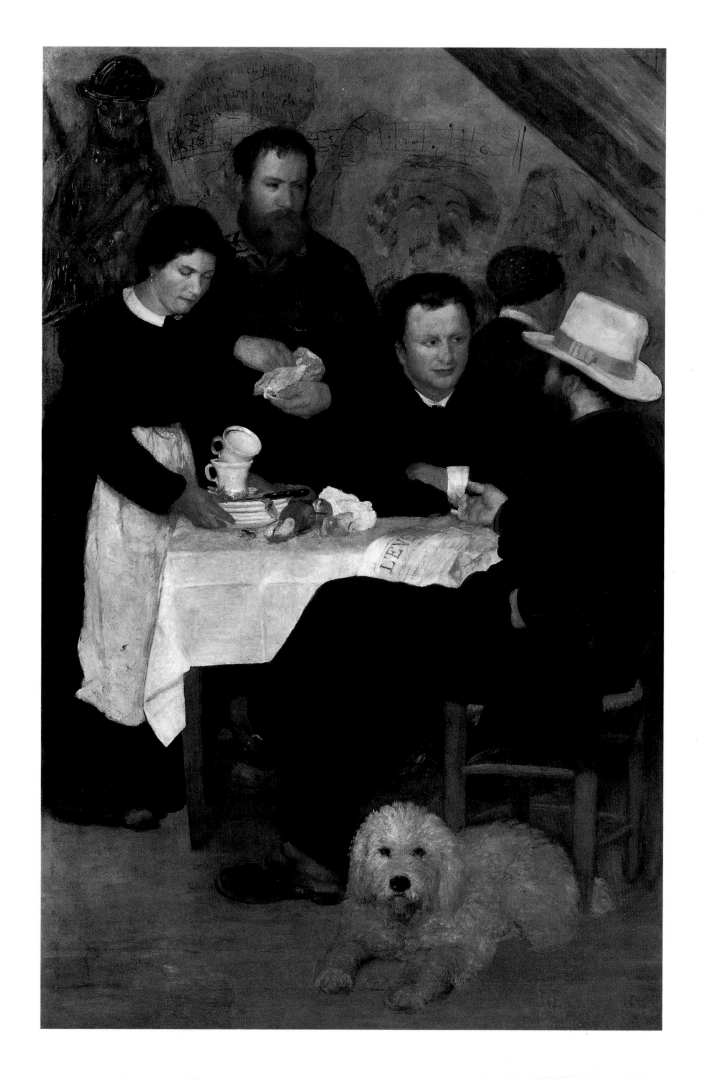

Edgar Degas

Degas and de Valernes c. 1864

Hilaire-Germain-Edgar Degas (1834–1917) provided catalytic
energy for the organization of the first exhibition of independent
painters who became known as Impressionists. He himself resisted
the appellation and never shared the Impressionists' enthusiasm for
plein air landscape painting, although he participated in all but one
of the eight exhibitions.

The son of an Italian-French father and a Creole-French mother,
Degas rejected the aristocratization of the family name to de Gas
adopted by some members of the widely flung banking and
mercantile family. He received only minor parental opposition to his
chosen career, and family prosperity made possible a cultivated and
relaxed existence.

After a number of early self-portraits, he gave up the perusal of
his own features but persisted in scrutinizing the visages and
demeanour of others. Here, he poses as the more retiring, aloof
companion of his friend Evariste de Bernardi de Valernes
(1816–96). The two men had met in 1855. De Valernes, the
impecunious son of a nobleman, had studied painting in Delacroix'
studio, and he made his Salon debut in 1857. Outdatedly Romantic
and irresolute, de Valernes shared with Degas an enthusiasm for
Rome, whose topography can be made out in the sketchy view
through the window.

Although the bright window silhouettes the darker figures, their
faces are lit from another source, in front and to the left. De
Valernes' easy slouch across the foreground brings out his dreamy
character. His eyelids are half closed, and with his right hand he
fingers the stub of a cigar. In contrast, Degas sits tensely alert
behind the barrier of the table. His habitual gesture of stroking his
chin adds a certain protective reserve to his image. (See also the
portrait of his sister Thérèse and her husband, p. 64.)

Degas left the painting unfinished, though he had already shown
himself capable of complex and psychologically resonant group
portraits. Apart from the figures, the paint application remains
sketchy. The redrawing on de Valernes' left shoulder and hand may
indicate an attempt to rectify the disproportions of the figure. It has
been revealed by X-ray that Degas originally sported a top hat and
rested his arm on the table.

Unlike numerous self-portraits by his Impressionist associates,
Degas' painting does not construct an image of a professional artist.
A reverse study of his figure indicates that he even rectified the
mirror's inversion. Rather, this double portrait presents Degas' social
bearing and his slightly ironic personal detachment.

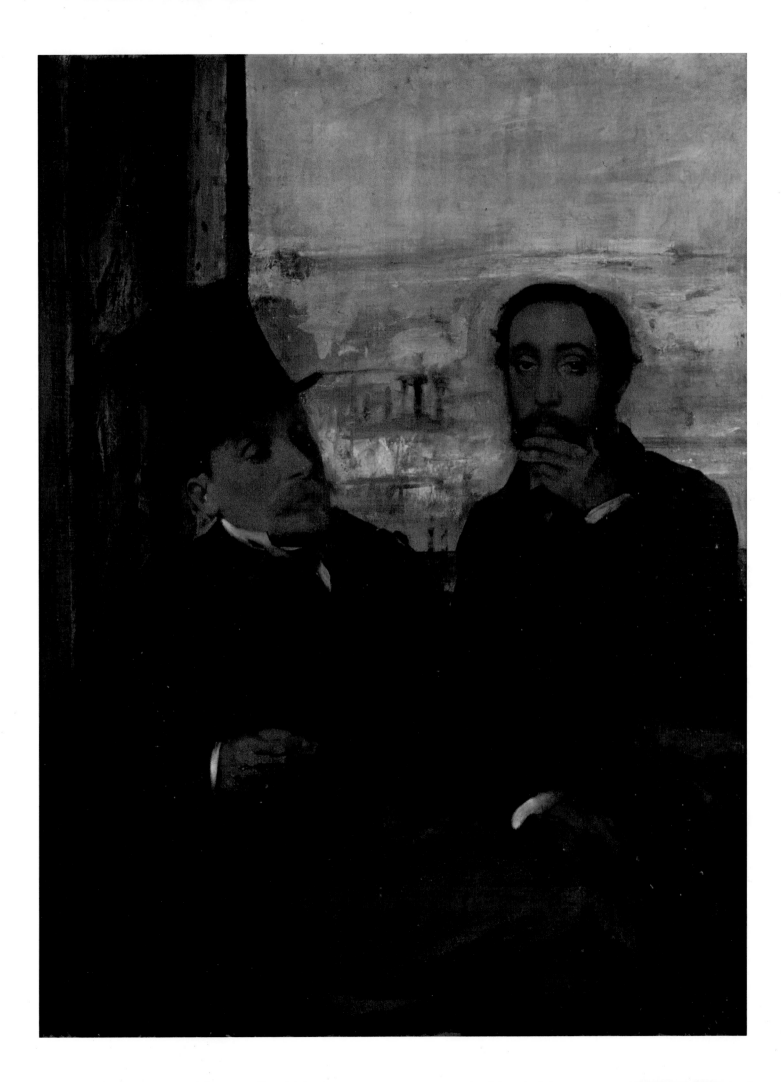

Edouard Manet

The Balcony 1868–69

The isolation and psychological distance of the figures in *The Balcony* puzzled contemporary critics. The painting acknowledges works by Goya, as well as the more contemporary Constantin Guys (1802–92), in which sexual allusions are more explicit. That sexual innuendoes were still readable here is attested by Berthe Morisot's remark that her image had been described as that of a 'femme fatale'.

As in most of Manet's scenes that conflate art history and modern life, the features of his models are immediately recognizable. The three foreground figures are friends from his artistic and social milieu. The painter Berthe Morisot (1841–95) is seated, resting on the framework of the railing. To the right, the violinist Fanny Claus (1846–69) toys with her glove while cradling an umbrella. Jean-Baptiste-Antoine Guillemet (1842–1918), a landscape painter, is framed by the open shutters against the dark interior. Within the depths of the room a child, probably Manet's son Léon Leenhoff (1852–1927), carries a tray.

Morisot had been introduced by the painter Fantin-Latour to Manet in 1867, while she was copying a Rubens in the Louvre. This is the first of her several appearances in works by Manet, who became her most significant artistic mentor. By 1868 her work had been accepted at the Salon, where it was discussed by Zola. Although counselled by Manet against joining the Impressionists she exhibited in all their shows except for that of 1879, when she was expecting her child – she had married Eugène Manet (Edouard's brother) in 1874.

Morisot's acquaintance with Guillemet dated back to the early 1860s. He had met a number of the future Impressionists at the Académie Suisse, and his support had enabled several of his friends to show at the Salon. Like Manet, he preferred to continue with his Salon submissions rather than to exhibit with the Impressionists.

Claus, a concert violinist, played with the Sainte Cécile quartet, but she also joined Manet's wife Suzanne, a talented pianist, in private music making at the home of the painter. She was to marry Pierre Prins, a sculptor friend of the Manets.

Léon Leenhoff, also known as Léon Koëlla, was the son of Suzanne Manet, though often passed off as her younger brother, Although Manet never legally acknowledged the child, born some years before Manet formalized his liaison with Suzanne, it is usually assumed that he was Léon's father.

A painted sketch of Claus seated attests to Manet's reworking of his initial ideas as he developed this painting. Not only did he employ preparatory studies but he also laboured over the final canvas. According to Mme Morisot, Guillemet posed at least fifteen times.

Claus' floral hairpiece and her features, given an orientalizing accent in the finished canvas, insert a reference to Japonisme into this European milieu. Morisot's physiognomy, with her dark hair and eyes, reinforces the allusions to Goya's Spanish precedent. The dog with the ball interjects reverberations from some of Manet's earlier paintings as well as referring to a range of past art.

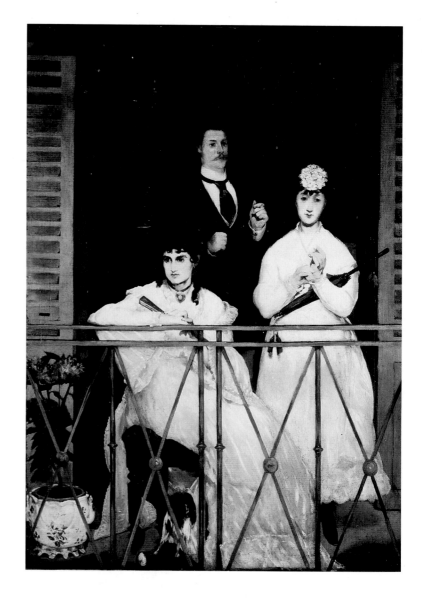

Although the painting is set partly outside, in daylight, the work was composed in the studio. A scaffolding of horizontals, verticals and diagonals fixes the placement of the models. The sharp green of the balcony railing and flanking shutters confines the white silhouettes of the women against the dark brown interior, into which the male figures are more or less completely grounded. The accents of red fan, blue cravat and yellow gloves take on the quality of specific attributes of their possessors. The scene suggests a tableau vivant with precise meaning, but it remains as enigmatic as the figures' individual, self-absorbed privacy.

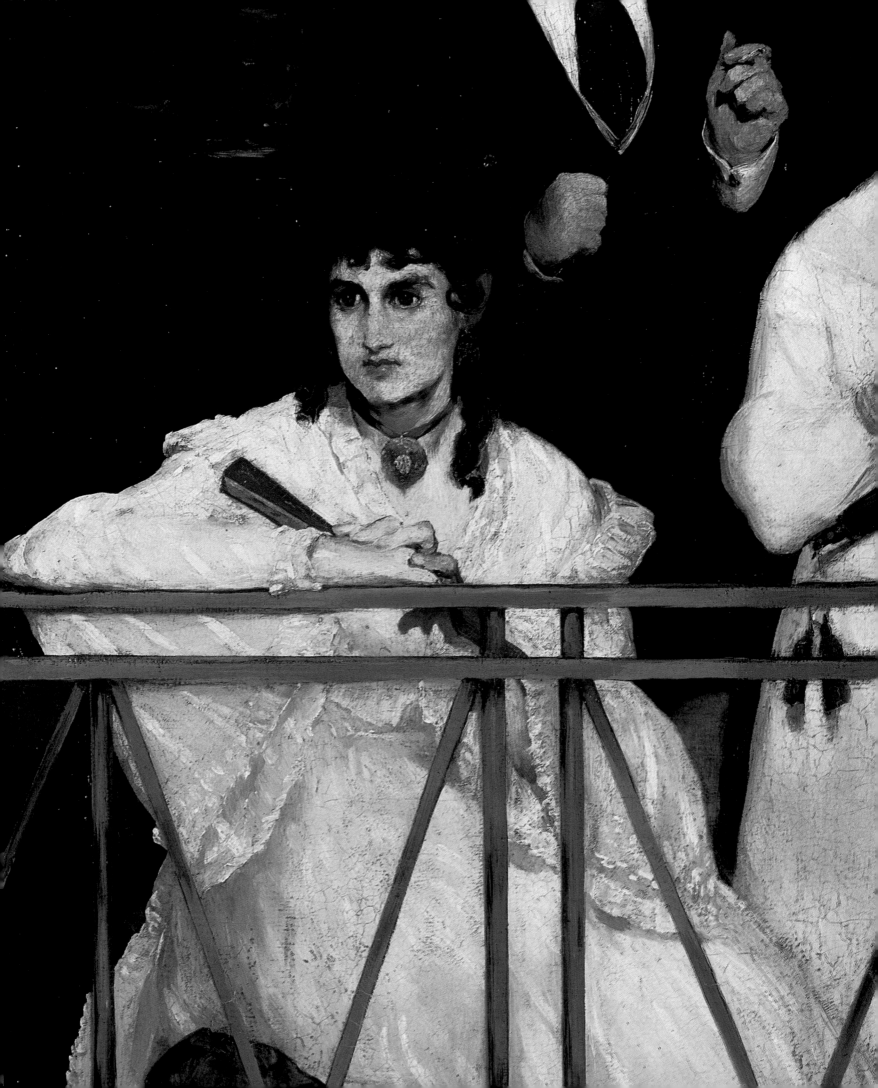

Edouard Manet

Repose (Portrait of Berthe Morisot) 1870

A little more than one year after her debut as an enigmatic Hispanic personage in Manet's *The Balcony* (p. 48) Berthe Morisot again modelled for her artistic mentor. Although this painting is more straightforwardly a portrait, Morisot retains her previous accessory – a fan – and still appears clothed in white, though the dress is here cut more simply in a sprigged fabric. Her visage, less precisely defined than in *The Balcony*, allowed one critic to see her expression as sickly and despondent. However read, it suggests interior reflection rather than the customarily more outward engagement of Manet's models.

As X-rays have revealed, her pose was originally more upright and frontal. Its final distribution does not bear anatomical scrutiny, and it invests the relaxed sprawl with tension. Her arms and torso intersect in a twisted cross, one arm spreading outwards and the other partially supporting her weight. A black belt fastens together the seemingly dislocated hips and bust. Indeed, physical discomfort was the memory Morisot retained of the sittings. So as not to disturb the folds of her skirt, she had to endure long sessions with her left leg tucked beneath her.

Cloaking the apparent displacements of Morisot's pose, the white dress assumes an irregular but dominant shape against the burgundy red of the sofa and the dark brown interior. While Morisot's skirt fans upwards to the left, three deeply sunk buttons on the sofa cushion to the right form a triangular constellation which plays against the broader wedges of her skirt. The star-like depressions seem to harbour some additional significance.

The prominent surface pattern and its off-centre, somewhat idiosyncratic distribution has a kinship with compositional devices found in Japanese woodblock prints. The presence on the wall of a tripartite print by Kuniyoshi may acknowledge the debt. Its sea-green colour contrasts with the interior decor, and the turbulence of its image hovering above Morisot's head acts as a counterpoint to her pensive expression. Manet's addition, probably slightly later, of a strip of canvas at the top of the painting gave the print greater prominence.

Manet had painted his pupil Eva Gonzalès (p. 74) in the same year as this portrayal of Morisot. Although Morisot was to have the more distinguished career as an artist, here she appears as a model, while Gonzalès was represented at her easel.

In 1873 Manet sent this portrait to the Salon along with *Le Bon Bock*. The latter, a sparklingly painted rendering of a traditional motif, earned Manet his widest critical approval for many years. The tense, somewhat disturbing portrait of Morisot found favour with only one journalist, Théodore de Banville, who remarked approvingly upon its modernity.

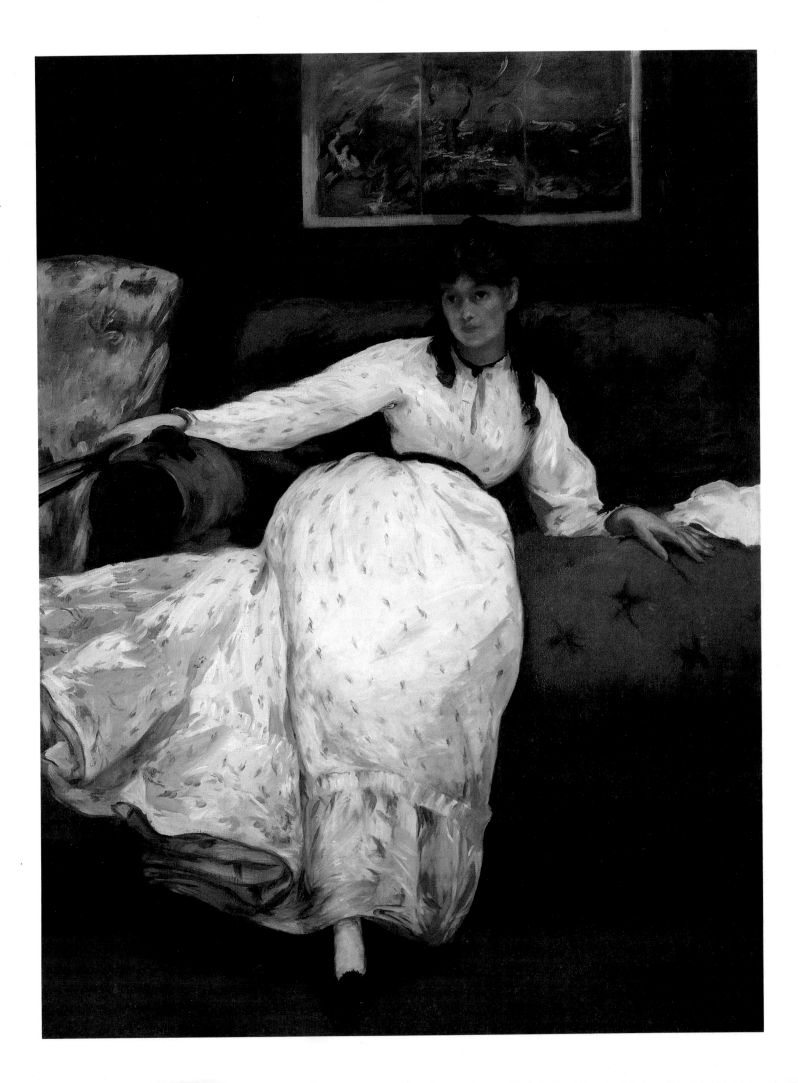

Claude Monet

Portrait of Mme Gaudibert 1868

Louis-Joachim Gaudibert was Monet's first important patron. In 1868 the Le Havre merchant and painting enthusiast had acquired several of Monet's seascapes when they were seized by creditors at the close of a local exhibition of maritime painting. It was probably Gaudibert who supplied Monet with an allowance in 1868 and 1869. In December Monet had written to Bazille: 'Thanks to the help of this gentleman from Le Havre I am enjoying the most complete tranquillity . . .'

The portrait of Marguerite-Eugénie-Mathilde Gaudibert (1846–77) was executed in the Gaudiberts' château at Montivilliers near Le Havre. It is one of a pair commissioned by Louis-Joachim's parents to depict their son and daughter-in-law. Eventually, Monet painted two portraits of Louis-Joachim (now both lost) because Mme Gaudibert senior was dissatisfied with the first.

The turned pose with its profil perdu and the display of the abundant train of the dress is reminiscent of a fashion plate. Monet had earlier painted his mistress Camille Doncieux from a similar view, a device he also employed in several large figure compositions. The dress, rather than the features of the model's face, becomes the substance of the portrait. Such a pose might usefully flatter the sitter for a commission, but this was not a necessary objective in the case of Camille.

The emphasis on the dress, together with the interior surroundings, establishes Mme Gaudibert as a person possessing the means to dress fashionably. Although a black bonnet appears casually laid on the table, the pose itself has a formal and deliberate arrangement. The red and turquoise cashmere shawl pulls in the back of the buff-coloured skirt, releasing a cascade of material below. Various kinds of materials vie for attention – silks, laces, trims. Not only are materials carefully observed, but the fairly loaded spread of paint emphasizes the physical surface of substances.

Despite the predominance of greys and browns, a light atmosphere pervades this picture. Crisp shadows may delineate fabric folds, but the skin of Mme Gaudibert's face and hands is evenly illuminated, its pinkish tinge picked up by the two roses on the gold-trimmed table.

The life-size scale of this painting sets it within a tradition of ambitious portraiture, although its masking of the sitter's features is less conventional. It tells us surprisingly little about the sitter's appearance but much more about her status and concomitant tastes. She has been objectified into something like a mannequin. The image suggests a type more than an individual, a woman belonging to a family well enough off to want to commission such a painting.

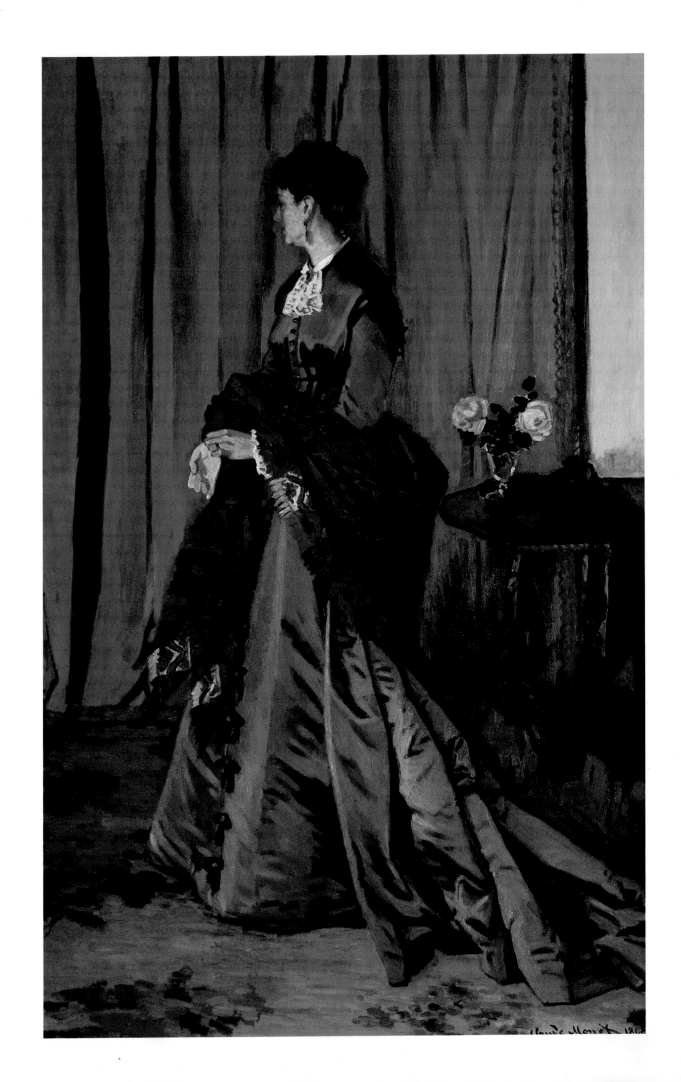

Pierre-Auguste Renoir

The Engaged Couple (The Sisley Family) c. 1868

Although both tradition and documentary evidence accept the male figure as the painter Alfred Sisley, the woman may be not Sisley's wife Eugénie Lescouezec (1834–98), but Renoir's mistress Lise Tréhot (1848–1922). Her unconfirmed identity suspends the work between the categories of straightforward, double portraiture and genre painting. Artifice rather than naturalness pervades the scene's staging. The blurred landscape background contrasts with the sharply drawn figures and their self-consciously attentive poses. The painting offers an exemplar for pre-conjugal behaviour, the woman clinging to her support and the man solicitous.

The colour of the woman's dress likens her to the flower bed behind, the frills and furbelows of contemporary fashion turning her into a decorative creature. In contrast, her male companion in his black and grey outfit stands apart from both colourful nature and decorative frivolity.

Both lighting and space are ambiguous. Sunlight falls on the landscape, while the couple stand on a shaded path. Minimal shadows in their own features and bodies suggest a more diffuse light source. The consequent flattening of form and the incisive drawing of their outlines cuts them out against the unfocused background space. The truncation of the woman's skirt at the framing edge anchors the couple to the surface. Their somewhat peculiar proportions, along with the hovering pose of the man, unfix the viewer's vantage point. More than fifty years later, Picasso, intrigued by the painting, drew a copy exaggerating its plastic distortions.

During the year this was painted, Sisley shared an address with Renoir and Bazille, having spent periods working closely alongside Renoir for several years. He had already married Eugénie Lescouezec, a model and florist, in 1866, so the work cannot be a literal testament to their engagement. The Sisleys had spent part of the summer of 1868 near Renoir in Chailly. Unfortunately, there are no records to assist the verification of the women's features as those of Eugénie. The model's resemblance to other images of Lise Tréhot, who was Renoir's mistress from 1866 to 1871, supports the alternative identification. The painting's more general title, *The Engaged Couple*, seems to have adhered later, perhaps inspired by the attitudes of the models and the prominent interplay of rings on the woman's hands. If it is a genre scene, it represents one of Renoir's early efforts at a Manet-like construction of contemporaneity.

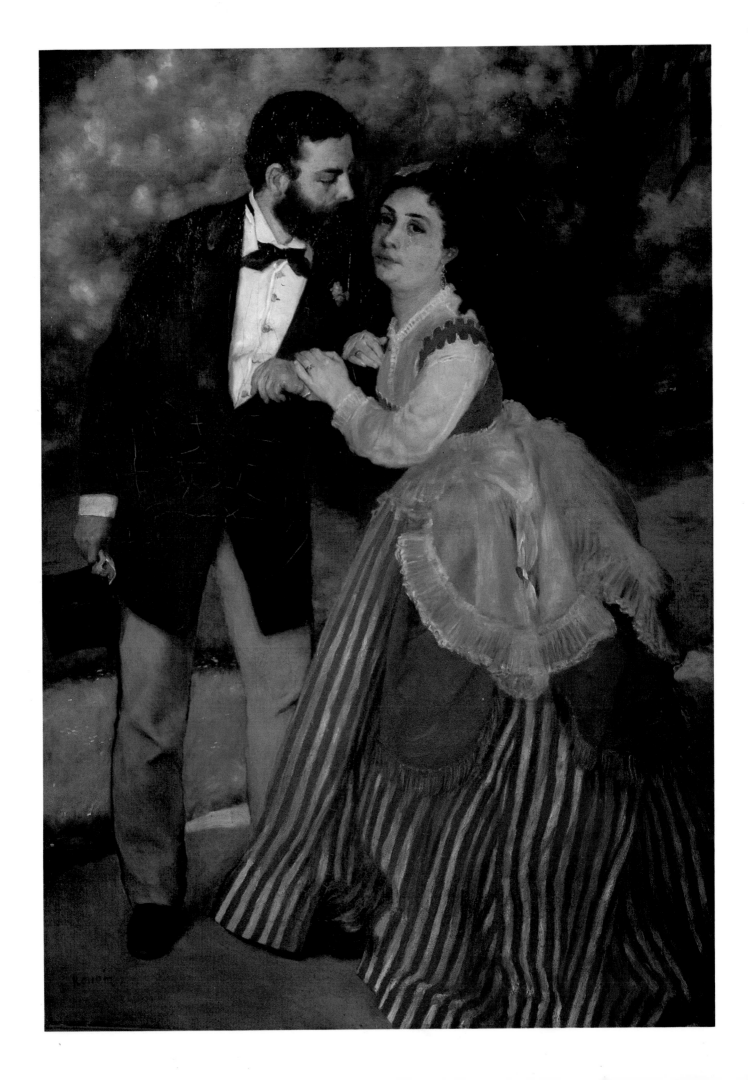

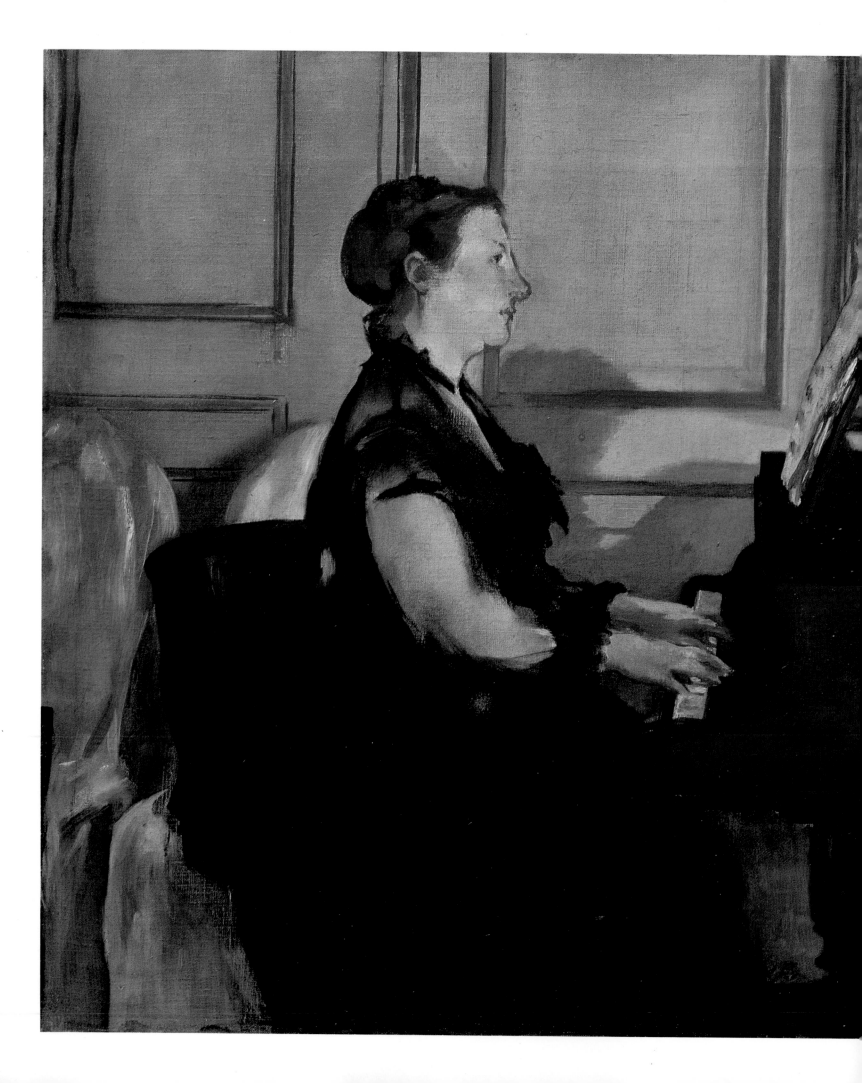

Edouard Manet

Mme Manet at the Piano 1867–68

Manet made the acquaintance of Suzanne Leenhoff (1830–1906), a Dutch pianist, in 1849 when she gave lessons to his younger brothers. An intimate liaison soon developed, but the couple did not marry until fourteen years later, after the death of Manet's father. Manet is often assumed to be the father of Suzanne's son Léon Koëlla (also passed off as her brother), although he never officially acknowledged his paternity — an insight into the conflicting mores of the period.

The daughter of an organist, Suzanne Leenhoff often played at private soirées, such as those given by Auguste de Gas, receiving praise for her renditions of Schumann, Beethoven and Chopin.

In the mid 1860s Degas had painted a double portrait of Manet listening to his wife at the keyboard. Manet, dissatisfied with the depiction of his wife's features, sliced a strip off the right-hand side, a vandalism which led to a temporary rift between the two painters. In his own portrait of Suzanne, the gold strip of panelling behind her face intersects her features precisely along the line where he imposed the vertical excision upon his friend's work.

The scene was painted in the Paris home of Manet's mother in the rue St-Petersbourg where he and Suzanne lived for several months. The mirror, reflecting a mantelpiece on the opposite side of the room, expands the shallow, parallel space which accommodates Suzanne, her piano and several pieces of furniture covered by dust cloths. The mantelpiece appears, in turn, to support another mirror, producing a second reflection. Manet's fascination with mirror imagery led to a number of pictorially riveting conundrums. Although not as striking as his late *Bar at the Folies-Bergère*, 1881–82, the subtle displacements in the reflection here undermine the viewer's fixed position proposed by the perspective of the piano.

The way Suzanne is seated adds a precarious touch to the spatial disturbance. Presumably, her chair has been swivelled to accommodate the voluminous material of contemporary fashion, but as depicted it seems a barely adequate support; however, Suzanne Manet's calm absorption in her music making belies the implications of such an uncomfortable perch.

Her flattened, fair-skinned profile is etched out against the light background. Her sketchier hands suggest the vibrancy of movement. The dark shape of the black dress and chair, silhouetted against the wall and broken by her thinly veiled arms, disguises her somewhat matronly body.

Music making was considered a respectable accomplishment for women at this time. The motif has a long pictorial tradition, and Manet's depiction may allude to a seventeenth-century engraving after Gabriel Metsu, *Dutch Woman Playing the Clavichord*. Suzanne's concentration suggests that music for her was more than a mere hobby. The contact of her gaze with the sheet music, and the open U-shape made by her head and arms, the keyboard and score, associate this work with other images by Manet that construct a significant relationship between professional sitters and emblems of their practice.

Armand Guillaumin

Portrait of Camille Pissarro Painting a Blind c. 1868

Guillaumin and Pissarro had been introduced by Cézanne in the early 1860s, when all three artists were studying at the Académie Suisse in Paris. The late 1860s were years of financial struggle for those of the future Impressionist circle without independent means or family support. After leaving his ditch-digging job with the Paris Municipality in 1868, Guillaumin painted blinds for a living, and Pissarro joined him in this task.

Guillaumin's thick paint, worked with the palette knife, its sombre browns, greys and ochres accented minimally with green and blue, recalls Pissarro's and especially Cézanne's handling and colouring of the period. Pissarro's awkward, not quite convincing pose, his legs ill supporting the weight of his body, also resembles Cézanne's inelegant drawing. The clothing seems to twist and ripple independently of the figure, possessing a rough vitality which accords with the depicted labour.

Hardly a portrait in the conventional sense — without the title the identification of Pissarro would be circumstantial — the painting stands as an unsentimental document of the less romantic features of nineteenth-century artistic life. It presents the studio as a workplace rather than as a bohemian garret. Pissarro, back turned, showing only the side whiskers of his beard, paints on an inclined surface. The image has not yet materialized, but other works to the right appear to be landscapes. Are they canvases or do they indicate the kind of work Pissarro produced as a sign painter? Although depicted in an interior, Pissarro wears the wide-brimmed hat familiar through several portraits of him at work out of doors.

The space is difficult to read. The various orthogonals suggest the corner of a room, but the amorphous flare of scumbled paint along the left edge ambiguously occludes the wall. The light slab of Pissarro's current work surface, hovering at an angle, silhouettes the profile of his upper torso and imposes a looming presence upon which Pissarro seems to advance, his fine brush directed like a dart.

In 1868 Pissarro lived barely half the year in Paris. By May 1869 he and his family were based at Louveciennes, though he also worked at Chailly, where he found further utilitarian employment of his painting skills decorating an inn. Guillaumin, on the other hand, remained a Parisian resident, while joining his friend occasionally in the countryside. By 1872 he was once more back at work labouring with the city administration, an activity which allowed him to spend his painting time on his own terms.

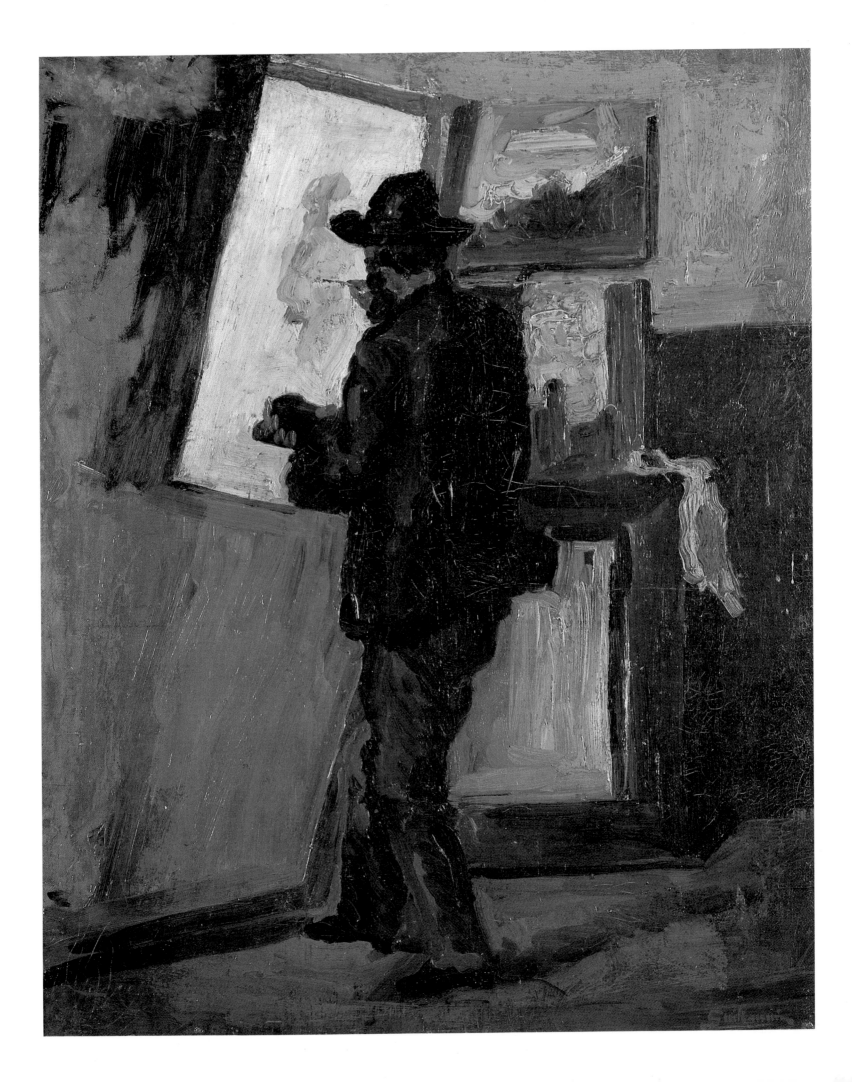

Edgar Degas

Portrait of the Painter James Tissot 1866–68

By the time Degas invited the painter James Tissot (1836–1902) to join in the first Impressionist exhibition, his friend had settled in London. Born Jacques-Joseph Tissot, he had already anglicized his name. Like several other artists whom Degas attempted to recruit, Tissot declined the invitation. Neither anglophilia nor the search for patrons had motivated Tissot's emigration; he had gone into voluntary exile after the 1871 Commune. While his politics may have been more radical than those of his artistic colleagues, his painting adhered more closely to traditions and conventions of bourgeois taste.

Tissot's artistic training had been thoroughly French. From about 1856 he studied at the Ecole des Beaux-Arts in Paris, and was a pupil of Hippolyte Flandrin and Louis Lamothe, the latter also Degas' first teacher. By the later 1850s he had become friendly with both Degas and Whistler. Historical costume pieces and scenes of contemporary life formed his repertoire during the 1860s and earned him acceptance at the Salon.

The images surrounding Tissot's figure acknowledge his admiration for an eclectic range of art, but only the small portrait centred just above and to the right of his head has an attributable source. It derives from a German sixteenth-century painting from the workshop of Cranach. The spatial arrangement of the Japanese garden scene above appears more Japoniste than truly Japanese. Plein air landscapes with figures flank both sides of the painting, while behind the easel a representation of 'The Finding of Moses' alludes to a type occurring in Venetian Renaissance and Baroque art. None of these images depicts known paintings by Tissot or Degas; more likely they serve as signals for genres and styles.

Degas frequently exploited the kind of high vantage point seen here. Less usual is the insistently parallel spatial construction. Even Tissot's legs conform to the repeated, rectilinear profiles of canvases, stretchers and furniture. His upper torso, twisted against the axis of his legs, as in Egyptian painting and relief, relaxes against a table. The coat and top hat flung on the table obscure its edge. Tissot gazes upwards towards the viewer, but while his eyes engage in contact the facial expression remains unforthcoming. The tension of his clenched left fist and his right hand grasping the stick (a mahlstick or a cane?) contrasts with his general attitude of dandified languor. Tissot could just as easily be a connoisseur visiting a studio as an artist in his own workplace.

Although Tissot returned to Paris in 1882, he and Degas seem to have drifted apart during his exile. Their pictorial commitments and lifestyles had diverged since the moment of accord given testament in this portrait.

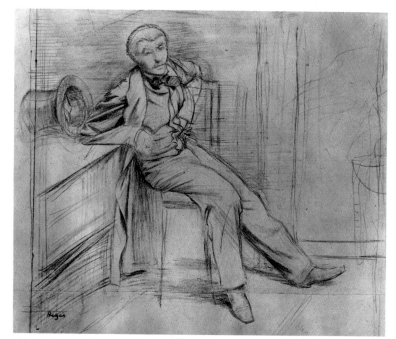

Edgar Degas
Study for the Portrait of James Tissot

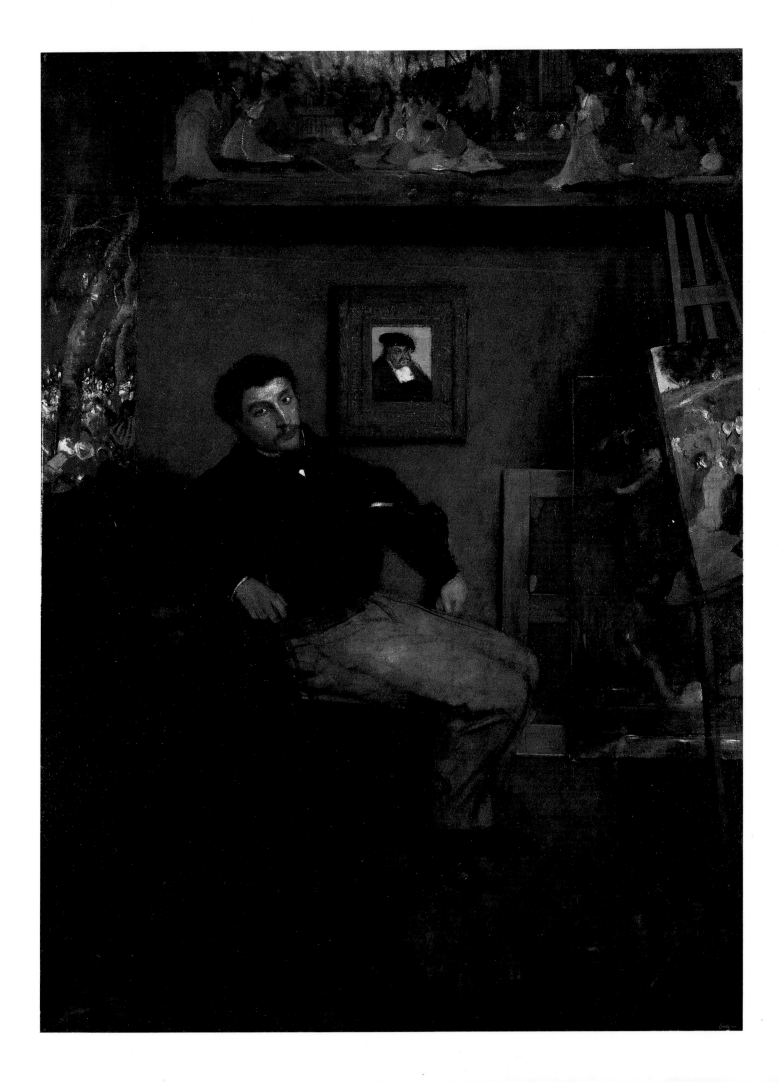

Edgar Degas

Mlle Fiocre in the Ballet 'La Source' 1867–68

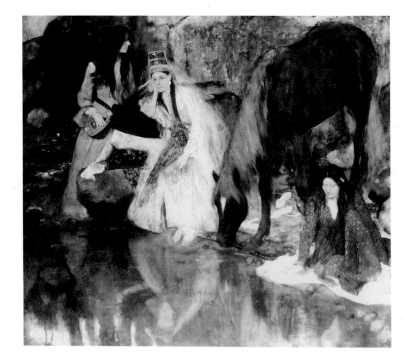

Degas' first ballet painting is also one of the few in which he portrays a specific ballerina and depicts a particular scene. The chosen moment underplays the balletic nature of the subject and gives no hint of Degas' future involvement with dance gestures. Indeed, the naturalistic presence of the horse (a live one was used on stage) comes across more powerfully than the choreography. Degas had already studied horses in his early racing scenes. Unlike the slightly later scene from *Robert le Diable* (p. 122), the theatrical location is minimized. Zola in his Salon commentary took it for a genre painting, preferring to call it *A Riverside Halt*.

The Salon catalogue gave the title *Portrait de Mlle. E. F., à propos du ballet de La Source*. *La Source* ('The Spring'), with music by Delibes and Minkus and choreography by Saint-Léon, was first staged by the Paris Opéra in 1866. Eugénie Fiocre (1845–1908) danced the leading role of the cruel princess Nouredda. A *première danseuse* of the Opéra between 1864 and 1875, Fiocre owed her popularity as much to her face and figure as to her technical abilities. Bankers numbered among her lovers, and she retired at thirty with a fortune. In an era when male dancing was in eclipse, she made a speciality of travesti roles, creating the role of Franz in *Coppélia* in 1870. In 1875, the year of her retirement from the Opéra stage, she danced a revival of *La Source* for the inauguration of the new Palais Garnier.

Degas' painting closely parallels a newspaper description of the first act of the ballet. Paul de Saint-Victor wrote: 'Wearing a bonnet in the form of a mitre, with her body tightly laced in a Turkish officer's jerkin and her legs floating in trousers, she danced . . .' Following the dance she handed her lute to an attendant, put on a filmy robe, and struck a meditative pose. Degas may have relied on memory, but he also used a photograph to make a separate study of Fiocre's head. One of his undated horse sculptures is in a similar posture to the stage horse, and may have served him as a working model.

Nearly half the lower diagonal segment is given over to reflections in the pool of water. The literalness of the Opéra's decor extended to a real spring – the 'Source' of the title. Fiocre, dressed in blue with red flowers accentuating her waist, is the only one of the three figures to be identified. Her attendants in shades of red and orange-brown remain anonymous. A greenish-grey pervades the scenery, spotlighting Fiocre's bright, clear hue.

Like Manet's portraits of Faure (p. 120) and Ambre (p. 156), this painting belongs to a specialized category of costumed performers. Manet's portraits isolate the sitters and bring them to the foreground. Fiocre belongs to her stage setting. The costume does not just represent a role for which Fiocre was famed but is intrinsic to the scene. The choreographer, not the artist, prescribed her pose, which evokes Nouredda's, rather than Fiocre's, personality.

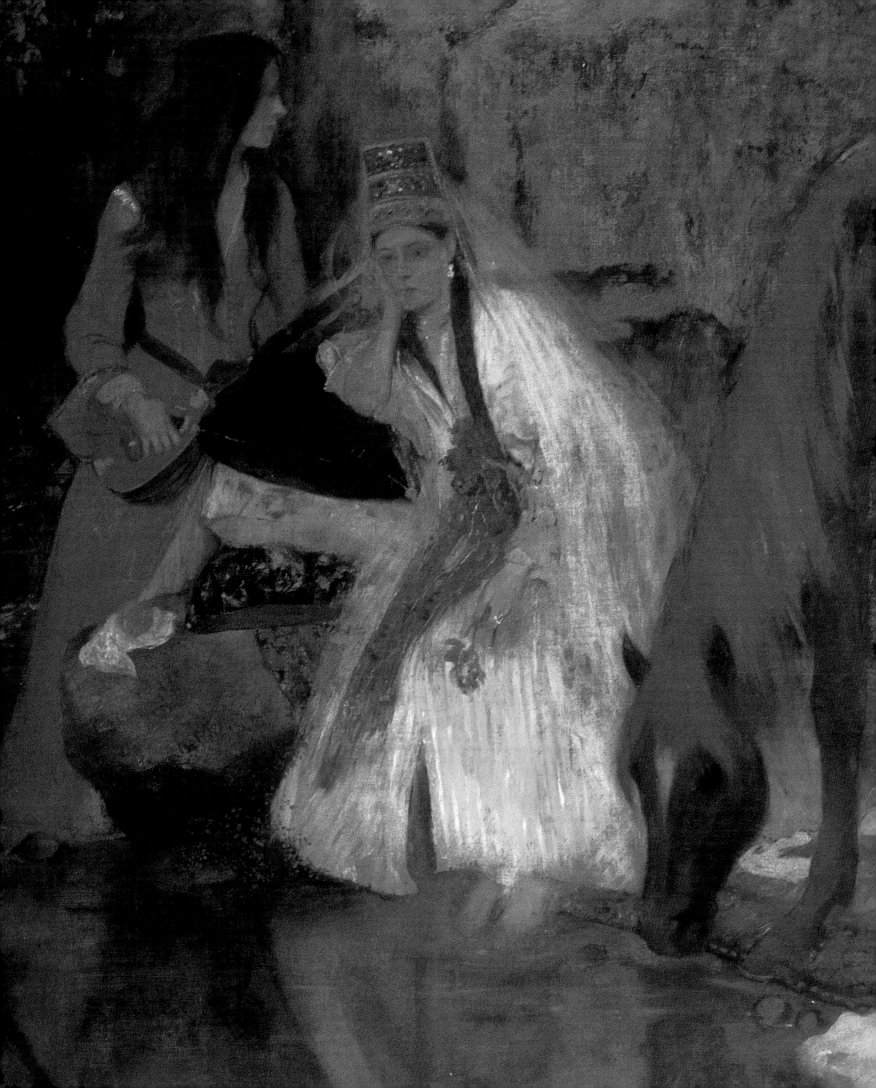

Edgar Degas

Edmondo and Thérèse Morbilli 1865–66

In 1863 Degas' younger sister Thérèse (1840–97) had become engaged to Edmondo Morbilli (1836–94), a member of the Italian nobility. The marriage required special papal dispensation, since they were first cousins. Of his two sisters Degas was less close to Thérèse, but he honoured her engagement with a single figure portrait in which she appears aristocratically confident.

Two double portraits of the Morbilli couple construct variant images of the marital relationship. The slightly earlier version poses Thérèse and Edmondo in an interior, she seated stiffly upright on a divan, he more informally perched behind. Although they appear to turn towards the viewer, the shadowy silhouette of a figure in the background doorway suggests the arrival or departure of a guest, lending overtones of domestic genre to the portrait. Thérèse's red shawl, a range of browns in the couple's furniture and clothing, and the ochre light visible through the doorway exude an atmosphere of warmth despite an expanse of green wallpaper.

The other double portrait insists on a more psychologically resonant vision. Signora Morbilli retires behind her more dominant husband whose figure bulks large against that of his wife. He leans assertively on the table and chair back and sits sideways on the diagonally placed chair. His occupation of space combines with the relaxed looseness of his hands and wrists: the attitude of one secure in his position of authority. His heavy-lidded eyes gaze with detachment and a kind of hauteur. In contrast, Thérèse's wide eyes emphasize the paleness of her face, which seems carefully set against any revelation of emotion. Her hand partially covering her chin and cheek recalls Degas' own gesture in his double self-portrait with de Valernes (p. 46). While Edmondo's figure presses forward, her silvery-toned dress sinks into the greyish background curtain. The confining table, with its dark oriental covering, completes the enclosure.

The paint handling combines precise drawing with a summary sketchiness. A masterly shorthand scumbling renders the black lace trim on Thérèse's dress. Thérèse's smoothly painted features have a softened focus, as if seen through gauze, which further contributes to her shadowy elusiveness. An almost spectrum-like variety of greys and blacks is offset with a golden ochre, which extends accents from the background into Thérèse's bracelet and the script-like pattern on the table cloth.

While colour distribution unifies the two sides of the painting, and the foreground with the background, the two figures are distinguished by the spatial construction. The diagonal lines in Thérèse's body interlock in a surface pattern with those of her husband. Although their right hands align in a perpendicular continuity, the spatial leap between the figures telescopes spatial depth.

The contrasts of pose and placement, of colouring and space, between the two paintings suggest not only shifts of dominance, assertiveness, submission and withdrawal in the Morbillis' relationship but also of Degas' own perceptions of his sitters. The paintings also propose more general visions of the personal and social interplay within marriage.

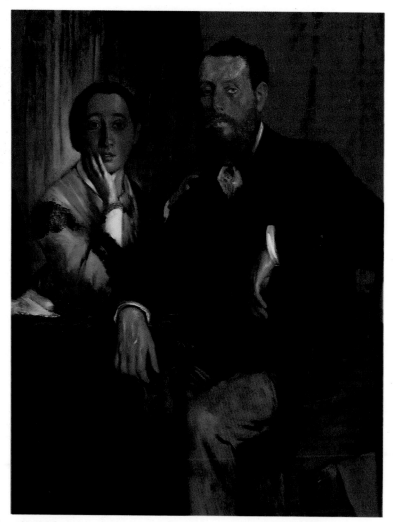

Edgar Degas
M. et Mme Morbilli, 1867

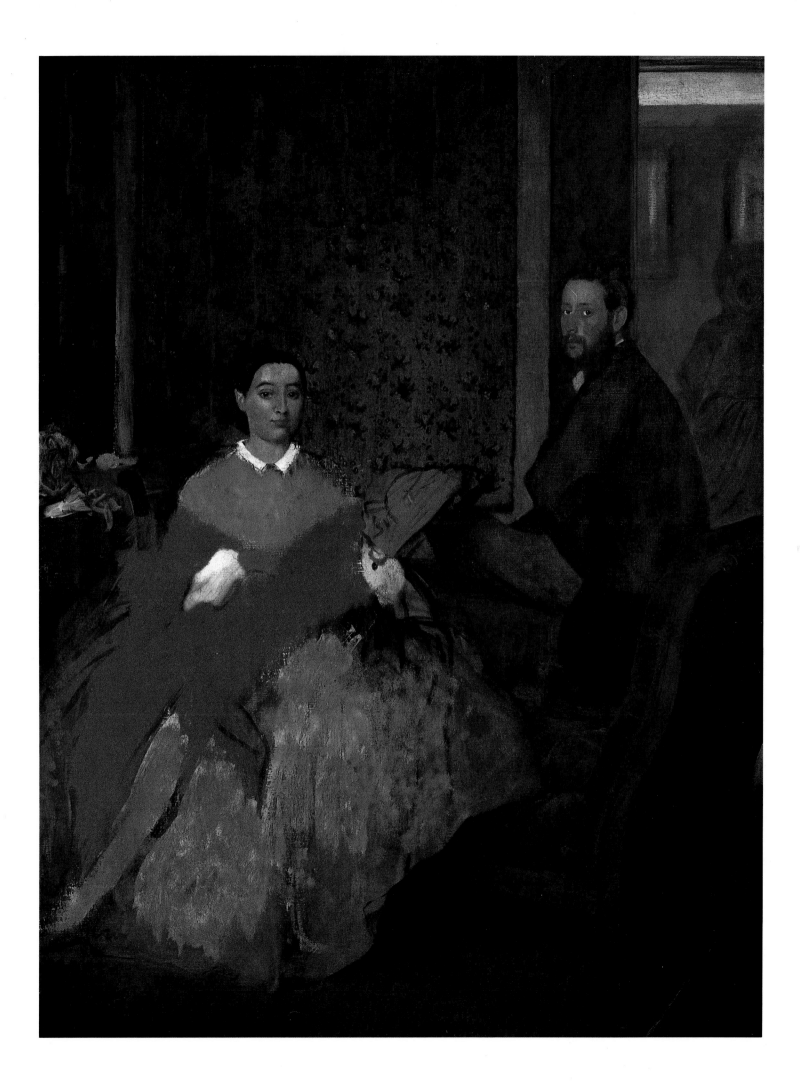

Berthe Morisot

Mother and Sister of the Artist 1870

The fortune of Morisot's double portrait of her mother, née Marie-Cornelie Thomas, and her sister Edma Morisot Pontillon caused the painter unusual anxiety. Realizing that she was dubious about the work, Manet offered his advice and eventually extensively retouched portions of the canvas. As Morisot wrote to her sister, 'He took the brushes and put in a few accents that looked very well. . . . Once started, nothing could stop him; from the skirt he went to the bust, from the bust to the head, from the head to the background.' In agony, she sent the painting off to the Salon hoping it would be rejected. Sympathizing with her daughter, Mme Morisot withdrew the work before the Salon's opening, but then, fearing to offend Manet, she changed her mind. In the event Morisot received 'quite a number of compliments on her exhibits', according to her mother.

Edma, who had been her sister's painting companion before her marriage, had rejoined her family for the birth of her first child, and the reunion gave occasion for the depiction of Morisot's two closest relatives. Unlike the later portrait of Edma before the birth of her second child (p. 76), this double portrait minimizes Edma's pregnancy. It would be hard to guess that it was painted in the week before the birth of her daughter. While Mme Morisot reads, Edma is caught in a moment of reverie. Although Mme Morisot was supposedly reading aloud to Edma, the two sitters appear privately absorbed in active and passive contemplation.

The carefully structured space is compressed against an emphatic surface pattern. The contrast of the black- and white-clothed figures organizes the composition. Mme Morisot, occupying the foreground lower right-hand corner, forms a foil to the lighter background. Edma's figure, protectively sealed in by the foreground elements, nearly merges into the light, patterned chintz of the sofa. The greyish wall closes the space behind, but the cropped gilt frame presents an ambiguous easing of the spatial enclosure. The pillows, Edma's hair ribbon, and the purple bouquets on the table distribute scattered nodes of colour.

While contrasts differentiate the two women, the pose of their heads invites comparison. On approximately the same level, they incline towards each other. Across the middle of their bodies their hands play across the spatial interruptions. The painting confirms the separation and continuity of two generations, soon to be joined by a third.

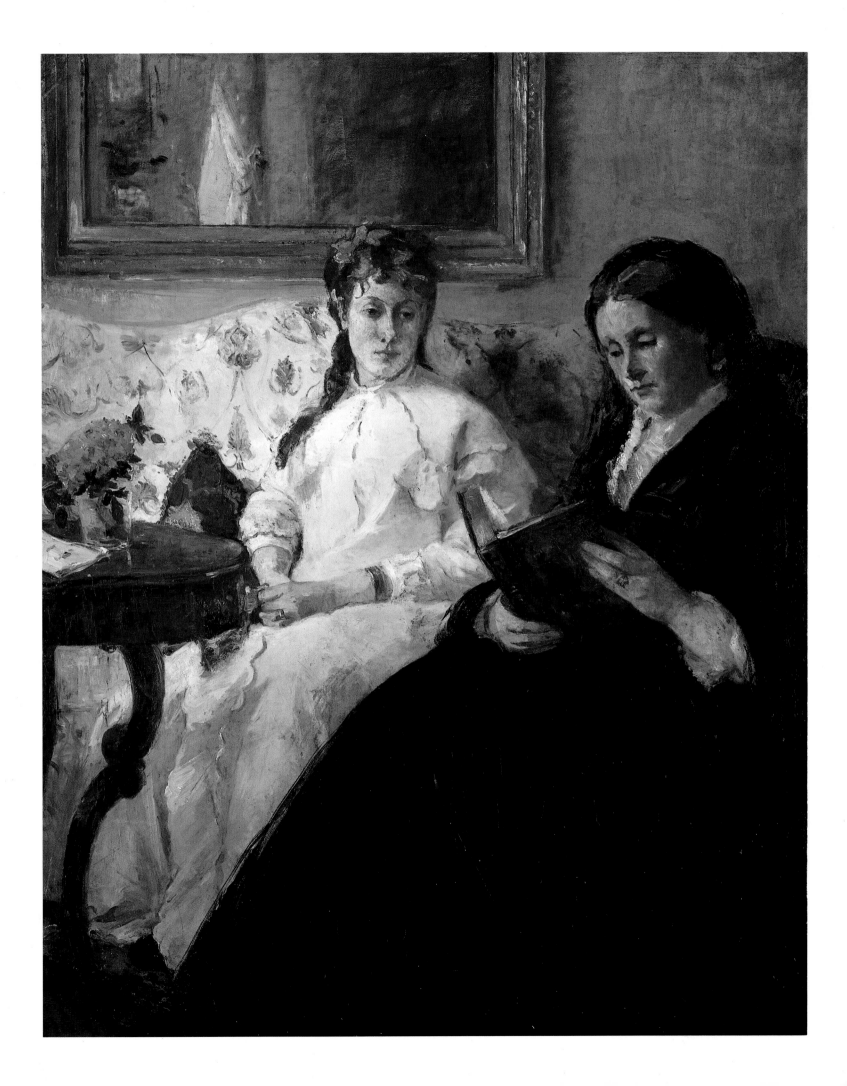

Edgar Degas

Degas' Father Listening to Lorenzo Pagans c. 1869

Musical life in nineteenth-century Paris was oriented towards opera, but much music making on a more modest scale took place at private soirées. Auguste de Gas (1808–74), the painter's father, organized Monday evening concerts in his rue de Mondovi home. A banker of mixed French and Neapolitan origins, he had the financial and social position to be able to cultivate his musical tastes, which favoured eighteenth-century Italian works.

The performer here is Lorenzo Pagans (1838–83) – Llorenç Pagans in his native Catalan – a tenor who had made his debut at the Paris Opéra in 1860 as Idrène in Rossini's *Sémiramis*, the French version of *Semiramide*. A favourable review remarked that 'he vocalizes easily and will make a place for himself in the repertory.' Born near Gerona in Spain, Pagans was already singing in the Gerona Capella de Musica at the age of eight, and in his teens he served as organist at the church of Santa Maria del Mar in Barcelona. He moved to Paris when he was twenty-one. In addition to his operatic performances, he frequently appeared at private musical soirées, accompanying himself on the guitar. His repertoire ranged from eighteenth- and nineteenth-century music to popular Spanish songs, some of which he composed himself.

In another, sketchier version of this painting Auguste assumes much the same pose but Pagans turns in profile. Here Degas steps back from the models and centres on Pagans. The singer appears to perform for an audience placed at the viewer's vantage point rather than solely for his host, while Auguste's absorption manifests the intensity of auditory experience. His open mouth seems to breathe in the sound issuing from that of Pagans.

The play of feet and hands and the juxtaposition of faces directly bond the music maker with his listener, while the clarity of the figures delineates them against the softer focus of the background. A tonality of reddish browns, ochres and earth colours predominates, interrupted by the grace notes of green ribbons at the neck of the guitar and a pink nosegay in Pagans' buttonhole.

This painting was Degas' first portrayal of his father. Years later it hung over the artist's bed, and he considered it one of his finest works. Depictions of music making, both vocal and instrumental, have a long tradition, but rarely has the relationship of musical interpreter and auditor been described with such keen visualization.

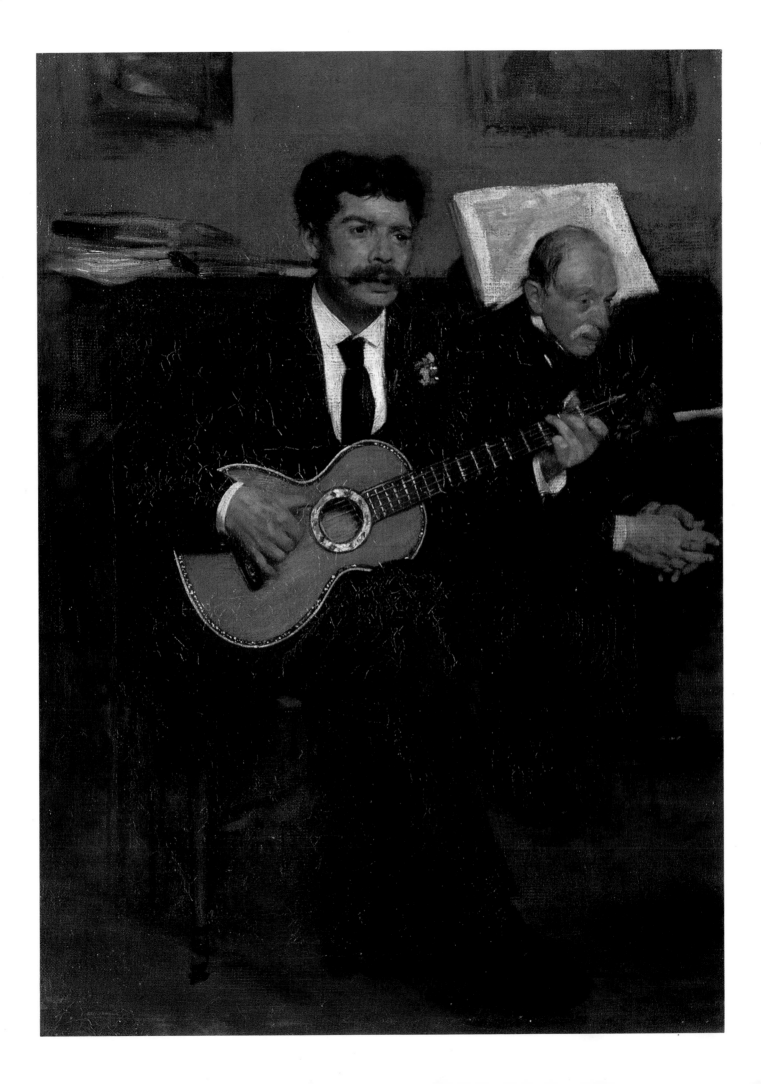

Paul Cézanne

Paul Alexis Reading to Emile Zola *c.* 1869

The two figures of Paul Alexis (1847-1901) and Emile Zola (1840-1902) have been juxtaposed in a space startlingly discontinuous and idiosyncratically foreshortened. The figure of the art critic, poet, and novelist Paul Alexis, a friend of both Cézanne and Zola, appears almost to have been deformed to fit into the left side of the room. Is he sitting on a child-size chair, or are its stumpy frame and Alexis's legs viewed radically from above? Alexis suffered from acute myopia, which partially accounts for the compressed space between his head and the manuscript. Zola, a better known novelist and critic than Alexis, partly reclines in a pose suggesting an oriental sage, while listening to Alexis read. The unfinished look of Zola's figure leaves the ambiguities of his pose less troubling than those of Alexis, but the pictorial awkwardnesses of this double portrait invest the separate presences of the figures with tension. The surface pattern of the austere composition threatens to split in two, but the drawing locks it together.

Zola had been one of Cézanne's boyhood friends in Aix-en-Provence. The young poet had encouraged Cézanne's first visit to Paris, and the painter in turn expanded Zola's acquaintance with art and artists. In 1866 Zola had become a reviewer for the daily paper *L'Evénement* and had begun to write articles in support of his artist friends, particularly Manet. Later, he came to view the Impressionists with less indulgence, as the discord between his ideas of literary naturalism and Impressionism became more apparent.

Alexis, on the other hand, remained closer to the members of the Impressionist group, frequenting their gathering place, the Café de la Nouvelle Athènes, in the 1870s. Younger than Cézanne and Zola, he had begun to assert his literary aspirations in 1869, about the time of this portrait, sending verses to the newspaper *Le Gaulois* and preparing a publication, *Le Grognon Provençal*. In the same year Zola made Alexis the object of an article in *Le Gaulois*.

Zola had been portrayed by Manet in 1868, having recently written a pamphlet in defence of the painter, and Cézanne's paint application, colour and compositional discipline here seem to acknowledge Manet's work. Cézanne's early paintings often exhibit an agitation, both in motif and handling. Here, a more rigorous control asserts itself, although the unfinished state of this painting may indicate problems of resolution.

Although there are numerous portraits in Cézanne's oeuvre, the double portrait format is unusual until the late *Card Players*. Intriguingly, a vestigial narrative, the depiction of verbal communication – words spoken by Alexis and attended by Zola – suggests their personal relationship, while the pictorial construction conjoins their bodies.

After years of friendship and financial support at crucial moments, Zola alienated Cézanne with his novel *L'Oeuvre*, published in 1886. *L'Oeuvre*, which vividly describes artistic life, was part of the Rougon-Macquart series written by Zola between 1871 and 1893, a saga of a family's heriditary decline. The characterization of the protagonist Claude Lantier, partly modelled on Cézanne, is disturbingly pessimistic. Alexis remained friends with both Cézanne and Zola, sometimes serving as a link of communication between the estranged friends.

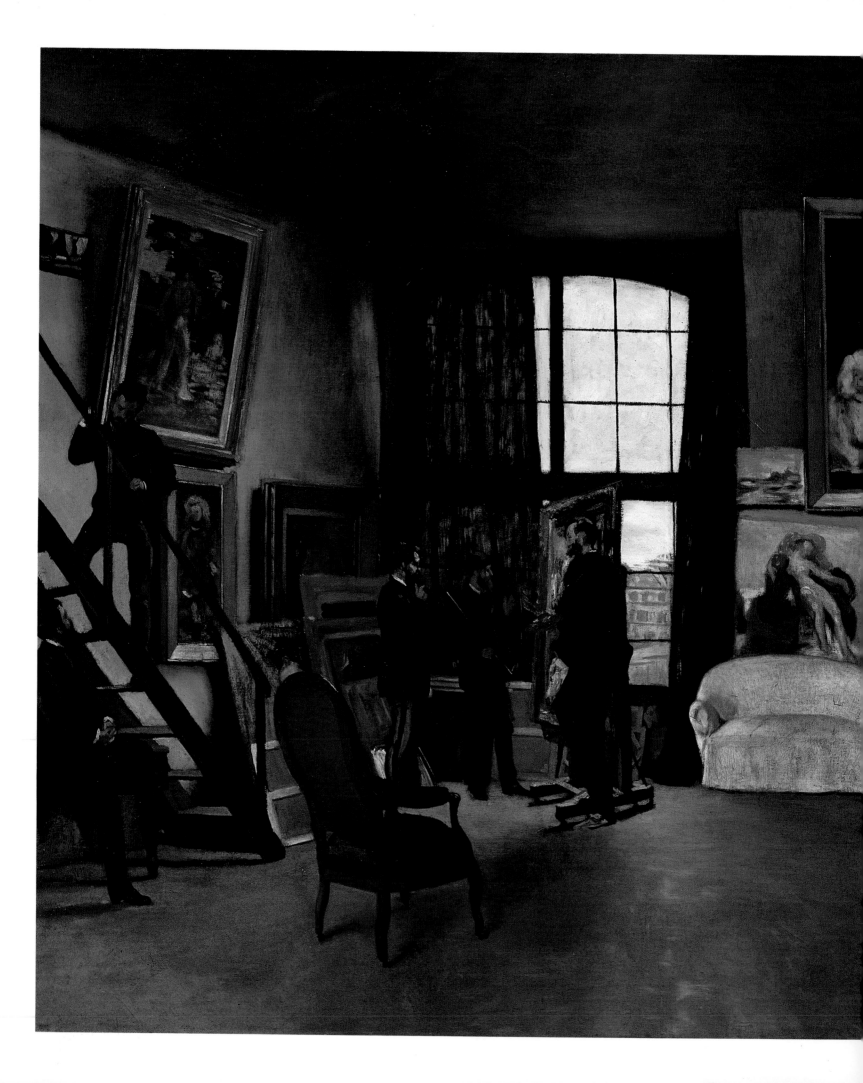

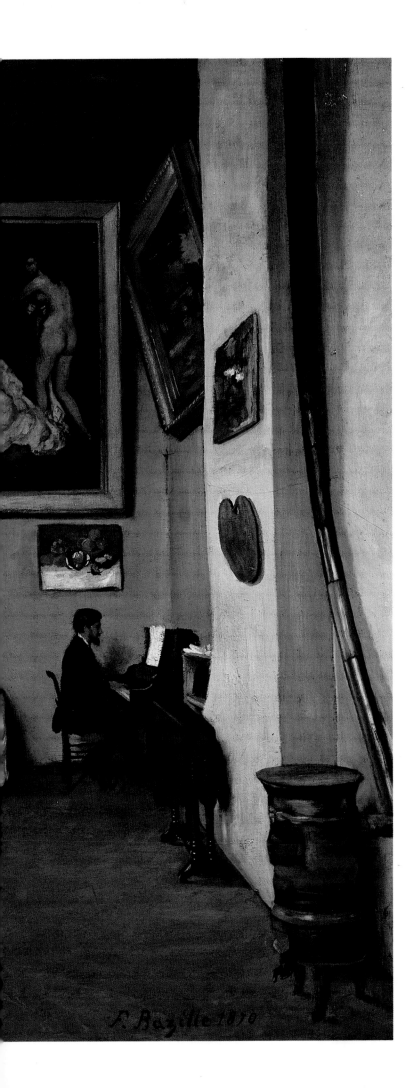

Frédéric Bazille

Atelier in the rue de la Condamine 1870

Bazille wrote to his father in 1870: 'I have been amusing myself recently with painting the interior of my studio with my friends. Manet is helping me with it . . .' Bazille's studio in the rue de la Condamine was the third of his Paris studios, which he shared with the impecunious Renoir. In this painting he has produced a kind of conversation piece, documenting the association of painters and friends.

The tall figure of Bazille himself at the easel was executed by Manet, the dandily dressed figure who gesticulates near by. The amateur musician Edmond Maître is seated at the piano apart from the others. The remaining men are not so securely identifiable. Both Monet and the writer Zacharie Astruc have been proposed for the third participant in the discussion round the easel. The man on the stairs may be Zola or Monet and his seated partner Renoir or Sisley. The scale and vertical format of the painting on the easel discount it as a depiction of the present painting.

Despite the physical impossibility of this being an actually observed scene, the painting's casual arrangement and informal poses suggest a naturalistically perceived moment, unlike the monumental Realist allegory of the artist's studio painted by Courbet fifteen years earlier. Homage to Courbet's precedent, however, is rendered in the somewhat free copy of his *Bathers* prominently displayed high on the wall. Bazille's own *Fisherman with a Net* provides a male counterpart on the left. Among the other paintings are Bazille's still unfinished *La Toilette* behind the sofa, begging comparison with the *Bathers* above, and what appears to be his *Terrasse de Méric* abutting the *Bathers*.

The spacious, orderly, light-filled studio hardly resembles a bohemian garret, nor do the well-attired figures suggest starving artists. The wide-angled view of the interior sets its population at a distance, participants mingling with the products of artistic profession. Only the stove nears the foreground. The armchair turning its back on the viewer provides a kind of domestic enclosure, something like the imaginary fourth wall of naturalist theatre.

Bazille, who was killed in the Franco-Prussian War only a few months after this picture was painted, was closely associated with the artists who were later to be termed Impressionists, but his work had been moving away from the direction pursued by Monet, Renoir and Sisley. Perhaps it is significant that his figure is next to Manet's and that it was actually painted by his older mentor.

The seemingly innocent, instantaneous appearance of this painting may be deceptive. While not an allegory in the manner of Courbet's *Atelier*, its staging suggests a conscious imbuing of the picture with a meaning waiting to be decoded.

Edouard Manet

Portrait of Eva Gonzalès 1869–70

Eva Gonzalès (1849–83) was Manet's only official pupil. Although several women established themselves as major talents in the Impressionist milieu, it was not socially acceptable for a woman to be a professional artist. In Manet's portrait this contradiction is apparent in his presentation of a charming young woman who is nevertheless a serious artist engaged in concentrated work. The pose, with Gonzalès apparently applying a few touches to an already framed painting, draws attention to its staged artifice. Gonzalès' best-known work portrays people, but here she is portrayed as a painter of floral still-lifes, traditionally a permissible genre for women artists. The floral motif spills into further permutations with the full-blown peony on the carpet, whose pattern is described with botanical detail. Scintillating brushstrokes sweep Gonzalès' spotless white dress across a major portion of the canvas. Manet's signature on the rolled up grisaille print superimposes deliberateness upon the seemingly casual clutter on the floor.

The freshness of painterly touch and the cool colouring belie the effort that Manet devoted to this portrait; Morisot remarked to her sister that Manet had once again scraped off the head at the fortieth sitting. It engages with a tradition of artists' portraits, particularly those by women artists of the eighteenth century. The dress recalls Goya as much as current informal fashion, as do Gonzalès' doll-like pose, the range of blue and grey hues, and the arresting disposition of Manet's signature. The arrangement of the artist's tools becomes commandingly gestural. The dynamically crossed axes of arms and mahlstick contrast with the bland passivity of Gonzalès' facial features and her stiff posture.

Gonzalès, the daughter of a well-known author of the period, Emmanuel Gonzalès, became Manet's pupil at about the time of this portrait. Earlier, she had studied with the fashionable portraitist Charles Chaplin. By 1870 her attainments were sufficient to earn her acceptance at the Salon. Like Manet, she chose not to associate with the Impressionist exhibitions. After marrying the engraver Henri Guérard in 1878, she died from complications of childbirth, shortly after the death of her teacher.

Berthe Morisot

Portrait of Mme Pontillon 1871

Edma Morisot had been a close companion and professional colleague of her younger sister. Daughters of a rich councillor and magistrate, Edma and Berthe Morisot had dedicated themselves to art with a seriousness that took them beyond the norm of accomplishment appropriate to young ladies of their class. The two had studied and painted together since 1858, first copying in the Louvre under the direction of Joseph-Benoît Guichard, and then exploring landscape painting with the advice of Corot and his pupil Achille François Oudinart. Corot had actually preferred Edma's work to that of her sister. In the 1860s Edma's artistic abilities had earned her several acceptances to the Salon, where her paintings attracted Zola's critical notice, but in 1869 she married Adolphe Pontillon, a naval officer, and moved to the Pyrenees. Marriage ended her painting career, though the decision to sacrifice her profession seems not to have been easy. A tinge of regret pervades her letters at this time: 'To chat with Degas while watching him draw, to laugh with Manet, to philosophize with Puvis, all these are things which deserve my envy . . .' After her marriage she remained her sister's frequent model and travelling companion, and in the 1870s Berthe Morisot's paintings chronicle the growing Pontillon progeny.

This portrait is drawn in pastel, a medium in which women artists had excelled in the past. Colour and draughtsmanship unite in vibrant strokes of pigment. The dominant rich black of Mme Pontillon's dress, contrasting with the colour-embroidered, light grey background, has an affinity with the work of Morisot's current artistic mentor Manet, who exploited the colouristic potential of black. Otherwise, black is used minimally for a few accents of shade on the tufted sofa, accents which vie with the splayed leafy fabric pattern behind. The fabric design reflects the popularity of Japonisme, and, indeed, the simply blocked-out shapes of the pastel's composition seem to acknowledge the contemporary impact of Japanese prints.

This portrait was executed in 1871 when Edma had rejoined her parents and sister in Passy for the birth of her second daughter. The hands poised high within her voluminous pyramidal shape emphasize her obvious pregnancy. Beside her a basket of needlework adds a further sign of domesticity. She gazes forward from the picture, her eyes acknowledging the reciprocity of the act of looking and being looked at, while conveying a certain self-contained withdrawal. The blank grey rectangle in the upper left invests the environment with an equivalent spatial ambiguity. The possibility of multiple pictorial readings contrasts poignantly with Edma's decision to abandon her professional pursuits in favour of a conventional female role.

Edgar Degas

Hortense Valpincon as a Child 1871–72

Later in life Hortense Valpinçon remembered being induced to hold her pose through the reward of pieces of apple. One quartered segment is centrally displayed in her hand. Although her figure is child size, she gazes towards the viewer with an assurance that conveys a maturity and awareness. She herself occupies the right-hand side of the long horizontal format, the left portion being given over to the table. Its cloth was embroidered by Hortense's mother, and from a work basket an unfinished piece of needlework pours forth. The prolific floral pattern in the more diffusely focused background sets a foil to the simplicity of Hortense's light- and dark-clothed figure. Her outdoor apparel plays against the interior decor's artificial, decorative rendering of natural forms.

The Degas family and the Valpinçons had a long association. Edouard Valpinçon, a friend of Degas' father, introduced the aspiring artist to Ingres. His son Paul and Degas were schoolfellows. It was on a visit to Ménil-Hubert, the Valpinçons' estate in Normandy, in 1861 that Degas became interested in horses, one of his major motifs over the following decades. During the Commune, in 1871, Degas again sojourned at Ménil-Hubert, a likely moment for his work on this portrait of Paul Valpinçon's daughter. Several other Valpinçon portraits can be attributed to this time. Hortense later modelled for one of Degas' more ambitious sculptures, a half-length figure with arms, which unfortunately disintegrated in the casting.

The broken black line descending along Hortense's back suggests Degas' thoughts for further revision. Reportedly, the artist insisted that he had not finished, but Paul Valpinçon, knowing Degas' reluctance to stop working over his paintings, took the picture before Degas could carry on.

A variety of warm yellows, oranges and reds gives off an autumnal glow harmonizing with the little girl's skin tones. The whites of her dress and shawl offer a flattened shape, a composite of truncated triangles. The needlework, which inclines against the direction of her form, hints at another incomplete triangle. The table, arranged slightly askew, flattens to a sloping surface. This decentred, spreading composition may reflect Degas' admiration for Japanese prints. Even the tablecloth pattern evokes an orientalized design.

The self-possession of the child, the arresting juxtaposition of her hands with the pincer-like hold on the apple, the green cord snaking from the embroidery basket and the garden of floral decoration make Hortense Valpinçon into a diminutive Eve. She may be a child in stature, but her expression, with its hint of sultriness, forecasts adolescence.

Edgar Degas

Interior of a Cotton Market, New Orleans 1873

In the autumn of 1872 Degas and his brother René made a voyage
to New Orleans, their mother's birthplace. The Creole-American
branch of the family had established a cotton business in the city.
'One lives for cotton and from cotton', wrote Degas to his friend
Henri Rouart (depicted on p. 188).

This painting appeared in the 1876 Impressionist exhibition with
the title *Portraits in an Office (New Orleans)*. Degas, writing to his
friend Tissot, expressed the hope that it would find a purchaser
among the industrial patrons of Manchester. 'If a textile
manufacturer of cotton ever wished to find his painter, I would
make quite an impression.' Not only is it an ambitious group
portrait but also a unique pictorial construction of commercial
enterprise.

Industry and leisure intersect in the painting's composition. In the
foreground the proprietor Michel Musson (1812–85), Degas' uncle,
examines a specimen of his product, while Degas' two brothers
Achille (1838–93), lounging against the window frame, and René
(1845–1926), reading the local newspaper, remain detached visitors.
The members of the business are portrayed in their various
commercial functions. The bookkeeper John E. Livaudais attends to
the company's records on the right; James S. Prestidge, seated on a
high stool, appears in consultation; Musson's son-in-law William
Bell (1836–84), perched on the cotton table, offers a sample of the
fibre to a client.

Black and white accents sharply delineate the interior and its
population, while the steeply receding floor and acutely angled
walls shape the space. The contrasting warm and cool tones,
together with the detailed observation, may have prompted Zola's
criticism of the painting as being 'halfway between a seascape and a
newspaper reproduction'. Part of an actual seascape appears, high up
on the right.

Spatial intervals and proximities channel the eye of the viewer
through the painting, inviting and foreclosing entry. Its ambitious
composition tempts analogy with history and narrative painting, but
the discontinuities of activity and relationship among the figures
forestall narrative reading. Alienation, absorption and association
produce conflicting meanings. The painting refuses categorization as
simple portraiture, genre or conversation piece.

Degas remained in America until the spring of 1873, and the
painting was probably finished in France. Achille and René, who
had already set themselves up as wine importers and commission
merchants, remained in their adopted city. René's alliance to New
Orleans had been secured by his marriage to his cousin Estelle,
Musson's daughter, in 1869. In the mid 1870s financial and family
crises shattered the businesses and associations momentarily, if
enigmatically, established in this painting.

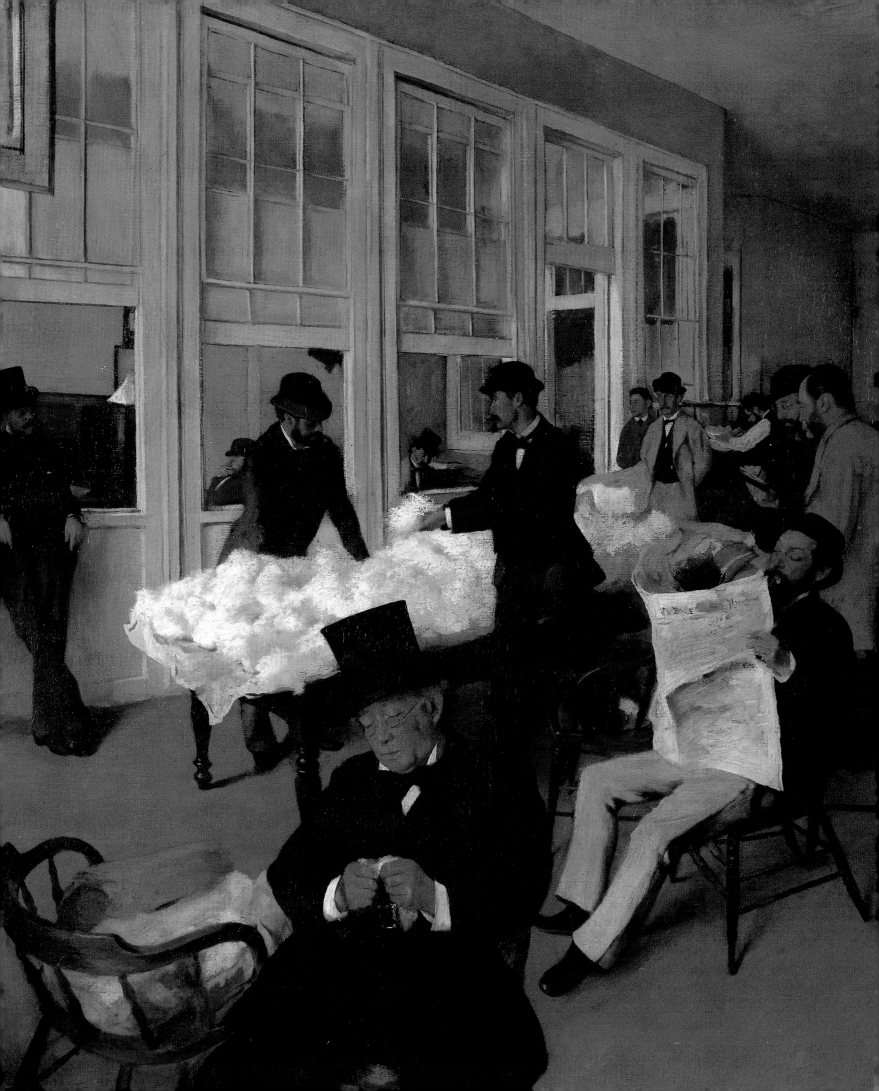

Camille Pissarro

Self-portrait 1873

This, the earliest of four known self-portraits painted by Camille
Pissarro (1830–1903), puts across his patriarchal visage. Friends
noted his resemblance to a bearded Moses. The oldest of the
Impressionists, he provided support and encouragement to younger
artists. He was born of French-Jewish parents on Danish territory in
the Virgin Islands, where his father ran a general store. By 1855 he
had embarked on a painting career in France. From his petit
bourgeois origins he became an anarchist in later years, seeking in
his art practice an accord with his political sympathies. Here, he
portrays himself in a workmanlike smock rather than the more
bourgeois dress chosen by a number of his colleagues.

In 1873, the year of this self-portrait, he had received the
encouragement of several new patrons, among them J. B. Faure (see
p. 120), but his financial circumstances were rarely comfortable,
especially as he was the father of a large family. During the Franco-
Prussian War and Commune he fled to London, losing most of his
possessions and paintings. After his return he settled in Pontoise in
1872, and was joined for a while by his colleagues Guillaumin and
Cézanne. Although some early landscapes had been accepted by the
Salon, in 1873 he decided not to submit.

During the 1860s and 1870s Pissarro primarily painted
landscapes. He acknowledges his principal motif here, in the two
unidentified works in the background to the right of his brow. The
light-drenched wall silhouettes his face, most of which is cast in
shadow. Light streams through his hair and beard, fuzzily rendered
in multi-directional brushwork. In contrast to the painterly central
core, the horizontal and vertical divisions of the background
provide a firm matrix for Pissarro's head, while strong light-dark
contrasts define the structure of the skull's dome, the nose and ear.
The rest of the face emerges more subtly in modulations of the
lower range of the painting's overall brown tonality. The palette of
umber, ochre, muted salmons and pale green seems temperate
compared to the contrasts of many Impressionist plein air paintings.

Pissarro's friendship with Cézanne, particularly warm in the early
1870s, became mutually fruitful professionally. Not long after this
self-portrait Pissarro portrayed his friend in a comparable pose and
environment (p. 106).

In 1875, the year after the first Impressionist exhibition, Pissarro
was involved in a new artists' association, L'Union, intended to
replace the Impressionist group officially dissolved the previous
December. Subsequently, however, Pissarro continued to exhibit in
the Impressionist exhibitions, becoming the only artist among the
constantly varying participants to show in every exhibition.

Paul Cézanne
Portrait of Camille Pissarro

Camille Pissarro

Portrait of Minette Standing c. 1872–73

As with Pissarro's later portrait of his son Félix (p. 166), this portrait of his daughter Minette presents a slightly troubled vision of childhood. Centred in the space, she appears isolated. Her wide-eyed features are set in a solemn expression, and she stands self-consciously as if earning marks for good behaviour.

Minette was the family nickname for Jeanne-Rachel Pissarro (1865–74), second child and first daughter of Pissarro and Julie Vellay. She was about seven years old at the time of this portrait, and died not long after. Subsequently, another daughter, born in 1881, was also named Jeanne. Minette's young life had not been uneventful; during the Franco-Prussian War the family had fled to London, and after their return, having lost family possessions, they finally settled in Pontoise.

Minette is dressed in her schoolgirl's blue smock, below which emerges the layered sequence of her dress, pantaloons, socks and shoes in reds and greens. Green also occurs in the wainscoting and skirting of the room and in the still life items, but the more pervasively yellowed environment complements her fair complexion and light brown hair. Her immediate background is plain, but the patterned wallpaper to the left and the items on the table to the right and in the niche above bracket her standing posture. Light falls gently from the left, casting diagonal green shadows back from her feet and connecting her to the perpendicular table leg.

The scale of the room brings out the diminutive size of the little girl, yet the ambiguous placement of the viewer's eye level raises questions about the subjectivity of space. While the perspective orthogonals locate a raised vantage point, she appears viewed from head on, suggesting that the somewhat overbearing dimensions are part of her perception of the world. While her clasped hands emphasize a formal gravity, subtle adjustments to her essentially frontal pose moderate its potential severity. Her eyes glance to the right, as if her attention were caught by something to the side. Below, her feet are directed ever so slightly to the left.

Pissarro painted several portraits of Minette during her short lifetime, as well as executing a lithograph of her on her deathbed. His sober images of his own children are in keeping with those of many of his colleagues. Apart from Renoir's generally more sweetened portraits, Impressionist children seem to have been viewed seriously. Monet depicted his own son in an even more sombre attitude (p. 100). The collected images give a view of childhood that balances carefree moments with gravity and with a surprisingly adult awareness. Their avoidance of sentimentality is astonishing.

Pierre-Auguste Renoir

Mme Clementine Stora in Algerian Dress
(Algerian Woman) 1870

Harem scenes served an earlier generation of French painters with exotic and erotic motifs. Renoir, indeed, paid homage to Delacroix's precedent in a costume piece, *Parisian Women in Algerian Dress*, 1872, as well as in a less Europeanized *Woman of Algiers*, 1870. Although the portrait of Mme Clementine Valensi-Stora (1845/47–1917) was also known as *Algerian Woman*, it belongs to the costume genre. The model was the wife of an antique and carpet dealer whose boutique on the boulevard des Italiens in Paris was known for its Arab trinkets. Perhaps her husband's profession partially accounts for Mme Stora's dressing up, but the exoticism accords with Renoir's own proclivities at the time.

Costume portraits occur in several guises in the 1870s. Monet posed his wife *à la Japonaise* (p. 112) and Manet depicted Nina de Callias in the garb of a *maja* (p. 88), a mode of dress she often donned for her salons. To male artists the otherness of the female sex made women more suitable objects for the projection of alien imagery than men. Performers provided the only occasion for male costume portraits (see p. 120), and here the costume merely serves professional identification. Whether Mme Stora donned Algerian garments simply for the purpose of this painting or whether she habitually received guests in this fanciful manner, the exotic potential of her dark eyes and hair suits such role playing. In contrast, her skin is of porcelain paleness.

The more delicate blending of paint for her face provides an area of repose within the almost over-rich surface of loaded brush tracks and gouged scoring. Brushstrokes describe texture, decoration, directional gestures and modelling, sometimes without coherence. The rounded form of Mme Stora's left arm contrasts with the unsatisfactorily flattened paw of her right arm.

Despite weaknesses, even clumsiness, this painting remains a considerable achievement. The blue, gold and white costume sparkles with the freshness of its unlaboured paint application. The wine-red pillow beneath her arm sets off her paler red lips, while a plummy mauve curtain acts as a less insistent background foil. An X or lozenge motif in the fabric of her skirt echoes, in miniature, the larger compositional framework of the pose in which the diamond-shaped thrust of her elbows, intersecting with the framing edges, embraces the inverted Vs of her gold sash and neckline.

This engaging portrait infuses Mme Stora with more personality than Renoir usually granted his female models. Her sparkling eyes engage with the viewer, while the set of her mouth reads ambiguously. Seriousness, even determination, mingle with an incipient smile.

Edouard Manet

Woman with the Fans 1873–74

Although Hector de Callias, editor of *Le Figaro* and estranged husband of the sitter of this portrait, intervened with Manet to prevent the attachment of his surname to the painting, the woman with the fans is usually referred to as Nina de Callias (1844–84). Born Marie-Anne Gaillard, she was also known as Nina de Villard. A pianist, composer and poet, she is best remembered for her salons, to which she invited artists, writers, musicians, politicians and bohemians. Her intelligent, vivacious personality attracted numerous admirers and lovers, but her hectic life burned out in an early death from alcoholism.

Manet's portrait expands upon the reclining woman motif. His Impressionist colleagues were also fascinated by this pose. Unlike Renoir's portrait of Mme Monet (p. 94), however, this painting of Nina de Callias contains many emblematic details alluding to her sexuality. The dog at her feet corresponds to the cat in Manet's painting of the demi-mondaine *Olympia*, 1863. The crane on the Japoniste wallpaper is a pun on the French word *grue*, also meaning a courtesan. (Manet repeated this visual-verbal play in his later *Nana*.) Although Manet painted the portrait in his studio, he surrounded Nina de Callias with accoutrements from her own milieu: scattered Japanese fans (a decorative device later adopted by Monet in *La Japonaise*, p. 112), and the costume of a Spanish *maja*, which she often wore to receive visitors at home.

The borders of the sofa and wallpaper reinforce the painting's horizontal format, crossed by the more subtle divisions in the wallpaper and the less insistently descending axis of Nina de Callias's head and bolero jacket. This rectilinear structure forms a shallow space overlaid with decorative features and vibrating broken brushstrokes. Within the turquoise- and golden-hued milieu the form of the black-clad woman zig-zags and expands outwards, the jet cascade formed by her hair and her dress counteracting her reclining body. Within such complex superimpositions the face of Nina de Callias appears as a calm focus of repose. With her head propped heavily against her flexed arm, she gazes outwards – but not with the distancing, fixed stare Manet often accorded his female sitters. Her expression registers acknowledgment of the spectator, but it also could be read as a kind of wearied, calm resignation. The contrast of these features with the rest of the painting exposes the tensions between her public life style and her more private personality; she was remembered as kind hearted and companionable.

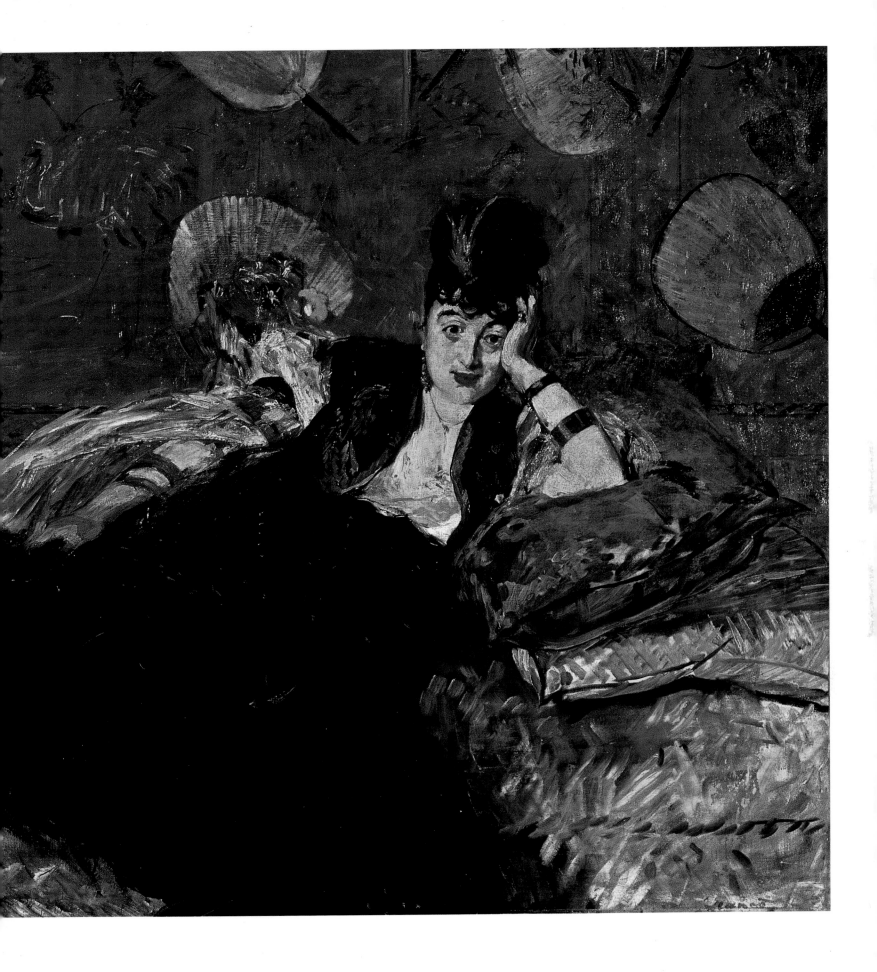

Pierre-Auguste Renoir

Monet Painting in his Garden at Argenteuil 1873

Renoir's portrait of Monet in his garden, like Manet's painting of Monet on his studio boat (p. 92) a year later, constructs a quintessential image of an Impressionist painter at work in the open air. Monet lived and worked in Argenteuil from 1871 to 1879, where he was frequently visited by Renoir. Whereas Monet preferred to depict his garden as a private verdant enclave, Renoir shows the suburban impingement of houses just beyond the dahlia-laden fence, which confines Monet to a narrow foreground strip.

Renoir's usually fluid paint application here takes on the more stippled texture of his colleague's handling, perhaps in tribute to the subject as well as deriving inspiration from the close proximity in which the two artists worked. Although the figure of Monet is no more precisely detailed than his surroundings, his characteristic blue jacket and hat immediately identify him.

The pyramidal scaffold of the lightweight, portable easel barricades Monet to the far right, leaving the majority of the canvas to the townscape. Rather than absorbing the figure into a play of light and atmosphere as a natural inhabitant of the landscape, Renoir has set Monet at the margin and distinguishes him from his environment through the darkness of his attire. It may be significant that the floral abundance is relegated to the left half of the painting, while Monet himself is grounded against the man-made architecture. The prominently splayed out easel takes possession of its space, as Monet, the landscape painter, controls his view.

Although red, yellow and pink flowers spray across the bank of green foliage, the painting is cast in an overall cooler blue. The folded parasol diagonally marking the ground plane beneath the easel subtly points to the overcast sky and absence of cast shadows; plein air painting did not always supply dappled sunlight.

As the spread of suburbia gave painters an easier access to the countryside, human presence impinged on nature. So, too, domestic gardens imposed an order on nature through human intervention. This painting, one of Renoir's most rigorously structured landscape views, responds to the contradictory tensions. The intersecting network of horizontals, verticals and diagonals coalesces around the figure of Monet and his easel, constructing a metaphor for the painter's relationship to his labour and his motif. The figure of Monet, while not a conventionally dominant portrait image, becomes central to this visual paradigm of Impressionist practice.

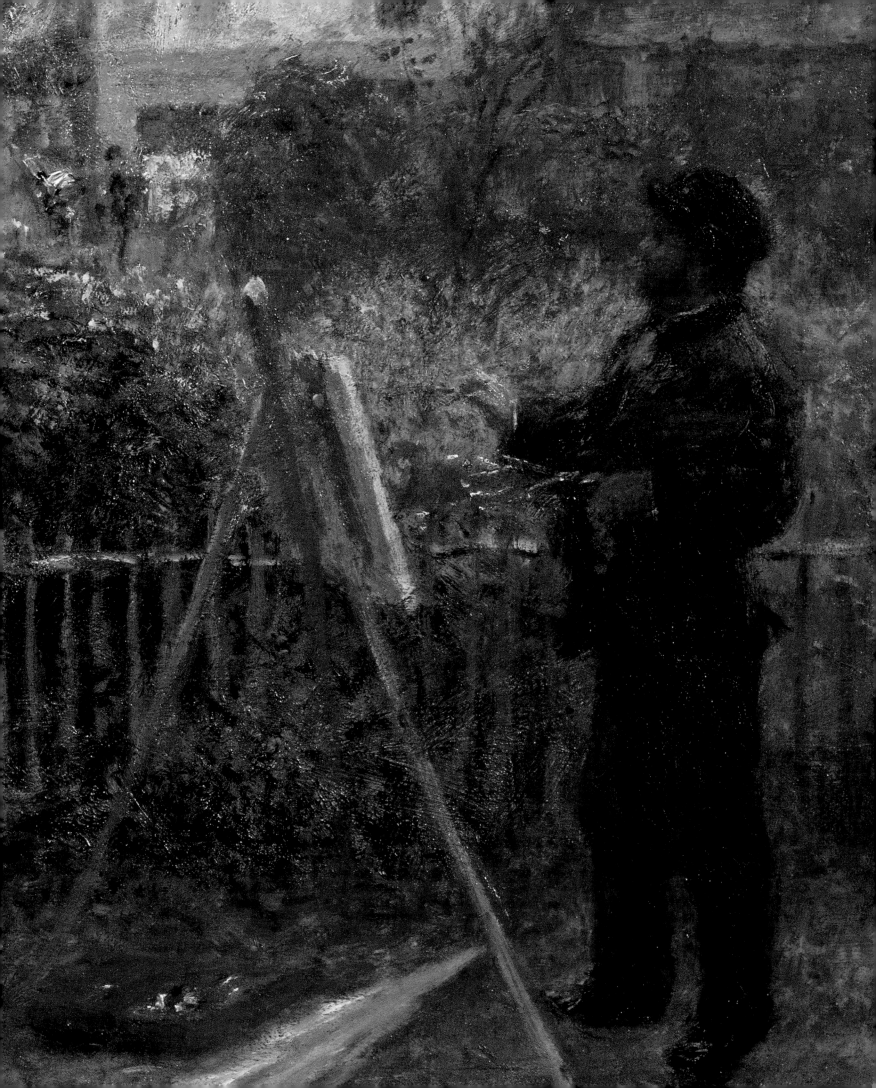

II

The First
Impressionist Exhibition
and After
1874–80

Edouard Manet

Monet Working on his Boat in Argenteuil 1874

In 1874 Manet, staying at Gennevilliers, joined his friends Monet and Renoir in Argenteuil. At this time his paintings show the greatest affinity with the plein-airism of his younger colleagues. Manet never adopted the pulverized colour and brushstroke of the paradigmatic Impressionist painting, but even among the work of more orthodox Impressionists such a paradigm was not constant. The clarity of the separate hues, the multidirectional short brushstrokes, and the juxtaposition of colour contrasts, particularly in the rippling water, attest to Manet's receptiveness to the ideas of his friends.

While the greater portion of Manet's outdoor scenes divulge his training in studio composition, the Argenteuil landscapes concede to a more casual, on the spot appearance; however, the pictorial arrangement still evinces careful control. The structural lines of the boat frame the central group of Monet, Camille, and Monet's landscape painting. The angle of the oar darts towards this picture on its easel. Behind, the smoke from the stacks of Argenteuil's growing industry mimics the oar's diagonal axis across the vertical framework with an insistence usually avoided in Monet's own landscapes.

Monet, inspired by the Barbizon landscapist Daubigny, had a studio boat, made perhaps with the assistance of Caillebotte, an avid yachtsman. Large enough to sleep in as well as to work in, it was sufficiently sturdy to undertake journeys as far afield as Rouen. Floating on it, Monet painted the river Seine and its banks amidst the transient reflections of the water. As in Renoir's portrait of *Monet Painting in his Garden* (p. 90), the artist is shown at work on the spot, in a testament to Impressionist plein-airism. Camille serves as a more passive, but observing accessory. Despite the overhanging canopy, Monet's profile and figure reflect bright illumination, his features more sharply indicated than those of his body or the sketchily laid in figure of Camille seated in the doorway. Camille's pose, supporting her head on her hand, was captured as a characteristic gesture in contemporary paintings by both Manet and Renoir.

Various members of the Monet family frequently appear in the works of the three artists painted during the summer in Argenteuil. Manet began another, more close-up double portrait on the studio boat as well as painting a family garden scene. Multiple depictions of Camille indicate that she was amenable to posing, but of the three painters only Monet served as a frequent model for his companions – simply a fortuitous occurrence or one that reveals differences in working habits, attitudes and relationships?

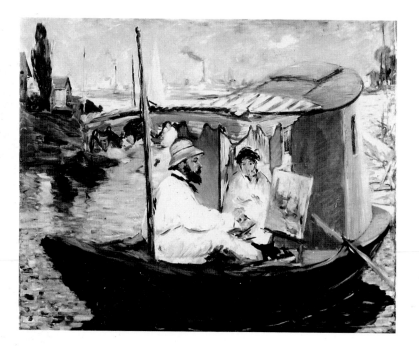

Pierre-Auguste Renoir

Mme Monet Reading 'Le Figaro' 1872/74

Camille Doncieux served as model not only for her companion and husband Monet, but also for his colleagues Renoir and Manet. In this portrait she poses in a variation of the familiar reclining woman format (see also pp. 97, 98). Historically, a horizontal pose had signified sexual availability, rendered most explicit in reclining nudes. 'Les Grandes Horizontales' became a descriptive epithet for the great nineteenth-century courtesans. Manet had unsettled the artistic convention with his notorious *Olympia* in the 1860s. Although Camille is depicted clothed, her combination of passivity and alertness, together with her gaze, is a development of Manet's precedent. Even the sheeting and pillows beg the comparison.

Camille, for all the irregularity of her early life with Monet, behaved no differently to the greater number of women who formed liaisons with Impressionist painters. Bourgeois respectability had been formalized by her marriage to Monet in 1870. Whatever its pictorial genealogy, this portrait of Camille does not signify a demi-mondaine profession, but encodes some of the cultural ideologies that circumscribed women's position.

Camille looks toward the viewer as if just interrupted from her reading. Reading, like sewing, occurs with formulaic regularity in female imagery. More often women read books, while newspapers remain something of a prerogative for male sitters. She holds a copy of *Le Figaro*, which was hardly a radical journal, and its specified presence contributed to the bourgeois character of the painting. Its art critic Albert Wolff wrote scathing reviews of the Impressionists.

The airy, thin brushwork suggests the fashionable detail of the loose blue robe. Indeed, the shape of the robe masks the actual pose of the figure within. The golden appliqué work pours diagonally across the centre of the picture, to join the horizontal hem of the sofa covering. Rectilinearity, playing within and around the figure, stabilizes the insistent diagonal. The barest touches of red enliven the chord of blue and gold, while the white sofa and pillows offset Camille's ebony hair, the black heels of her slippers and her dark eyes.

Recently, it has been proposed that this portrait was executed in 1872, two years earlier than its customary dating. In both 1872 and 1874 Renoir worked closely with Monet and stayed with the Monet family in Argenteuil. Surprisingly, in his portraits of Camille Renoir departs from stereotyped prettiness and brings out her prominent jaw and chin, here somewhat camouflaged by her upturned collar. She comes across with a more forceful personality and presence than the plump, vacuous models Renoir usually favoured.

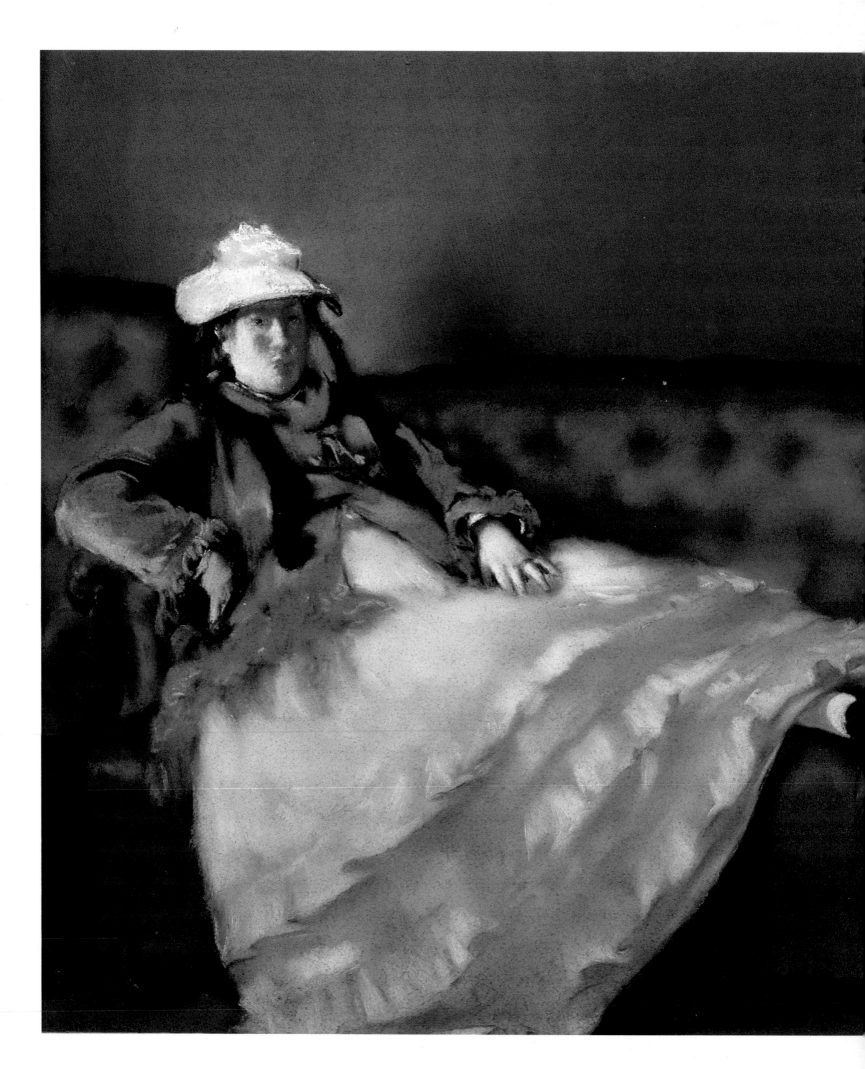

Edouard Manet

Mme Manet on a Blue Sofa 1874

In this pastel portrait Manet's wife Suzanne reclines on a sofa in a pose reminiscent of the partially recumbent, partially erect *Olympia* painted over a decade earlier. Unlike *Olympia*'s model, whose nudity signals sexual availability, Mme Manet appears overdressed, her outdoor apparel enveloping her form which sprawls doll-like on the stuffed sofa. In both works the splayed left hand becomes a meaningful focus. Olympia's calls attention to her pudenda while foreclosing sight: Mme Manet's spreads awkwardly to isolate her ring finger circled by a gold band.

The dusty medium may have encouraged the softening and lack of definition in Suzanne Manet's visage. Although she looks outwards, she does not engage in the disturbing confrontation asserted by Olympia's focused features. Like her concealed body, her face (as well as the paw-like right hand) seems only partially present, its inclusion something of a necessity to hold up her beribboned hat.

The luminous, concentrated colour of the pastels glows in the blue sofa and the bracketing chairs to left and right, while the red-brown background and the floor provide a warm contrast. A more neutral range of white, black and grey is accorded to the model. The full wedge of Suzanne Manet's skirt anchors her pose to the lower framing edge and intersects the horizontality of her legs with a less insistent vertical descending from the crown of her hat. The diagonally trailing ribbons, the flexed elbow, the open wedge of the jacket, and the ascending skirt ruffles overlay the picture's rectilinearity with visual diversions.

This portrait may well be Manet's first endeavour in a medium which was to attract a number of Impressionist painters. While colleagues such as Degas exploited the draughtsmanly potential of pastel, Manet favoured the velvety absorbing surfaces which could be obtained through smudging. A soft-focus atmosphere pervades the work, apart from the judicious use of descriptive marks in the ruffles and folds of the jacket.

Along with contemporary paintings by Renoir and Morisot (pp. 94, 98), the portrait of Mme Manet adapts a traditional pose to an image of bourgeois leisure. It undermines conventional readings in its rephrasing of some of the subversions formulated in *Olympia*. The image of Mme Manet does not offer a supine sexual availability; she has already been possessed—as is indicated by her ring and by her fashionable clothing.

Berthe Morisot

Portrait of Mme Hubard 1874

The identity of Mme Hubard remains tantalizingly elusive. Despite the accepted spelling of her name in the portrait's title it is tempting to associate her with Morisot's friend Mme Hubbard (d.1894), whose son (or other relative) took charge of Morisot's legal affairs late in the painter's life.

This portrait of Mme Hubard begs comparison with Manet's and Renoir's depictions of reclining women (pp. 94, 97), but these paintings by Morisot's male colleagues are more readily set against a background of discourse about the imaging of female sexuality. Morisot's work is more difficult to locate within the pictorial conventions.

The blue and gold colouring, the crossed ankles of Mme Hubard exposing the prominent mules on her feet, and the spread skirt of her dress falling over the edge of the bed challenge comparison with Renoir's painting. In contrast to Manet's and Renoir's works, however, this painting angles the divan upwards, so that it breaks away from the horizontal axis of the painting's dimensions. Mme Hubard's body relaxes into its support, while her head, propped up by the pillows, achieves a more vertical incline. Morisot's painting avoids the contrasts of tension and passivity which lend a sexual frisson to its nearest counterparts. Indeed, the furniture resembles a bed and Mme Hubard's lassitude suggests the enervation of an invalid. The manner in which she holds her fan implies functional use rather than flirtatious display. She turns her head towards the viewer, but her eyes shy away from confrontation.

The paint is applied loosely and thinly. While dress and bed are summarily sketched, with delicate linear traces accentuating the folds of material, the head, fan, left hand and feet mark out more fully defined points of attention.

The fan, the most elaborately rendered accessory, presents a foil to Mme Hubard's face. Its black sector, flecked with red, engages in an interplay with the irregular crescent of her hair. On her neck, a broken, black thread outlines a ribbon or necklace, establishing the volume of her body, which is otherwise camouflaged by the loose robe. Mme Hubard's alert, dark eyes, regularly arched brows, and mouth picked out with incidental black touches present an accommodating but unrevealing visage that is uncannily akin to the face of Manet's Eva Gonzalès (p. 74). While the pose reworks a pictorial formula, the face accepts a general type of prettiness.

In January 1874 Morisot's father died. In the same year she had been active in the organization of the first Impressionist exhibition in which she was the only woman participant. A few months later, when she was thirty-three – considered an advanced age at that time – she favoured the courtship of Eugène Manet (the painter's brother) with marriage. Although the year had been one of the most eventful in her life, she has here produced a painting that is redolent of languor.

Claude Monet

A Corner of an Apartment 1875

Monet's wife Camille and his son Jean populate many of his
Argenteuil garden paintings of the 1870s. Here, they sink into the
tunnelling interior of the apartment in their second Argenteuil
home. A sequence of receding openings, like stage flats, narrow
down the darkened hallway, which is illuminated in the foreground
and at the far end. The shape suggests a cavern, a Gothic cathedral
nave, or perhaps an enveloping womb. The bright green foliage
reaches across the yellow foreground curtains which are patterned
in red, orange and green. The parquet floor of the passage retreats
from orange and green striations to the blue interior.

The contrast of dazzling light with the gloom initially obscures
the figures. Camille, seated by the table at the far window, is nearly
absorbed in the darkness. The eight-year-old Jean, hands in pockets,
head cocked to one side and mouth slightly open, appears wistfully
isolated; only the yellow spots of his buttons glitter in the
darkness.

At first the painting may seem to engage more with a formal
play of illumination than with the figures. Natural light defines the
foremost and farthest planes. A hanging oil lamp is centred in front
of the window, while a chandelier seems to be suspended above
Jean's pocket of space. Neither of the artificial light sources
alleviates the obscurity. It is the figures, however, who break the
unrelenting symmetry of the composition, and their placement
suggests more than a merely formal device.

Jean, to the right, faces the viewer. His tiny scale against the
steeply rising floor leaves him slightly forlorn. Camille, much more
remote on the left, her features barely picked out, seems in an
attitude of waiting. The distance of the figures from the viewer
makes them shadowy presences, and their separation from each
other precludes contact. The enclosing interior may signify security,
but the tentacular plants forbid intrusion. Even the light at the end
of the tunnel is partly barricaded by the lamp, which assumes a
grotesque visage.

The painting does not portray the appearances of its inhabitants,
though these are well recorded in other paintings by Monet. He did
not need to set down another image of their features. Rather, the
composition seems to propose psychological relationships. The lack
of intimacy between mother and child is compounded by the
viewer's and painter's distance from them. Unlike Renoir, Monet
seemed little inclined to promote an imagery of the maternal bond.
While not being explicit, the painting sets up disturbing
contradictions to the ideal of bourgeois domesticity.

Claude Monet

Camille Monet and a Child in a Garden 1875

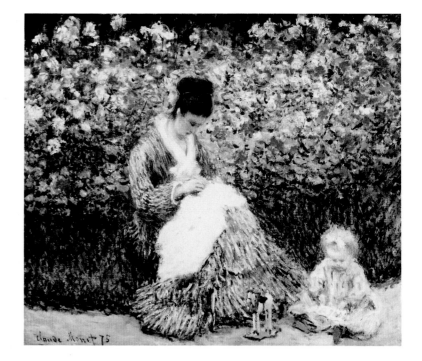

Interior scenes with women sewing had featured in genre painting since the seventeenth century, and the theme was taken up in numerous Impressionist paintings (pp. 134, 144). Here Monet has moved his seamstress outdoors to his garden at Argenteuil, adapting the traditional image of female industry and domesticity to plein air painting. In a sense it still belongs to genre. Camille, his wife, had modelled for him since the beginning of their liaison. Modifying her image from the earlier fashion plate poses, he here sanctifies her as a housewife, but despite the maternal allusions this is not strictly a family portrait. It updates the Raphaelesque tradition of the *Madonna of the Meadow*. The child remains unidentified, too young at this date to be the couple's son Jean, who appears in numerous other compositions of the period (pp. 42, 100). The flowers in the child's hair may suggest a young girl. She or he examines a book.

Light floods the painting to the extent of virtually cancelling out shadow. Camille's lowered face and the child's chin are darkened with a deeper rose hue, suggesting a touch of sun as much as reduced light. The hint of blue in their faces reverberates with their dresses. Both visages materialize through broken touches of paint, and are rendered nearly as schematically as the flickering texture of their garments, the grass and the closely containing floral background. This is not a landscape vista but an enclosed garden.

Unlike many Impressionist scenes where the figures are absorbed into the landscape, this painting sets the blue-clothed figures apart from the red-accented, green environment. In the absence of sky, the figures supply a cooler hue.

Camille has been centred, but the turn of her body and the child at her feet shift the composition to the right, opening the left-hand side to the invasion of the horizontal bands of path, grass, flowers and foliage. Ambiguity destabilizes the triangle of Camille's pose; the fall of her skirt suggests that she is raised on a stool, in contrast to the pyramidal form of the child settled on the path, but the union of dragged brushstrokes used both in the grass and striped fabric fixes her, too, on the ground.

For all its apparent casualness, this painting raises questions about its meaning. Although the setting and the relationship of the figures seem relaxed and natural, the minor displacements, the ambiguities and the foreclosure of depth reveal deliberate planning. During his residence at Argenteuil, Monet's landscape painting moved from a wider engagement with the town to the protective containment of his garden.

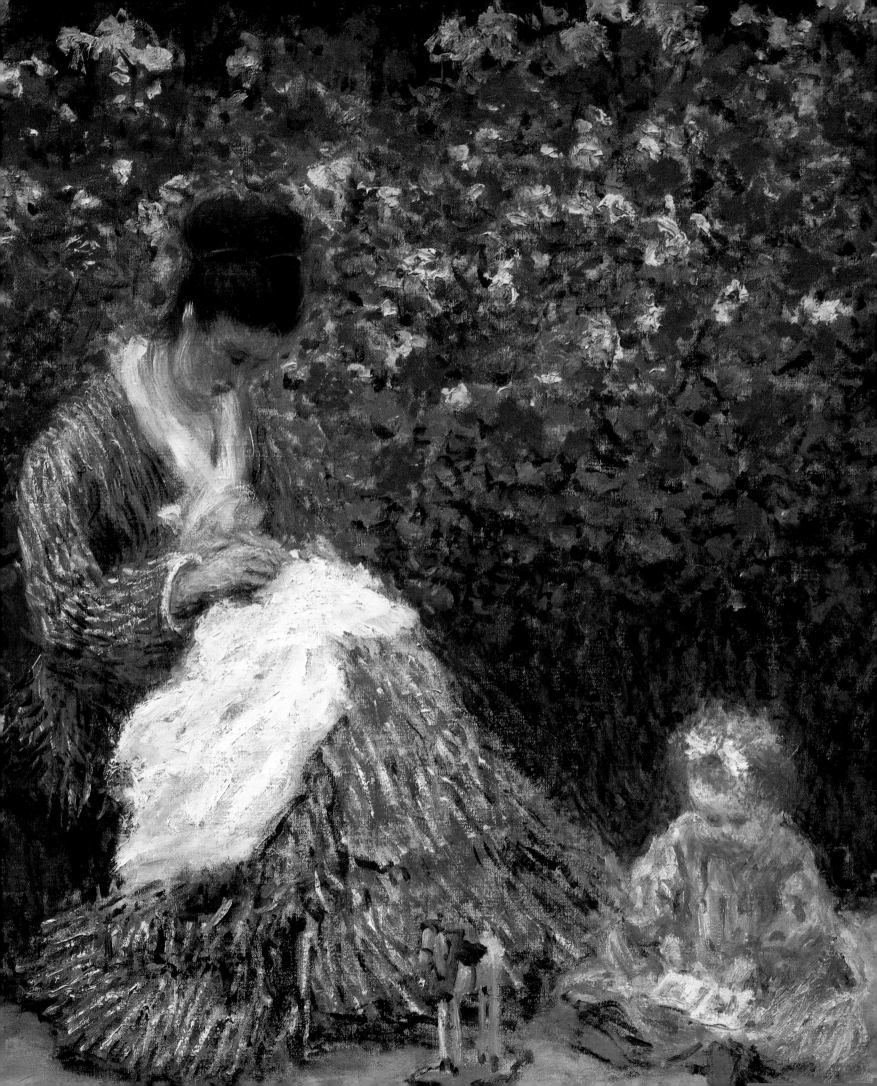

Edouard Manet

The Artist (Portrait of Marcellin Desboutin) 1875

This full-length standing figure against an indeterminate background harks back to the seventeenth-century Spanish painting of Velásquez. The format served Manet throughout his career for the presentation of a range of character types: philosophers, performers, critics, children, dandies, artists. This portrait's overall brown tonality is warmer than that of many of its predecessors, the brushwork more painterly.

Marcellin Desboutin (1823–1902) exhibited once with the Impressionists in 1876. Although from an aristocratic background, he managed to waste his fortune. Debts forced him to sell a castle in Florence where he had lived for several years. Before entering the Ecole des Beaux-Arts he had studied law, and besides practising painting and engraving he also wrote, well enough to have a play accepted by the Théâtre Français. A lively conversationalist, he frequented the Café Guerbois, where he may have met Manet in 1870, and led the move to the quieter Café de la Nouvelle Athènes, which became the gathering place of the Impressionist circle in the 1870s. The environment of the Nouvelle Athènes supplied the locale for Degas' painting *L'Absinthe*, 1876, for which Desboutin posed in the guise of an even more destitute character than his appearance here would suggest.

After a series of Salon acceptances, Manet's submission to the Salon of 1876 — this painting and *Le Linge* — was rejected. He exhibited both works privately in his studio to crowds of visitors.

Like his Impressionist colleagues at this time, Manet had lightened his palette, and increased its colour range. Interestingly, his portraits of artists number among the more monochromatic works, but this painting differs from the more self-confident portraits of Morisot and Manet himself in its depiction of the artist as care-worn and pathetically ill-attired.

This image is evocative of an earlier, more Romantic conception of the artist. Unlike many of Manet's portraits of professionals in the arts, it makes no specific reference to the artist's practice. Rather, it presents an image of a bohemian combining dandyish touches, such as the cane, with a baggy shabbiness, the alert tilt of his head contrasting with a general impression of weariness. The artist's companion, a thirsty dog, anchors a broken diagonal which is re-stated in Desboutin's hands holding the pendulous tobacco pouch and long-stemmed pipe. The ennobilization of poverty echoes Manet's earlier series of mendicant philosophers. Desboutin's own life may have been that of a poor bohemian artist, but it was not an experience shared by Manet. In this typological portrait Manet ignored his own material comfort and proposed a view of the artist as a person living on the margins of society.

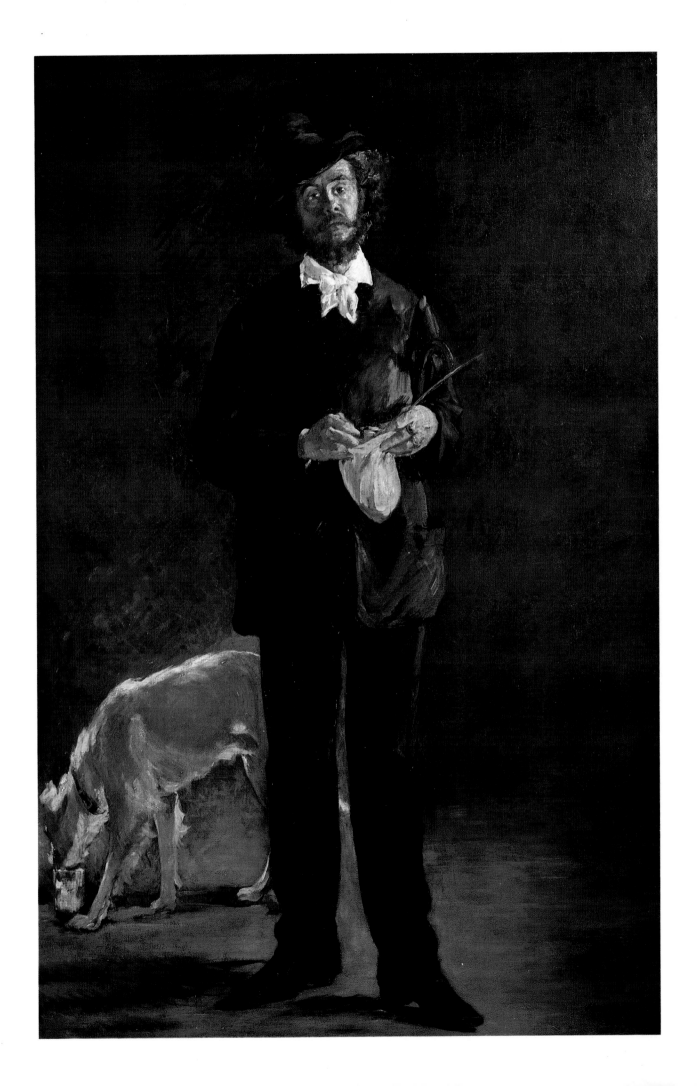

Camille Pissarro

Portrait of Cézanne c. 1874

Cézanne and Pissarro had met at the Académie Suisse, probably around 1861; however, it was not until the early 1870s when the two men worked closely together at Pontoise that the example of Pissarro's luminous plein air colouring and constructive clarity encouraged Cézanne to modify his more darkly impastoed, emotively worked paint. It was Pissarro who insisted on his younger friend's inclusion in the first Impressionist group exhibition of 1874. At about the same time, he painted this portrait of Cézanne, the earliest known record of Cézanne's appearance by an artist colleague.

The format bears comparison with Pissarro's own self-portrait of a year earlier (p. 82). Both artists turn slightly to the right, but while Pissarro depicts himself as if he were painting, with eyes focused forward, he portrays Cézanne resting his hands in his lap, with his gaze following the direction of his body. A wall hung with pictures provides a close background to the figure. The landscapes in Pissarro's self-portrait are too vaguely rendered to be identified, but the images in the portrait of Cézanne contribute to a more programmatic meaning. Above, to the left, is a cartoon by André Gill of Président Thiers, published in *L'Eclipse* in 1872. It commemorates the public subscription to pay the indemnity demanded by the Germans after the Franco-Prussian War. *L'Eclipse* often satirized official Government policies. To the right, a caricature of Courbet seems to look down on his fellow provincial. Courbet was identified with the political radicalism of the Commune as well as with an outspoken artistic independence. The political overtones are closer to Pissarro's own sympathies than to Cézanne's more apolitical, or if anything conservative, attitudes, but Pissarro may have perceived an affinity with Cézanne's fierce independence from artistic authority. The third image depicts Pissarro's own *Route de Gisors, La Maison du Père Galien*, 1873, a work Cézanne admired and also partially reproduced in the background of his *Still-life with a Soup Tureen*, c. 1874.

Cézanne's cap covers his balding head, and his heavy jacket and scarf emphasize a bulk which spreads nearly to the edges of the painting. The edge of his right arm runs parallel with the frame, while the lapels of his jacket echo and reinforce the curving volume of his arms. His dark eyes burn forth from a face whose mouth is nearly obscured by his bushy beard. Although his eyes seem to stare straight ahead, there is a hint of an upwards glance towards the image of Courbet. The direction of Courbet's eyes has been just perceptibly altered from that of the original cartoon, emphasizing an interaction between the two generations of artists.

This portrait remained in Pissarro's studio until his death, perhaps evidence of its deep personal meaning.

Camille Pissarro
Portrait of Paul Cézanne

Pierre-Auguste Renoir

M. Fournaise 1875

Alphonse Fournaise was the proprietor of the Restaurant Fournaise
at Chatou, on the Seine, a meeting place for oarsmen and Parisian
workers on holiday outings. The restaurant itself became the site of
Renoir's later *Boating Party*, 1880–81, for which M. Fournaise's son
posed among the other models. Its milieu was described in *La Vie
Moderne*: 'The meal is tumultuous; the glasses are filled and emptied
with dizzying speed; the conversation goes to and fro, interrupted
by the clatter of knives and forks which perform a terrible dance on
the plates. Already a rowdy, heated intoxication rises from the
tables, all filled with the debris of the meal on which the bottles
quiver and shake.'

Renoir depicted the genial host in a pose somewhat recalling
Manet's earlier, successful *Le Bon Bock*, 1873. He leans on his
elbow, his hand holding a pipe to his mouth. Two glasses sit on
the table in front of him, maybe indicating an invisible companion.
His relaxed posture accompanies a face in which twinkling eyes
enliven an air of reverie. However clamorous the restaurant, M.
Fournaise appears at ease.

His attire, too, is casual. Dressed in shirt sleeves and waistcoat
with a cap on his head, he plays the patron of an establishment
where guests wore a variety of garb from formal suits to singlets
and straw hats.

The feathery brushwork freely fills in the white sleeves and
thinly coats the background. The smaller, fusing strokes of the face
and hands offset the bushiness of his greying hair and moustache.
Like the contemporary portrait of Victor Chocquet (p. 140), M.
Fournaise's portrait exhibits the customary liquid handling and soft
focus of Renoir's paintings from the mid 1870s. Such delicacy of
surface and affable characterization was not restricted to Renoir's
female models.

The pose and clothing afford a simple construction of diagonal
and curving shapes. A non-specific background fills in the cropped,
close-up view of the figure. Local hues provide dark tones, while an
even light softens and flattens the features.

Portraits of older male sitters are not prevalent in Renoir's
oeuvre, especially during the Impressionist years. The less
conventional subject gives occasion for a more individual
appearance than the generalized charm of the prettified young
women and their male attendants. Akin to Renoir's portrait of
Chocquet in its intimate, investigative construction of the sitter's
image, this painting examines a very different personality. In
contrast to the more genteel, refined Chocquet, Fournaise has a
stocky fleshiness. The successful small entrepreneur displays a
rotund well-being.

Pierre-Auguste Renoir

Portrait of Sisley 1874

Alfred Sisley (1840–99) was the only major Impressionist not to
paint portraits. Plein air landscape preoccupied him almost
exclusively, the human occupants being appropriately scaled to the
field of vision.

Sisley was born in Paris to British parents. In 1857 his father, a
silk exporter, sent his son to London for a commercial
apprenticeship, where he spent his spare time studying the
landscapes of Constable and Turner. The family accepted his
decision to become a painter without opposition, but later the
Franco-Prussian War ruined his father's business, leaving Sisley with
only the meagre income from occasional sales of his art.

Returning to Paris in 1862, Sisley studied in Gleyre's studio
where he met Renoir. Together, Sisley and Renoir made painting
excursions to the vicinity of Fontainebleau. During the 1860s, with
other students, they began to explore and extend the practice of
naturalist landscape painting.

Rejections balanced Sisley's Salon acceptances in the 1860s.
After not submitting any work to the official Salon for several
years, he joined his close colleagues in the first independent
Impressionist exhibition, eventually participating in four of the eight
shows.

Sisley had been posing for Renoir ever since the mid 1860s (see
also p. 54), but in contrast to this earlier work in which portraiture
intersects with genre, in this portrait, probably painted in the year
of the first Impressionist exhibition, Renoir concentrated on Sisley's
image. He is presented informally, not in his professional role.
Although the portrait includes only his head and upper torso, the
position of the chair back implies that his figure straddles the seat.
One hand interlaces with the rungs, while the other props up his
inclined head. Such a casual pose, together with his lowered eyes,
suggests a moment of reverie.

Compositionally, the work establishes a simple rectilinear order,
flexibly adjusted and inflected into a shallow space. Although the
background window parallels the picture plane, the chair turns ever
so slightly inward, counterposed by the placement of Sisley's body.
The background absorbs the darkly clothed figure, while the bright
yellow accents of window and chair describe a spatial sandwich,
within which the illuminated skin of Sisley's face and hands gleams
brightly.

The artist's features seem to coalesce from the stippled
brushwork. The portrait evokes the intimate familiarity of friendship
rather than formally characterizing a personality.

Claude Monet

La Japonaise 1875–76

La Japonaise is a totally Westernized Japoniste costume piece. Hardly intended to be mistaken for a Japanese scene, it documents the fashion for collecting Japanese objects as well as the impact of the flattened patterns of Japanese woodblock prints on pictorial composition during the later nineteenth century. Camille Monet, the artist's wife, has been dressed up in a splendidly theatrical robe. Monet, who later referred to the painting as a caprice, remembered being tempted by 'a marvellous robe on which certain gold embroideries were several centimetres thick'. Indeed, the embroidered warrior bulks out as a figure in its own right, effecting a torsion at the juncture of Camille's body and the fanned-out hem.

Camille, who was a brunette, has been converted into a blonde, perhaps with a wig, which emphasizes her European features in contrast to the Japanese woman prominently isolated on the fan to the right. The helter-skelter explosion of *uchiwa* fans on the wall establishes a decorative surface and, together with the two fans dropped on the floor, counterpoints the wheeling display of the figure. She herself holds a folding fan whose arc reverberates with the robe's sleeve and hem.

Although the uptilted floor and the insistent shapes splaying across the surface acknowledge devices of Japanese composition, the painting exhibits a distinctly European modernist tension between two-dimensional surface and spatial illusion. The sequence of curves describes a vestigial volume, and the vital presence of the embroidered samurai within the artifice of Camille's pose playfully inverts the conventional relationship of decoration and figural presence.

Although Monet had earlier painted ambitious, large-scale figure compositions, in the 1870s he turned his attention to landscape in which an overall play of light and colour absorbs the figures. *La Japonaise* re-engages with the figure painting tradition. It is much more precisely delineated than his plein air landscapes, and the patterning of objects takes on the function of the broken, all over touch. The local hues of embroidered garment, woven mat, and decorated fans fragment prismatically into reds, blues and yellows.

As with a number of Impressionist figure paintings, its status as portraiture could be questioned. The practice of direct observation lends recognizability to the features of the model. Unlike earlier examples of theatricalized portraiture, this work does not infuse Camille's personality with allegorical attributes. Rather, she becomes the medium of a contrived exposition upon the Western fascination with exotic culture.

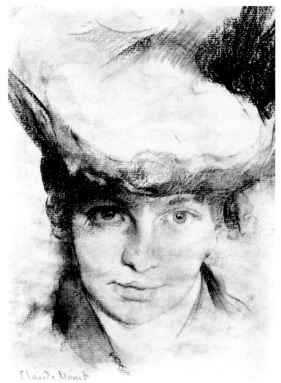

Claude Monet
Portrait of Camille Monet

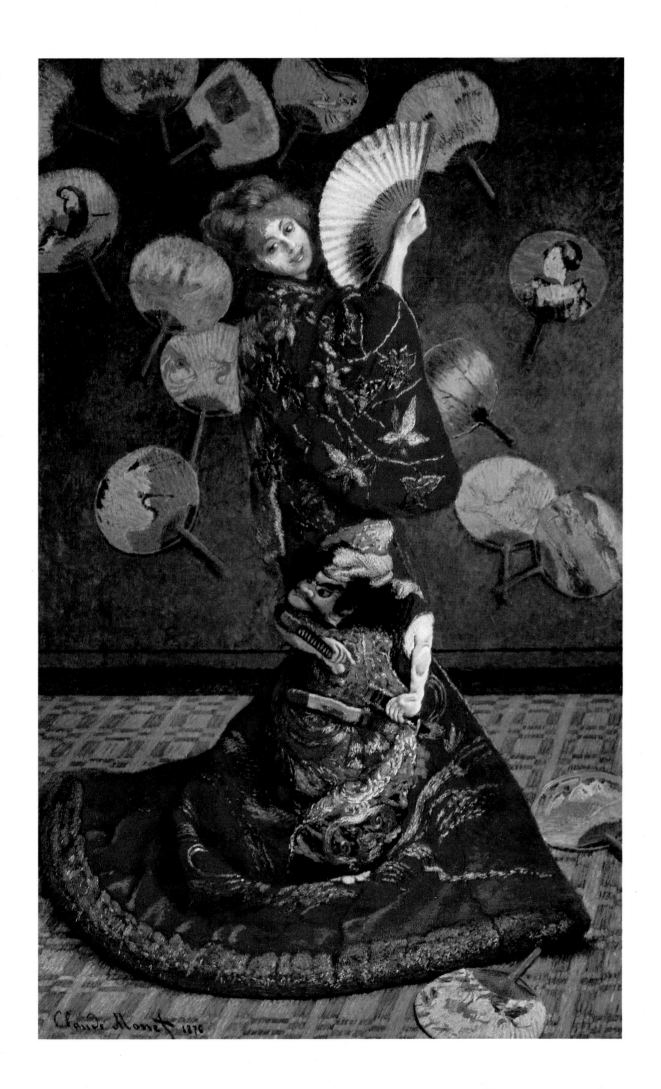

Mary Cassatt

Mrs Duffee Seated on a Striped Sofa 1876

In the years before she painted this portrait of Mrs Duffee Cassatt had briefly studied with and rejected the teaching of the academic painter Jean-Léon Gérôme and the fashionable portraitist Charles Chaplin. She had shown at the Salon but was already taking an independent stance. Although she had not yet met Degas, she admired his work. Reciprocally, Degas expressed respect for her painting even before they were introduced in 1877. Although brighter and more loosely painted than her earlier portraits, the motif, handling and even the style of the sitter's dress reflect an attention to the eighteenth-century French tradition, especially Fragonard. A revival of interest in the eighteenth century, promoted in the writings of the Goncourt brothers, pervaded contemporary fashion as well as artistic sensibility, and Mrs Duffee's dress reinforces the painting's eighteenth-century associations.

The person of Mrs Duffee herself remains elusive. Given the restricted circle of Cassatt's sitters, it is likely that she was an American friend visiting Paris. The portrait came to belong to the Duffee family, which might suggest a commission.

The motif of women reading forms a kind of sub-genre in depictions of women. The nineteenth century saw a rapid growth of women's fiction and magazines. Unlike Mme Monet in Renoir's portrayal (p. 94), Mrs Duffee is absorbed in her book and unconcerned with the viewer. One arm supporting her head and the other holding the book complete a circuit between the reader and her text. The intimacy of the close vantage point reinforces her quiet concentration.

Colour and decoration unite the sitter with her environment. The fabric of her sleeves and overskirt lightly reiterates the striping of the red and yellow sofa. The pattern on the furniture firmly constructs a horizontal-vertical matrix into which the figure more informally settles. Her hair, and the delineation of her features against the clearly lit skin, cast off russet and rosy reflections. The blue of her bodice and underskirt provides a cooler, crisper contrast and delicately modulates the skin tones. The wall behind, overlaying warm ochre with loosely brushed grey, moderates the variety of decorative and textured surfaces, while at the same time imparting breathing space to the closely confined domestic interior.

Cassatt's sympathy with her female sitters brings out an attractiveness in the relaxed, but self-possessed, features without resorting to prettifying conventions. The curve of Mrs Duffee's incipient double chin is simply one of a sequence of arcs descending from her face to her sleeve and skirt. Limited by her sex and class from portraying the working women and demi-mondaines that attracted Degas, Cassatt shared with him the experience of middle-class comforts and restrictions, an experience that emerges in her perceptive portrayals of close friends and family.

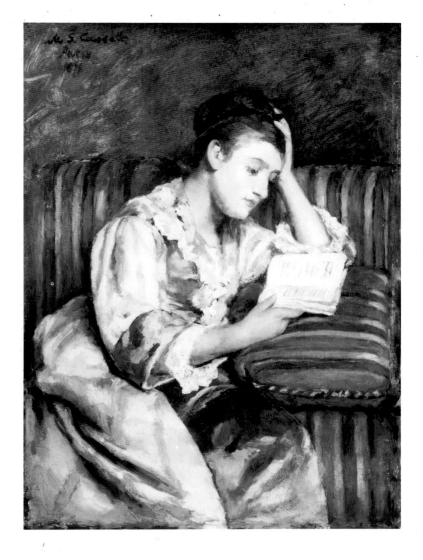

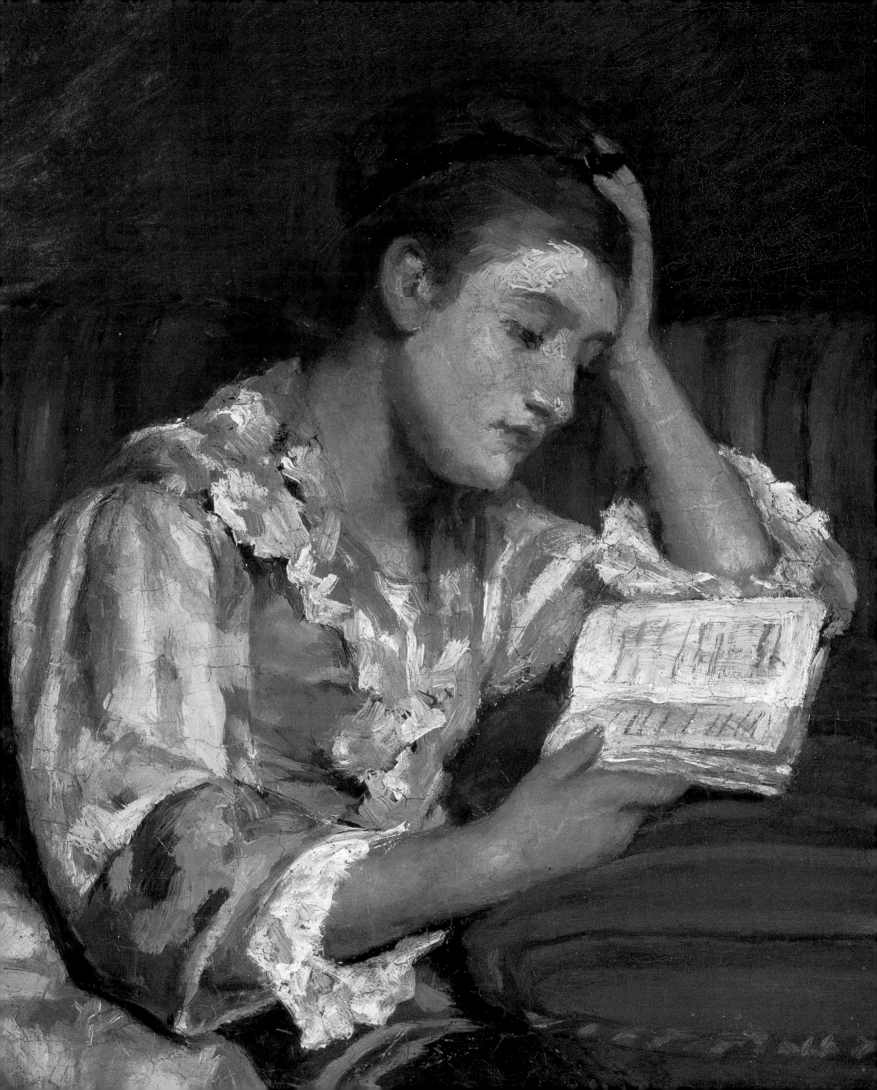

Edouard Manet

Portrait of Stéphane Mallarmé 1876

Manet and Stéphane Mallarmé (1842–98) probably first met in 1873, the year of the poet and critic's arrival in Paris. In the same way that the Realist and naturalist writers such as Zola were associated with the Impressionists, Mallarmé's evocative and elliptical poetry was to become the touchstone of the Symbolist generation. Manet's earlier friendship with Charles Baudelaire gave him a certain prestige in the eyes of the younger poet. At Manet's studio Mallarmé met Zola, Monet and Morisot and became a close friend of Manet. At the time of this portrait, Mallarmé had recently devoted two articles to Manet, and in 1875 they had collaborated on an illustrated translation of Poe's *The Raven*, the man in Manet's illustrations resembling Mallarmé.

The painting depicts Mallarmé in a moment of reverie, his hand resting lightly but pointedly on some sheets of paper. The thumb of his other hand, which is thrust casually into his pocket, directs attention across to the manuscript pages, as does the gaze of his eyes. A cigar gives off a drift of hazy smoke. The same Japoniste wallpaper that appears in Manet's portrait of Nina de Callias (p. 88) and his *Nana*, 1877, provides a background for Mallarmé's figure. Here, the pattern seems as evanescent as the cigar smoke – and Mallarmé's poetry.

Mallarmé's slouched posture evokes relaxation and informality, but the displacement of his body to the right isolates and emphasizes his manuscript in the barer left half of the painting. The image fuses a kind of double tribute to the man and his literary vocation. Although he is not actually writing, his gesture, so explicitly indicating the paper, affirms the contemplative side of an artist's work.

The colour range is restricted. Blacks, earth colours and whites predominate, brilliantly setting off the flesh tones. The loosely worked paint retains a freshness and simplicity, yet each mark perceptively describes Mallarmé's appearance. Manet and Mallarmé shared an eye and appreciation for style, particularly the elegance of women's clothes. Mallarmé's journalistic writing encompassed articles on fashion, under the pseudonym of 'Miss Satin'.

Manet gave this portrait to Mallarmé, and, among the numerous portraits of the poet by major artists, contemporaries deemed it the closest resemblance. Manet's widow later described Mallarmé as her husband's best friend, and this painting was no doubt the result of intimate knowledge. Many years after Manet's death Mallarmé gave evidence of his continuing admiration in his contribution to the subscription towards the purchase of Manet's *Olympia* for the Louvre.

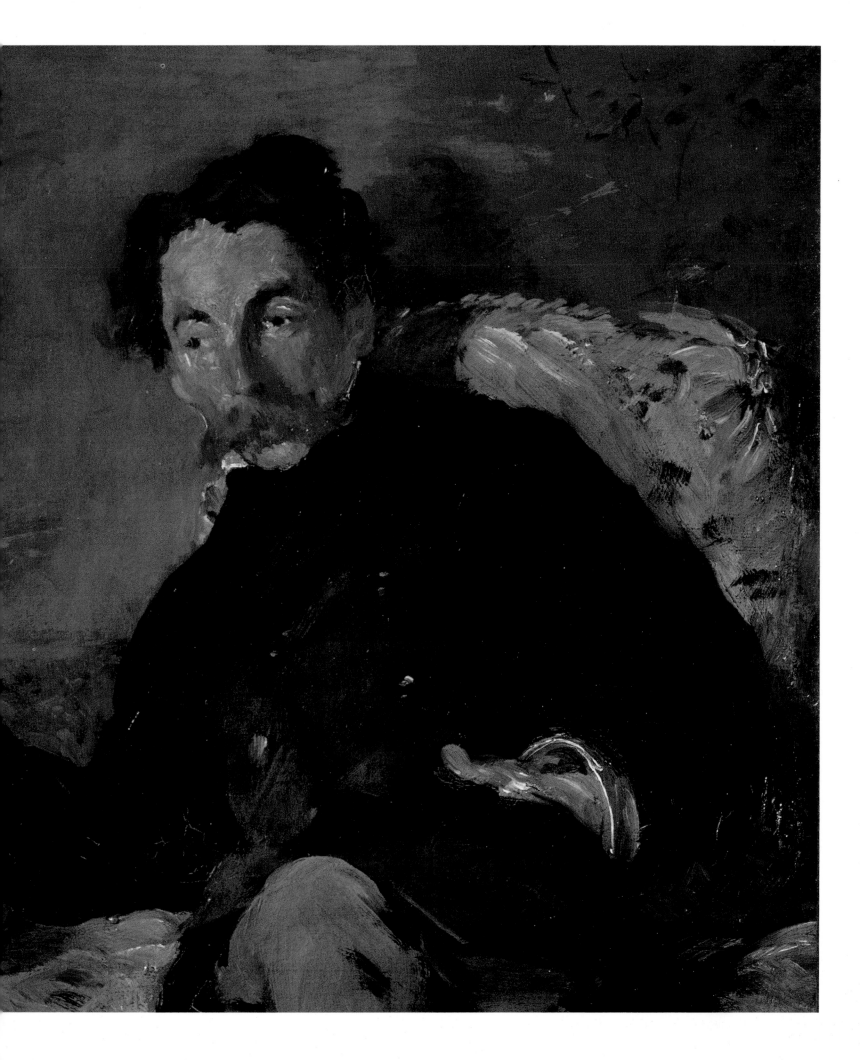

Pierre-Auguste Renoir

Self-portrait c. 1875/c. 1879

Pierre-Auguste Renoir (1841–1919) came from one of the humblest origins of any of the Impressionist painters. Born in Limoges to a family of skilled artisans (his father was a tailor and his mother a dressmaker), he became apprenticed at the age of thirteen to a porcelain painter at Lévy Frères. In the late 1850s, he turned to the decoration of fans and painted blinds. Entering Gleyre's studio in 1861, he met his future colleagues Monet, Sisley and Bazille. Several Salon acceptances in the 1860s did not lead to financial independence, and during the later 1860s he took advantage of the hospitality of the better-off Bazille, sharing several of his friend's studios.

Although occasionally more fortunate than his colleagues in finding purchasers for his paintings, Renoir, reacting to the general depression of the art market, encouraged his fellow Impressionists to hold an auction in 1875. This auction brought him to the attention of Victor Chocquet (see p. 140), whose patronage led to increasing success in securing commissions.

This self-portrait was painted at a time when Renoir's work had begun to receive outside confirmation and acceptance. He presented his features with a rather fiercely visionary aspect. The bust-length pose gives no signal of his métier. Even the eyes, which in most artists' self-portraits gaze outwards in intense scrutiny, here shift to a far-off stare. The intensity seems displaced into the working of the paint itself. Departing from his usual, more fluid manner, he here pressed short, chopped strokes of vivid colour onto the canvas as if scoring the impression of his features.

His slanting eyebrows accentuate his dark eyes, while his bristling moustache and abbreviated beard are counterposed by the upward jutting collar. Contained by the boldly spotted tie, this is reminiscent of the ruffles in sixteenth- and seventeenth-century portraits.

The vantage point – slightly from below – lends a sense of lofty stature. Together with the expression of the features and the aggressive handling, it suggests a lingering sense of Romantic arrogance or perhaps Nietzschian isolation.

Another self-portrait from the later 1870s presents Renoir in a much milder guise, but this one has a vitality and character which compare with Bazille's 1867 view of his friend (p. 36).

Usually dated about 1875, a date of 1879 has recently been suggested. In that year Renoir's favourite model, and probably mistress, Marguerite Legrand, died of smallpox. Renoir gave this self-portrait to his friend and patron the homoeopath Georges de Bellio, whom he had called upon to treat her. Renoir's distress may partially account for this surprisingly turbulent painting.

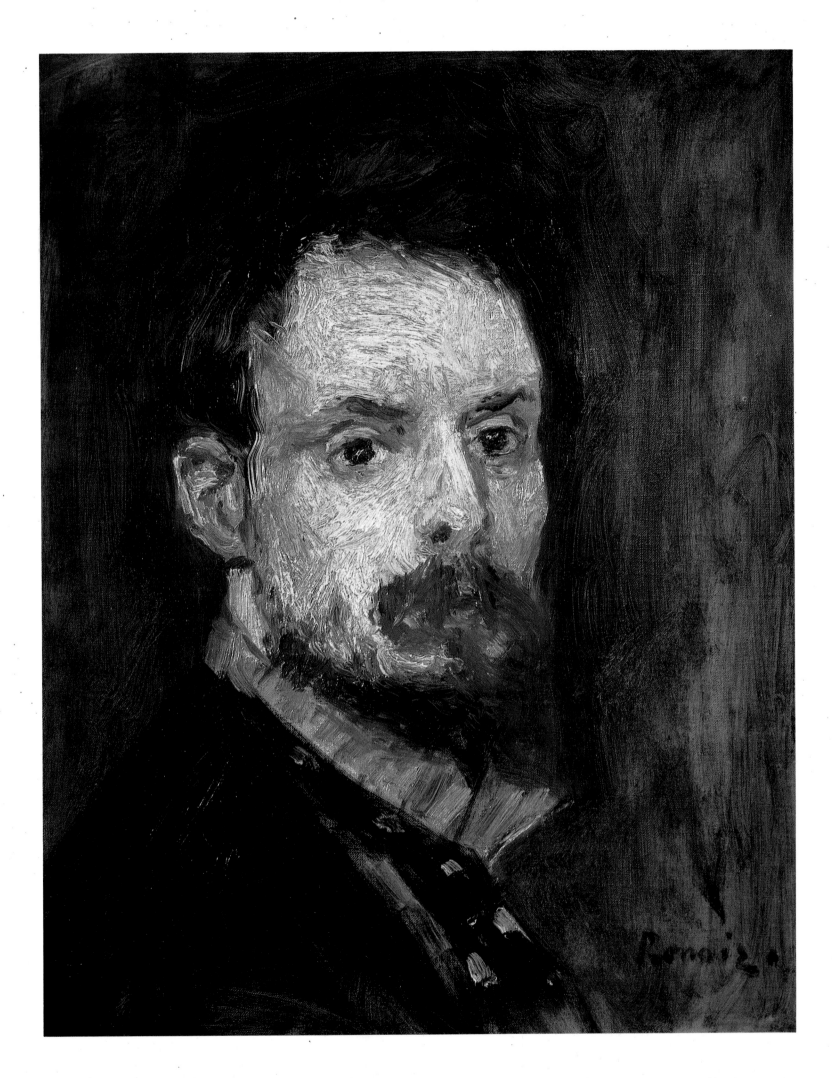

Edouard Manet

Portrait of Faure as Hamlet 1877

Upon his retirement from the Paris Opéra in 1876 Jean-Baptiste Faure (1830–1914) commissioned this portrait from Manet. He poses in his farewell role of Hamlet in Ambroise Thomas' opera, the work with which he was most closely identified. The repertoire of the great French baritone, which extended from the eighteenth century (Mozart's *Don Giovanni*) and early nineteenth (Rossini's *Guillaume Tell*), also encompassed the two important creations of Nelusko in Meyerbeer's *L'Africaine* and Posa in Verdi's *Don Carlos*. Verdi singled out Faure as an exception to his general disparagement of French singers.

Faure had made his debut at the Opéra-Comique in 1852 and first sang at the Opéra in 1861. After leaving the Opéra at the peak of his career he continued to sing at concerts and in the French provinces and abroad. Later in life he concentrated on his art collecting and dealing activities.

Faure had been one of the first important patrons of the Impressionists. An inheritance funded his early acquisitions. Starting about the time of his debut at the Opéra-Comique, he began to assemble the works of the Barbizon painters and Delacroix, and he soon struck up a friendship with the dealer Durand-Ruel. Selling off many of these purchases in 1873 he began to patronize the Impressionists, eventually acquiring over sixty paintings each by Manet and Monet and impressive holdings of Pissarro, Sisley and Degas. His sponsorship enabled Sisley to go to England in 1874. Faure's home on the boulevard Haussmann in Paris became a gallery, one of the few places where the public could view a large collection of Impressionist paintings, while his villa at Etretat housed his objets d'art: miniatures, ivories, small bronzes and faiences.

Manet made several versions of Faure as Hamlet. A small pastel depicts the stage encounter between Hamlet and his father's ghost. This large portrait adopts a stance that reverts to his earlier portrait of the actor Rouvière as Hamlet (*The Tragic Actor*, 1865–66), both recalling Velásquez's portrait of Pablillos de Valladolid. The cloak and sword appear to have been key accoutrements of Faure's interpretation, as well as standard paraphernalia associated with the character of Hamlet. They occur not only in the pastel, where the pose is rotated ninety degrees to a profile stance, but also in a contemporary illustration of Faure by Renouard. Manet's sketch for the finished portrait displays much more vibrant brushwork and presents Faure with the vestiges of a stage environment. Hamlet actively flings his cloak back and advances his weight onto his right leg, while a shadow, possibly indicating the ghost, is cast onto the foreground floor. The more tightly worked painting, which Manet sent to the Salon, is more emblematically static, and the background and floor smooth out into a grey void.

The work was badly received, not only by the critics but also by Faure who refused it. He complained that the legs were not his, to which Manet supposedly responded that he took them from a better looking model. The occasion did not alter Faure's regard for the painter, and in 1881 he commissioned another, bust-length portrait, apparently to commemorate his reception of the Légion d'honneur, an honour shared with Manet, both having been proposed by Antonin Proust.

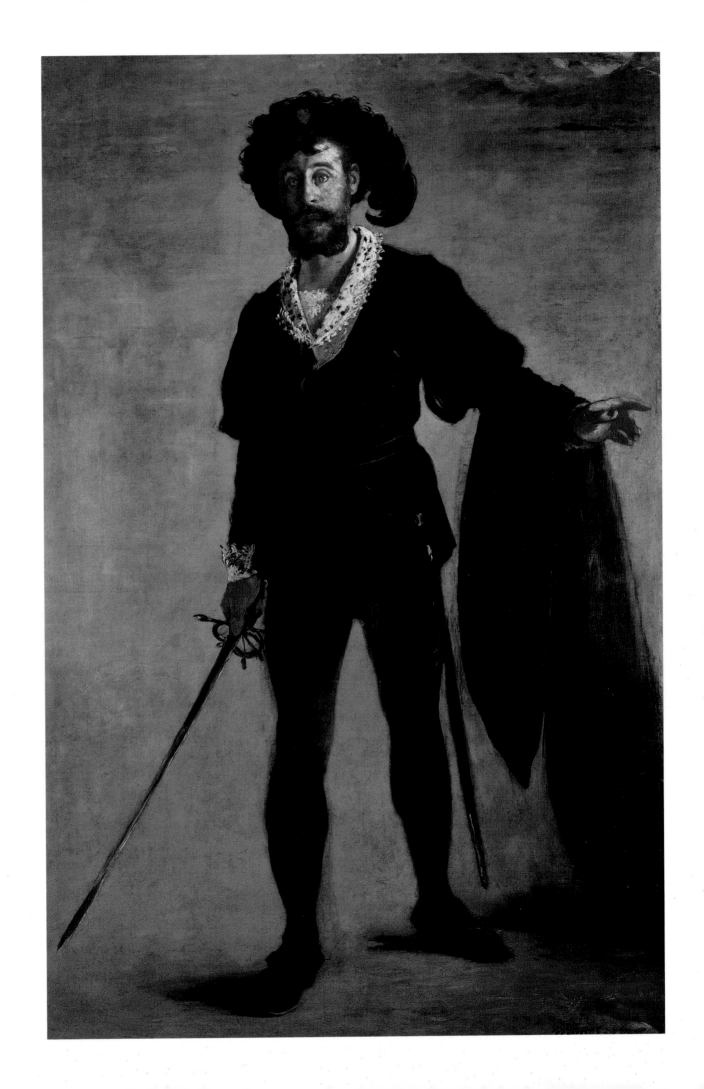

Edgar Degas

Ballet Scene from 'Robert le Diable' 1876

Rarely absent from the repertoire since its premiere in 1831,
Meyerbeer's seminal Romantic grand opera *Robert le Diable*
occasioned one of the few identifiable stage scenes in Degas' vast
output of dance and performance motifs. The moment is the ballet
of ghostly nuns in the third act. This painting is the second of
Degas' two versions. He gave the first, painted in 1872, a format
more nearly balancing audience and performance. Here, the
horizontal stage takes over, and the audience and orchestra gain in
complexity. The silhouettes of the bassoons and the conductor —
positioned between the orchestra and the stage — intersect the
realms of spectator and spectacle.

The bassoonist Désiré Dihau, third from the left, is one of the
recognizable individuals. Degas had earlier portrayed him at the
centre of his *Orchestra of the Opéra*, 1868–69. On the far left the
banker Albert Hecht scrutinizes the audience, rather than the
dancers, through his opera glasses, Hecht, an early collector and
friend of Degas and Manet, became the owner of the first version
of this composition. He was to be instrumental in helping Degas
gain access to the Opéra's dance examinations. In the foreground,
third from the right, is Vicomte Ludovic Lepic (1839–89), a dog
breeder and an amateur painter. Lepic, rejecting the family tradition
of a military career, studied in Gleyre's studio where he met Monet
and Bazille in the early 1860s. He showed in the first two
Impressionist exhibitions, as one of Degas' associates whose
presence was grudgingly accepted by the more radically inclined
artists. Lepic eventually earned the official recognition of a third
class medal in the 1877 Salon, but he shared Degas' experimental
approach to media. Degas produced his first monotype prints in
collaboration with Lepic.

Although the name of the leading ballerina, Laure Fonta, is
known, none of the diaphanous figures are sufficiently portrait-like
to enable identification. On the other hand, most of the men beg to
be matched with particular individuals. The more generally
evocative stage apparition resulted, however, from careful notes,
and the scene more probably resembles an actual moment than the
composite arrangement below, whose distribution differs from the
earlier version.

By implication the picture's viewer belongs to the depicted
audience which is compressed to the right side in counterpoise to
the tunnelling arcade of the stage décor. Few of the spectators are
actually concentrating upon the performance. Opera and ballet
attendance was a social event, and the audience took part in a
greater spectacle, especially before the advent of sunken orchestra
pits and darkened auditoriums. In this painting the distinction
between orchestra and audience is vague. The gender of the
audience asserts spectating to be a male prerogative; women
present themselves to be viewed. Ladies were confined to the loges
towards which Hecht levels his binoculars.

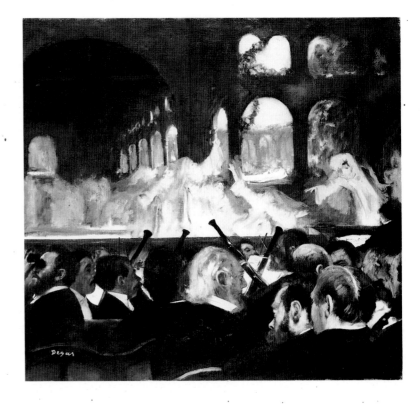

A reduced colour range evokes the artificial illumination. The
stage, predominantly a smoky blue-grey, contrasts with the
mellower blacks and browns of the audience. The lit scores of the
musicians present striking pinpoints in the darkness, as do the
scattered red accents of a buttonhole decoration, a velvet balustrade
and a heightened skin tone.

The painting's provenance includes a further theatrical
connection. Its first purchaser was Jean-Baptiste Faure, the leading
French baritone of the day and a perceptive patron of art (p. 120).

Edgar Degas

Henri de Gas and his Niece Lucy 1875/78

The juxtaposition of figures in Degas' double portraits often emphasizes psychological contrasts, the intervals between the sitters becoming charged with the unspoken aspects of the relationship. In this portrait of Degas' uncle Henri and his young ward Lucy, the inclination of their heads and the gestures of their hands are so closely paralleled that the small distinctions take on major significance. The two do not touch, but connection is made by Henri's armchair. Henri sits nearly in profile but turns his head, not quite regarding the viewer. His left hand, raised to his chin, holding a cigar, and the spread newspaper, supported by his other hand, suggest an interrupted moment, a reflective pause. Lucy stands behind the chair, on the same plane as her uncle. Her tilted head gazes outwards in acknowledgment, her hands lightly supported on the chair back.

Degas painted the work in Italy. Edoardo Enrico Carlo de Gas (1809–79) – Henri to the French branch of the family – was one of Degas' father's six siblings. He remained in Naples when Degas' father moved to France. A bachelor all his life, he became the guardian of his niece Aurora Lucia (1867–1909), or Lucy, after the deaths of her father Giovanni Edoardo (Edouard) and her uncle Achille, her first guardian, not long before this portrait was painted. Upon Henri's death she was once more transferred to the care of another relative, her cousin Thérèse Morbilli (see p. 64). When she reached adulthood, she conformed to family intermarriage patterns, becoming the wife of Edouardo Guerrero, Marchese de Baldi, the son of a cousin.

Aside from kinship it is difficult to imagine much in common between the nine-year-old child and the sixty-seven-year-old bachelor. The bare yellowish wall isolates and silhouettes Lucy's figure. Henri is contained within the embrace of his possessions and environment. The incline of his newspaper scoops upward, connecting his warm brown chair with the cool grey mantelpiece. The foreground segment of the table inverts this curve and pins his figure back against the mullioned screen and the nearby fireplace. While his space is filled with comfortable details, Lucy's is austere. In contrast to her uncle's relaxed pose in his chair, she stands somewhat gauchely, her black mourning dress sending out stiff protrusions.

Degas later adapted Lucy's pose and gesture in his frontal depiction of Hélène Rouart (p. 188), whose hand seems to seek reassurance and stability on the back of her father's chair. In contrast to Cassatt's double portrait of her brother Alexander and his son, which also utilizes a newspaper prop (p. 176), Degas' portrait brings out the distance between the generations as well as their relationship, a distance made more emphatic by distinctions of gender as well as age.

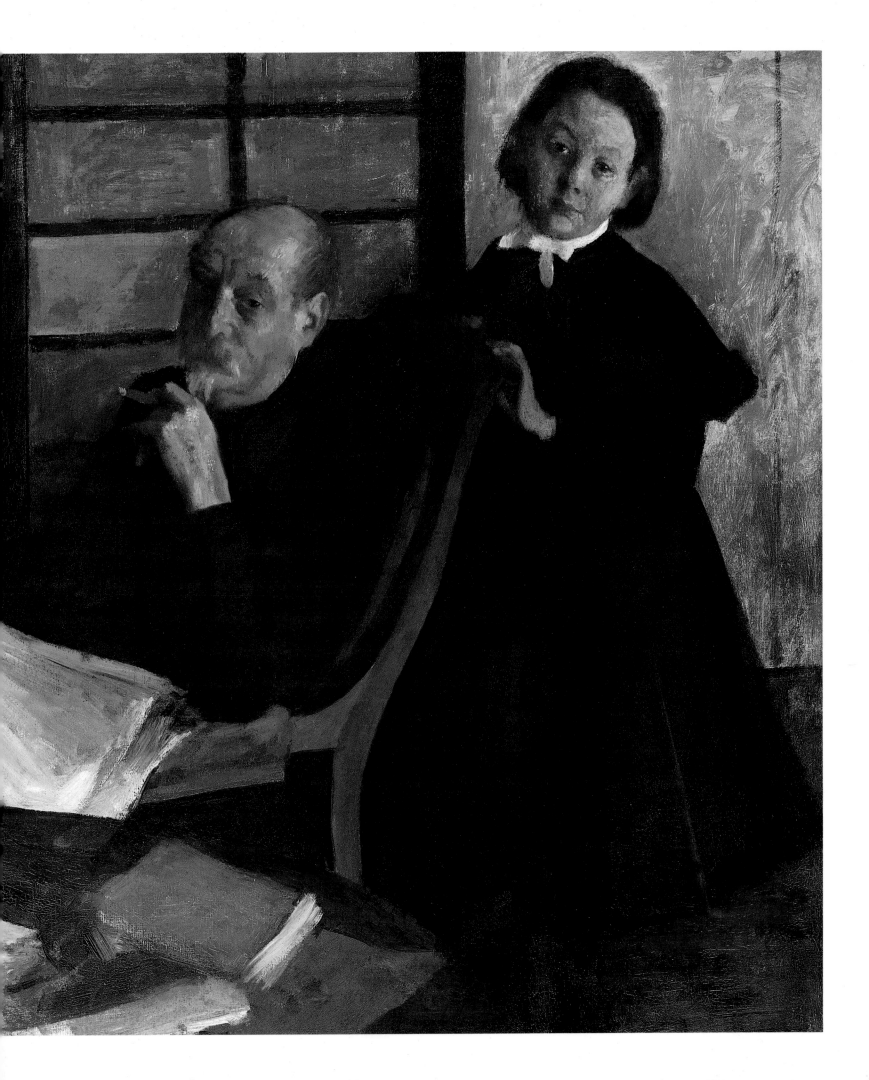

Edgar Degas

Henri Rouart in front of his Factory c. 1877

Stanislas-Henri Rouart (1833–1912), an amateur painter,
participated in all but one of the Impressionist exhibitions. He
withdrew in 1882 as a gesture of support for his friend Degas over
factional disputes within the group. Degas and Rouart had been
schoolmates at the Lycée Louis-le-Grand in Paris. The Franco-
Prussian War brought them together again as members of the same
regiment.

Rouart had attended the Ecole Polytechnique and displayed
diverse talents as a student of higher mathematics and as an
inventor. He also headed a metallurgical enterprise, but he spent his
leisure time painting and assembling an art collection which
comprised Egyptian and Greek sculpture, seventeenth- and
eighteenth-century bronzes, Romantic sculpture, paintings of the
Barbizon School, and works by his Impressionist colleagues.

In painting, his first mentor was Millet, and he had studied with
Corot. Enlisted by Degas in the first Impressionist exhibition, he
maintained an allegiance with the more conservative element of the
group. His work reflected its Barbizon origins, but he managed to
avoid the hostile criticism levelled by the more rebellious painters
against Degas' inclusion of his friends. Although he painted a
number of canvases, watercolour predominated in his oeuvre. He
also practised printmaking and figured among the projected
contributors to Degas' abortive venture to found a print publication.

Over the years of their friendship Degas painted a number of
portraits of Rouart and his family (see also p. 188). Here, he
presents Rouart as a successful entrepreneur industrialist. His cut-off
figure, with its bourgeois costume of top hat and black, velvet-
collared coat, is seen against the smoke-belching chimneys of his
factory. The converging rail tracks accentuate the spatial recession,
while their vanishing point locates the focus on Rouart's head,
whose visage is placed just off centre. Unusually for Degas, the
background is a kind of landscape, albeit industrialized. Not just a
window vista, it supplies an open air environment, although its
space flanks, rather than embraces, Rouart's figure. Like the New
Orleans cotton market (p. 80), this portrait of Rouart creates an
image of the expanding capitalist bourgeoisie.

Rouart's profile is sharply delineated against the light wall of his
factory. The somewhat whimsical counterpoint between his bushy
eyebrow and the ribbon of his hat band alleviates the grave
solemnity of his features. His thrust-out chest and the backwards
gesture of his shoulder and arm suggest a determinedly
proprietorial pose. The slight shadow cast on his brow by the hat
concentrates attention on his dark eyes and illuminated cheek,
giving a gaze that can be read both as meditative and as firmly
observant.

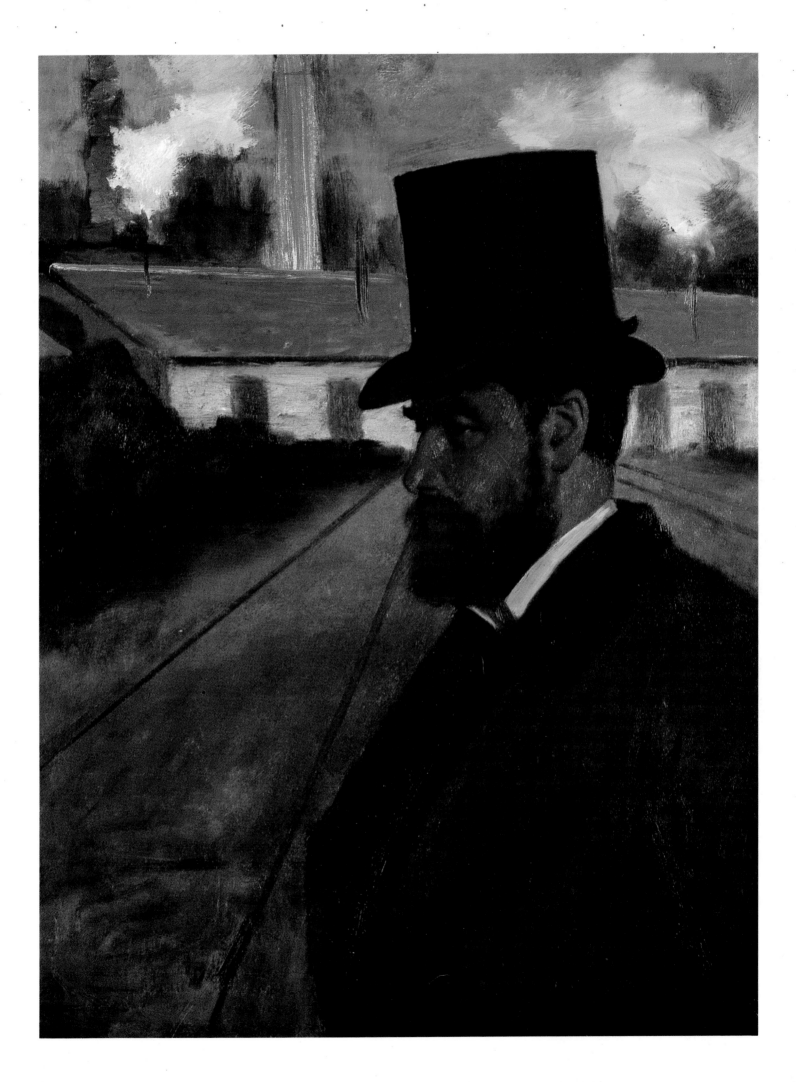

Paul Cézanne

Mme Cézanne in a Striped Skirt c. 1877

Mme Cézanne was her husband's most frequent captive sitter for his arduous portrait sessions. Repeatedly, she is presented stolidly posing, as if resigned to the ordeal. This work, painted around the time of Cézanne's second and last showing with the Impressionists, is one of his most colourful renditions, and the modulation of small patches of paint approaches the all-over texture of paintings by close colleagues such as Pissarro.

Hortense Fiquet (b.1850) worked as a model and met Cézanne in 1869. They began living together the following year. Cézanne kept their liaison and the existence of their son Paul, born in 1872, concealed from his father Louis-Auguste until 1878, when accidental discovery caused the elder Cézanne temporarily to reduce his son's allowance. Eight years later the couple finally married, but at the time of this portrait the relationship remained undisclosed to Louis-Auguste, although it was common knowledge to the painter's mother and closest friends.

While she accepted her tedious lot as model, Hortense Fiquet was not so submissive in her role as companion to a difficult artist. Unable to live openly with Cézanne in Aix during their early life together, she also seems to have found provincial life confining, and in later years the couple lived apart by choice.

Hortense poses frontally, her weight shifted to the left of the fantastically scrolled and tassled red armchair. Yet the heaviness of her body seems counteracted by the vertical suspension of her figure. Her hair connects with the framing edge, and the line of her body descends through her V neckline, the bow on her jacket, and her hands, each forming inflections off centre, and finally flows down the stripes on her skirt. Although the upper torso is flattened into an interplay of shapes against the chair, the bulk of her skirt is modulated in blues and greens. The join of the ruffle with the line of the skirting board pins back the bulging form. The warm yellow wall and vibrant red chair push forward against her cooler, predominantly blue form, while the planes of her face and hands, articulated with patches of yellow, pink and blue, pick up the hues of her surroundings.

The mask-like set of her expression with its dark, unseeing eyes, together with the decorative environment, imparts an oriental flavour to the painting. Cézanne's painting does not overtly manifest an alliance with the Japanese prints that stimulated so many of his colleagues, but by its colouring and design, evokes a kind of Chinoiserie.

A vertical shadow on the right running through the chair back and Hortense's skirt functions more as a structural pinion than as an indication of incidental illumination. It seems to exert its own force upon the positioning of Hortense's body. As in other portraits of Hortense Fiquet by Cézanne, the sitter's character emerges as a by-product of overall compositional construction.

Paul Cézanne
Portrait of Hortense Cézanne

Armand Guillaumin

Self-portrait 1878

Jean-Baptiste-Armand Guillaumin (1841–1927) remains much less well known than his closest Impressionist colleagues, despite his participation in all but two of the exhibitions. Born in Moulins, the son of a tailor, he began working in an uncle's lingerie shop in Paris while studying drawing with the Prix de Rome sculptor Louis-Denis Caillouette. Until 1891, when he won 100,000 francs in a city lottery, he had to maintain himself mostly as a labourer in the Parisian Administration des Ponts et Chaussées, painting in his free time. In order to leave the daytime free to paint, he dug ditches at night.

In 1864 he attended the Académie Suisse where he met Pissarro and Cézanne, who became his closest colleagues (see pp. 82, 180). During the early 1870s he spent some time with them in Pontoise and Auvers. He also occasionally shared studios in Paris with Cézanne. Like his two Impressionist companions, he was briefly associated with the rival L'Union group in the mid 1870s.

The pose of this self-portrait recalls that of Bazille (p. 32), although Guillaumin shows himself more radically twisted against the picture plane and cuts short his seated torso. He had already employed the format in an earlier self-portrait but had not included any of the professional trademarks. Here, the upward-tilted palette flanks the length of his arm – probably his painting arm as seen in a mirror.

The torsion of his body, with the head swivelled back over his left shoulder, and the rippling contours of his head and bust, give plasticity to the spatially condensed image. Guillaumin's broken touches of paint are organized directionally, modelling the surface of forms and describing textures.

Light falls on the sides of his face, leaving the frontal features in deeper shadow. The illumination brings out the bumpy undulations of his high forehead and contributes to the dramatic intensity of the image. The furrows in his brow, the widely staring eyes and the downcast turn of his mouth lend a slightly fraught look to his concentrated expression.

Later, in the 1880s, Guillaumin became friendly with the Neo-Impressionists Signac and Seurat (introducing the latter to Pissarro). He exhibited in the 1884 Groupe des Artistes Indépendants, and the Société des Artistes Indépendants, the only one of the founding Impressionists to do so, but again joined the Impressionists in their final show of 1886. His association with the Impressionists and with alternative independent groups suggests a search for artistic self-confirmation as well as for exhibition opportunities.

Paul Cézanne
Portrait of a Man (Armand Guillaumin)

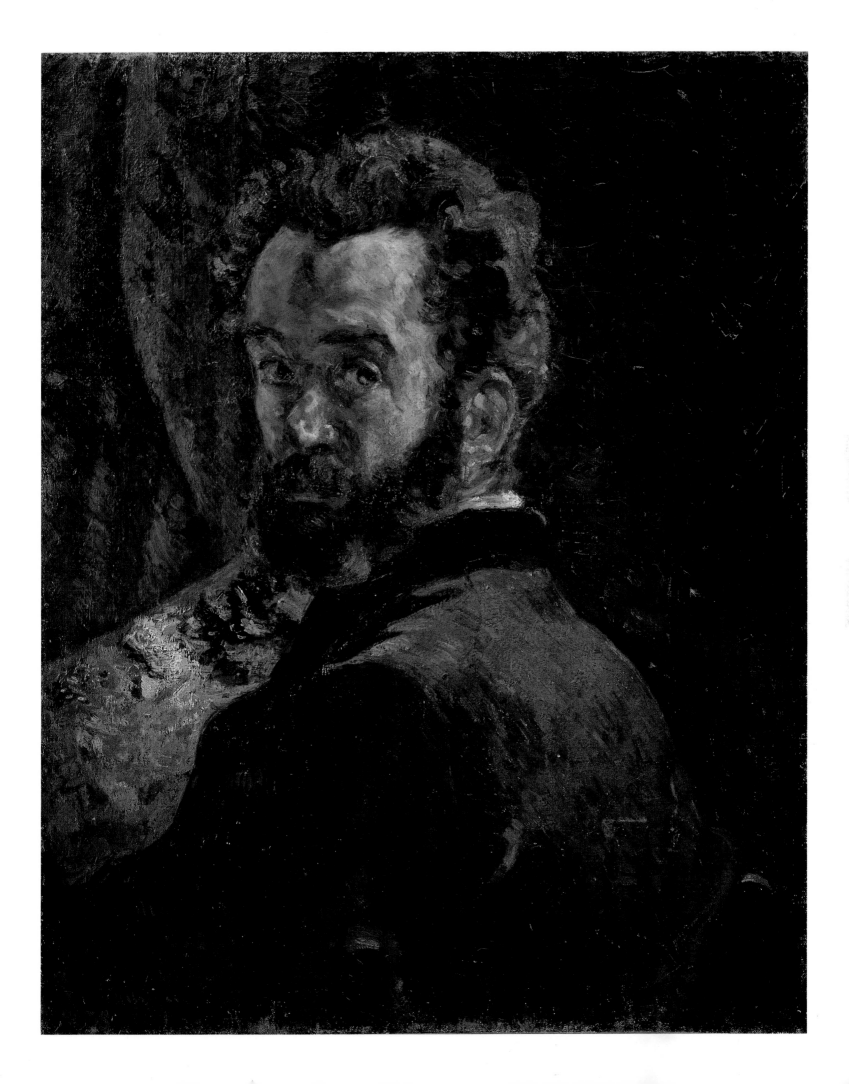

Mary Cassatt

Portrait of Miss Mary Ellison c. 1880

This is the second of two portraits Cassatt painted of Mary Ellison. In the earlier she is shown alertly looking up from her sewing at the viewer, a depiction which Ellison's daughter later thought more in accord with her mother's usually outgoing personality. Here, in contrast, she seems withdrawn, head lowered, sunk down in the chair, retiring behind her spread-out fan. The intensely dark but unfocussed eyes, the horizontal dashes of the eyebrows, and her relaxed but solemn features suggest inward reflection. The mirror behind her does not present perplexing dislocations as in Manet's paintings, but subtly raises the spatial vantage point and supplies a hovering, more secluded alter ego to the sitter.

Mary Ellison was an American compatriot from Philadelphia and a friend of Louisine Elder (who, as Mrs H. O. Havemeyer, was to become an important collector of Impressionist painting). The two young women came from families who valued a European cultural veneer on a woman's accomplishments. In Paris they lived at the pension of Mme Del Sarte, a friend of Cassatt. After visiting Cassatt's studio, Mary Ellison had requested her father to commission the first of the two portraits.

In this slightly later work the dominant scale of yellow unites the mass of chair, dress, fan and vases, while the mirror behind adds a dark blue contrast, shedding a few grace notes over the vases. The scattered touches of red, most prominent in the bows on Ellison's sleeves, set off the more muted red in her auburn hair. Generous shapes overlap and intersect with compositional clarity. In accord with the essential simplicity of the primary colour range, the emblem-like fan seems to distil the rhythms of parallel and inverted arcs, coursing over the chair back and through Mary Ellison's loosely embracing arms. The paint application indicates the various textures of the separate pictorial components, generalizing detail and allowing the focus of concentration to centre on the face of the sitter. Light falling from the left casts one side of her face into delicate shadow, without obscuring or dramatizing the features of her fair complexion.

The portrait does not divulge a personality through the sitter's possessions, nor does it impose a stereotyped presentation of late adolescent feminity. Rather, it evokes a condition, a moment of meditative concentration. The predominantly sunny hues, backed by the deeper blue, and the punctuation of reds, seem to represent the adjustment and balancing out of serious thought processes. Cassatt's work stands out as an image of a woman with something on her mind.

Paul Gauguin

Portrait of Mette Gauguin 1878

In November 1873, Mette-Sophie Gad married Gauguin, at the time a successful stockbroker. Between 1874 and 1883 the couple had five children. Mette was of Danish origin, and briefly in the mid 1880s the whole Gauguin establishment moved to Copenhagen for reasons of economy. By then Gauguin had left his more lucrative profession in order to devote himself to painting. The Gads, however, did not appreciate their son-in-law's artistic commitment, and the couple separated in 1885, Gauguin returning to Paris with his son Clovis (depicted on p. 191).

When he executed this portrait, Gauguin was still a part-time painter, although his achievements had already secured the acceptance of one of his landscapes to the Salon. He had met Pissarro the previous year, and while he had not yet exhibited with the Impressionists, this portrait explores atmospheric light effects and builds a surface of broken brushstrokes.

Mette sits at a table sewing. If the evidence of paintings alone were considered, it might be supposed that the wives and female models of the Impressionists did little other than sew or read. While reading might be seen as a sign of ample leisure time, sewing indicates domestic industry and accomplishments. Mette concentrates on her work, head lowered and hands poised as if for a delicate task. A sewing basket and a piece of cloth occupy the foreground of the table, draped with a patterned table cloth. She appears to be wearing a kind of smock or loose overblouse covering her dress.

In the background the horizontally banded curtains admit a shimmering, suffused light. The *contre-jour* effect casts her profile into shadow, but the illumination spreads across her upper torso. Her body turns slightly towards the viewer, and the angle of the table, too, loosens the compositional rectilinearity, set up in the background stripes, while completing the domestic enclosure.

The delicate brushwork, which describes texture and lightly models form, may owe something to the advice of Pissarro, but the composition, which centres the figure in the middle distance, adheres to older traditions of domestic genre. In comparison with Pissarro's slightly later portrait of his wife sewing (p. 144), Gauguin's work exhibits a more spacious and less interlocked surface pattern, conveying a sense of intimate informality, although the arrangement of items on the table, the swag on the table cloth, and the striped background display a conscious pictorial order. Neither the subject nor its handling forecasts the radical changes in Gauguin's life-style and art which were to follow his rejection of bourgeois respectability.

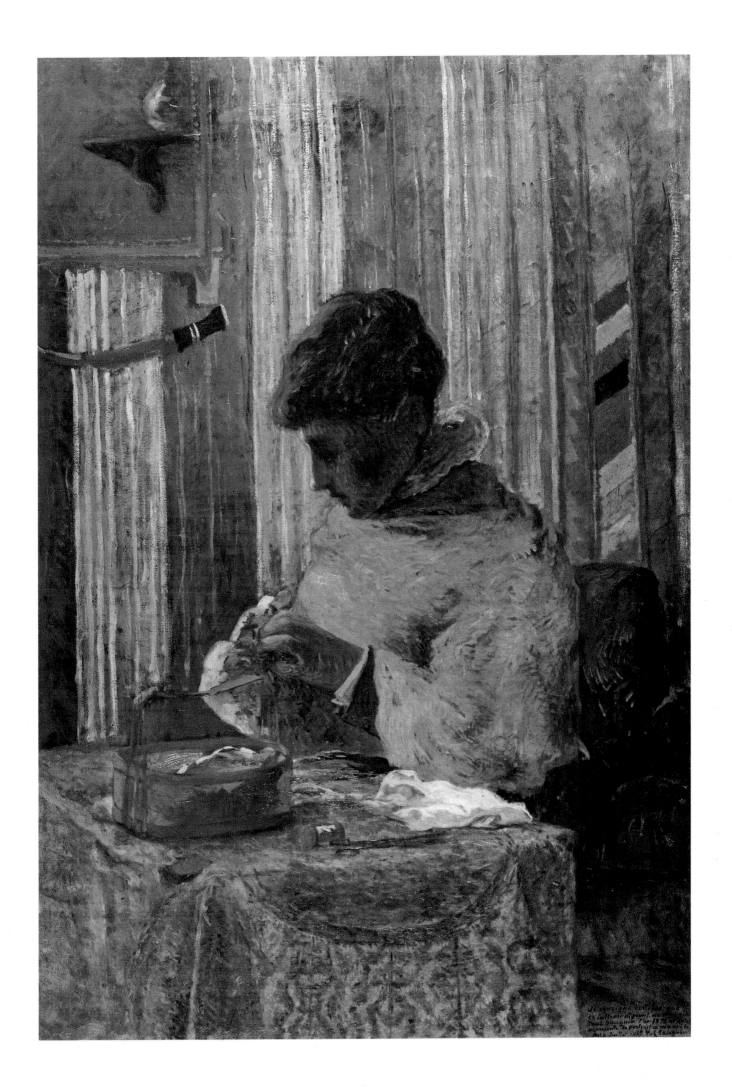

Pierre-Auguste Renoir

Portrait of Mme Charpentier and her Children 1878

Georges Charpentier, the influential publisher of Zola, Flaubert and the Goncourt brothers, commissioned this group portrait of his wife née Marguerite Lemonnier (d.1904) and her children Georgette and Paul (1875–95). He paid the not inconsiderable sum of 1000 francs. The social status of the Charpentiers ensured that the painting was well placed in the Salon of 1879, a year in which Renoir chose not to exhibit with the Impressionists. The Charpentiers had met Renoir after Georges Charpentier purchased one of his canvases from the 1875 Impressionist auction. While their patronage was most supportive of Renoir, their collection came to include works by other Impressionists.

Coming from a well placed bourgeois family, Marguerite Lemonnier married Charpentier in 1872. Her social prestige did not simply derive from her husband's position. She held a literary and political salon to which she invited illustrious guests of differing opinions. Such an intermingling of advocates of diverse beliefs was considered an innovation in Paris. In 1879, together with her husband, she set up a weekly journal, *La Vie Moderne*, devoted to artistic, literary and social life. Both Renoir and his brother Edmond contributed to its pages.

Renoir's painting presents not the ambitious hostess and publisher but Mme Charpentier the benevolent mother. Although Renoir here tempers his looser style of the preceding years, the informality of the composition distinguishes it from the conventional society portrait. The weight of the figure grouping is concentrated towards the left side, leaving the more open space on the right to the structuring patterns of the Esparto rug, interrupted by the frothy train of Mme Charpentier's black Worth dress. The richly painted flowers, fruit and furniture close off the background. The wall coverings reveal a prevailing taste for Japonisme. Reportedly, Renoir depicted this corner of the Charpentiers' home without rearranging any of the furniture. Marcel Proust in *Le Temps retrouvé* praised the painting's depiction of 'the poetry of an elegant home and the beautiful dresses of our day'.

The painting constructs a cultivated ideal of bourgeois domestic order. This materially splendid decor forms a fitting environment for the adornments of Mme Charpentier and her children. Within the red-yellow chord of the interior the children's dresses provide two localized patches of cooler blue, while Mme Charpentier and the dog punctuate the lush colour with neutralizing swaths of black and white. Georgette and Paul with their frilly, Sunday-best dresses and spun silk hair are presented with a cloying sweetness modified by the sulkily obliging animal who serves as a seat for Georgette. The flattering portrayal of the sitters does not noticeably deviate from the charming presences with which Renoir endowed his more intimately familiar models.

The scale and complexity of this painting, its attention to modelling and spatial construction, challenge comparison with the grander traditions of the portrait genre. Forty sittings were required. Even with the tightened composition and drawing, perhaps conceded to oblige a valuable client, several critics carped over its lack of acceptable finish, but Joris Karl Huysmans, an author published by Charpentier, praised its daring. The colouring, which seems to give off its own radiance rather than to reflect natural light, takes the most risks. Renoir was soon to develop the hints of a modelled volume, but he accompanied the venture with a more bleaching atmosphere.

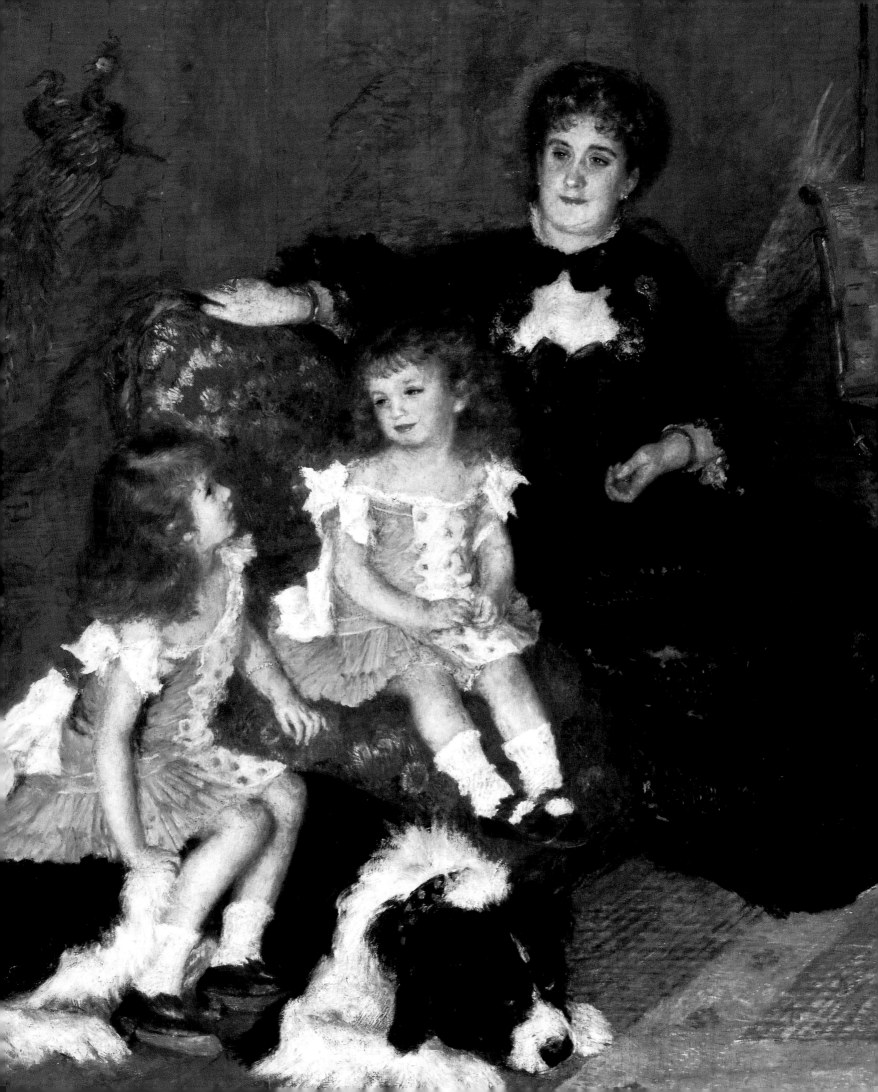

Paul Cézanne

Victor Chocquet in an Armchair c. 1877

Victor Chocquet (1821–91), one of the most enthusiastic early patrons of the Impressionists, made the acquaintance of Renoir around the time of the Impressionists' 1875 auction at the Hôtel Drouot. Renoir introduced Chocquet to Cézanne, and Chocquet soon became one of the most loyal admirers of Cézanne's work, eventually owning over thirty-five of his paintings.

With his modest income as a chief supervisor in the Customs Service, and a discerning eye, Chocquet had already formed a considerable collection, including among its early acquisitions a number of Delacroix's works. Having recently resigned from his job, Chocquet devoted himself to promoting the Impressionist cause, prosyletizing to the visitors in the galleries during the 1877 exhibition. According to the critic Duret, his passionate and well-argued conviction was regarded as 'a form of mild insanity' by the more sceptical public.

Cézanne followed an earlier, bust-length portrait of Chocquet with this seated depiction of his patron posed against a wall crowded with paintings. While Renoir, at Chocquet's request, had portrayed his sitter backed by one of Delacroix's paintings that Chocquet admired (p. 140), Cézanne seems to acknowledge Chocquet's more recent tastes. The most visible painting, a landscape, has not been specifically identified, but its configuration suggests a seascape. It is worth noting that Cézanne painted several views of the Mediterranean for Chocquet.

The tightly interlocked composition contrasts with the informality of Chocquet's sidesaddle pose, his lack of cravat, and his casual footwear. Chocquet's head touches the upper edge; the upper body seems suspended, settling below into an accommodation with the chair's framework. His posture, with locked hands and propped-up arm, may have been characteristic, since it occurs in Renoir's portrait. Cézanne, working upon the given gesture, stretches the wrist into an insistent diagonal over the fulcrum of the chair back, thus prising apart the vertical continuity of the picture frames and furniture and allowing a passage of space between the sitter and his close-fitting room. With such pivotal touches Cézanne's painting negotiates between portraiture's demands for representation and the equally insistent presence of pictorial surface and arrangement.

The patchwork of paint application coalesces into the nuanced grey, white and flesh colours of the sitter, while the broken pattern of the rug gives occasion for the all-over distribution of colour flecks, carried most prominently into red droplets on the wallpaper. A reduced, horizontally reorientated variant of these sprinkled red marks locates Chocquet's mouth. The analogy not only describes Chocquet's features but extends his personality into his environment.

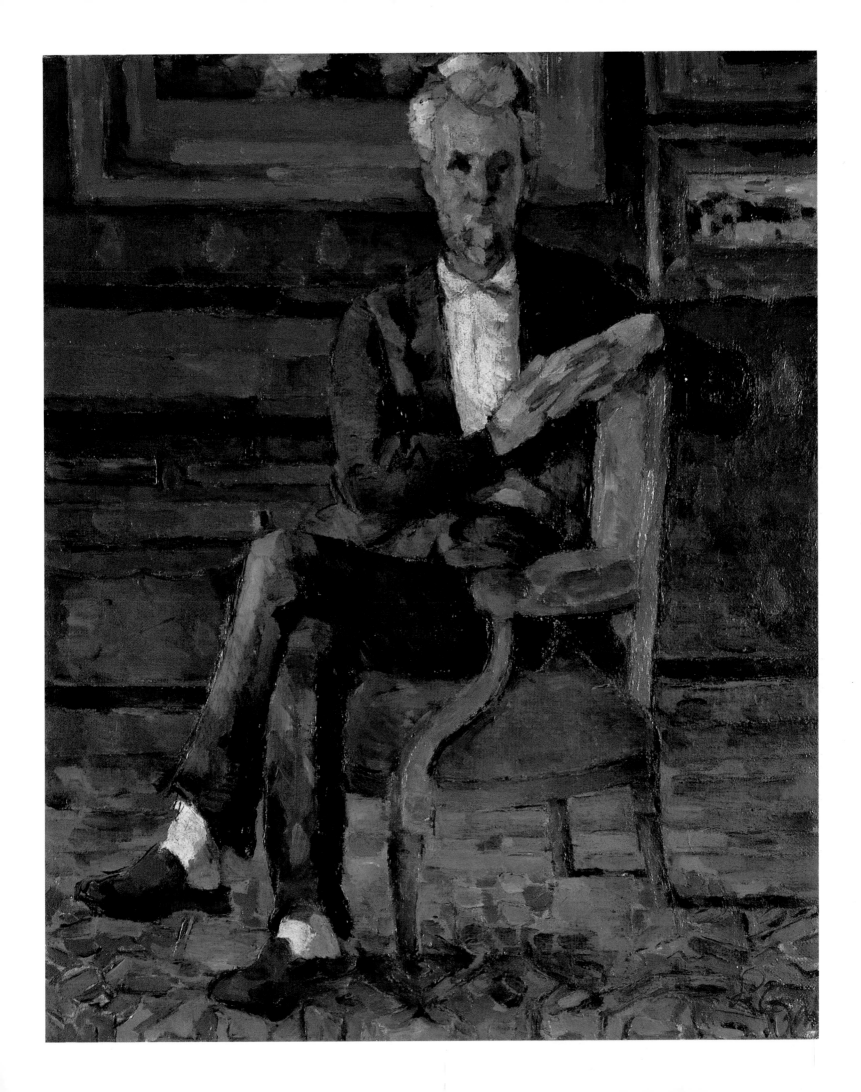

Pierre-Auguste Renoir

Victor Chocquet c. 1875–76

Victor Chocquet (1821–91) came to be Cézanne's foremost patron, but Renoir was the first beneficiary of his enthusiasm for Impressionist painting. After the Impressionist auction of 1875, Chocquet commissioned a portrait of his wife from Renoir. Renoir, who went on to execute two portraits of Chocquet himself, proceeded to introduce this important new supporter to his circle of colleagues.

With a modest income as a chief supervisor in the customs service, Chocquet had already shown himself to be a discerning collector, several paintings by Delacroix being among the pride of his collection. The semicircular Delacroix painting in this portrait forms a kind of displaced aureole behind Chocquet's head. Renoir's own appreciation of Delacroix made him a particularly appropriate executant for this double homage.

The near vantage point crops Chocquet's figure, isolating the juxtaposition between his slender hands and his lively, expressive face. Although Chocquet poses frontally, he leans on the back of the chair in a relaxed pose. A comparison with Cézanne's slightly later painting (p. 138) suggests that the interlaced clasp of the fingers was a habitual gesture. The collarless, open shirt contributes to the informality of the image.

The hues of Renoir's palette take their cue from Delacroix, but the sparkling, feathery touches of pigment lend lighter values to the figure, leaving the heavier colours of the Delacroix as a foil to the more brightly illuminated sitter. Although the textured paint application precludes incisive draughtsmanship, the border of Chocquet's jacket collar threads its way between his head and hands, while the tiny crevice of the open shirt points tellingly like a single index finger.

The rendering of Chocquet's physical appearance evokes a personality without pretension, one both open and intense. The unruly shock of grey hair crowns his visage. The dark eyes sparkle and return a direct gaze to the viewer. The corners of his mouth turn up in a slight smile which, in combination with the eyes, presents an aspect of eager affability. While female portraiture, especially Renoir's depictions, not uncommonly presents the model with a receptive expression, male portraiture tends towards a more serious demeanour. This variation of the norm reformulates the ingredients of Chocquet's personality and Renoir's special regard for his patron into one of his most appealingly individual portraits.

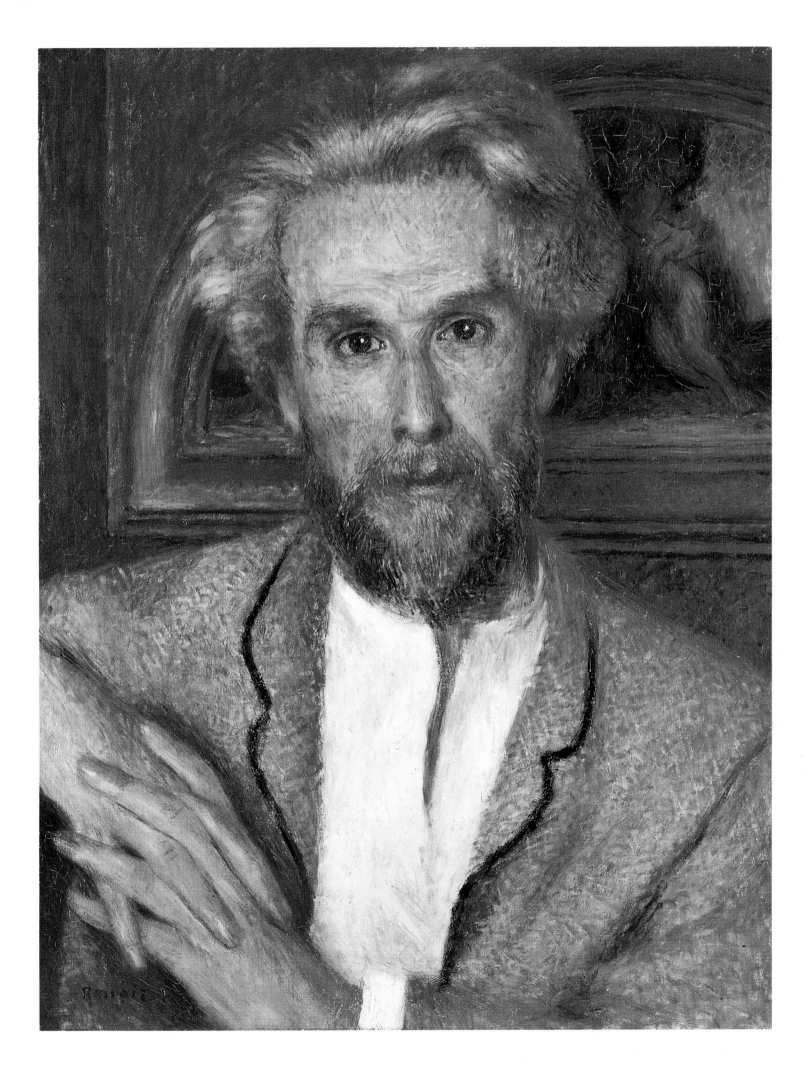

Edgar Degas

Singer with Glove 1878

Degas' fascination with spectacle embraced both the fashionable milieu of the Paris Opéra and the popular entertainments of the *café-concert*. Whatever the social position of the audience, the women who performed at both these venues were mostly from the working classes. Often they were admired by their public for their appearance as much as (if not more than) for their talents; however, Thérésa, who is depicted here and who was one of the most famous singers of the period, commanded a powerful voice and an apparently charismatic stage presence. Degas, one of her enthusiastic followers, wrote: 'She opens her large mouth and there emerges the most grossly, delicately, wittily tender voice imaginable. And feeling, and taste, where could one find more? It is admirable.'

Thérésa sang at the Alcazar on the Champs-Elysées during the Second Empire. The composers Rossini and Auber came to hear her, while the Empress Eugénie invited her to perform at the Palais des Tuileries. Although the repertoire for which she was famous consisted of popular, and sometimes censored songs, she also sang in Offenbach's opéra-féerie *Geneviève de Brabant* in 1875.

This pastel and distemper depiction of Thérésa exploits the drama of vantage point, gesture and lighting. Radical foreshortening of the figure contributes to a suppression of depth and emphasizes her silhouette. The background, which makes no concession to perspectival recession, seems to press against Thérésa's close-cropped figure, further compressing the space.

The syncopated bands of the background supply a counterpart to the diagonal thrust of Thérésa's black-gloved forearm and her tilted head. The oval of her mouth is echoed by the fur trim on her costume and by the exaggerated hollows and openings of her other facial features.

The viewer's position, almost directly below the performer, is reinforced by the light from the footlights. Creating a tension between reflected light and volume, the illumination catches her throat and lower face while casting her eyesockets into dark circular shadows and rendering her décolletage a greenish grey. Light-absorbing blacks set off the startling range of citrus and candy-floss colours.

The variety of marks demonstrates the versatility of the pastel medium in Degas' hands. A rough fuzz describes the fur trim of the dress; superimposed hatchings in the flesh areas serve to model forms and appear as scintillating reflections of light. In other areas the pigment smoothly fills a shape.

Although the model was a specific celebrity, Degas has produced an image that embodies the artifice, the stridency and the grotesque aspects of the *café-concert*. It also has power and intensity – qualities which undoubtedly singled out Thérésa from her colleagues.

Edgar Degas
Study for Singer with Glove

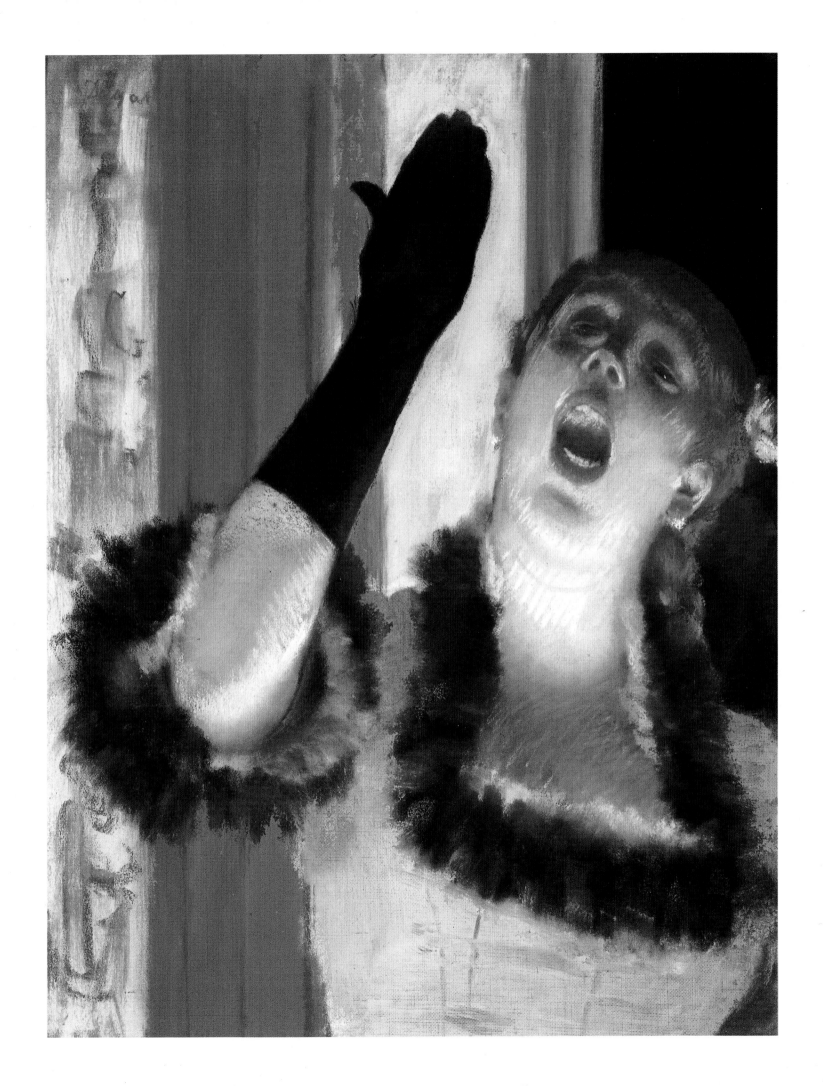

Camille Pissarro

Portrait of Mme Pissarro Sewing near a Window
1878–79

Pissarro met Julie Vellay (b.1838), the daughter of a Burgundian vine grower, in 1860, when she worked as his mother's maid. Their alliance caused Pissarro's father to cut off his son's allowance. They married in England in 1870 during their months of refuge from the Franco-Prussian War, by which time they already had two children. In the course of her life Julie was to bear six children. Their numerous family and Pissarro's modest picture sales resulted in financial privations sustained over a longer period than endured by most of the Impressionist circle. Even in the 1890s she had to borrow from Monet to make a down payment on a house.

The date of this portrait is still disputed, and so the locale cannot be established. The Pissarro family lived in Pontoise in the 1870s, but in 1878 Pissarro rented a studio in Paris. The wrought-iron grille may suggest a Parisian apartment, but the street scene does not offer a definitive topography. In 1878 the Pissarro's fourth son Ludovic-Rodolfe was born in Paris. The painting's close-up view gives no clue to Julie Pissarro's pregnant condition.

Her upper torso fills the right-hand side of the picture, her bowed head nearly touching the framing edge. Likewise, her arms seem to respond to the dimensions of the canvas, bending in conformity with the lower right-hand corner. Thus, her body comes into accord with the formal, rectilinear structure of the composition, while its softened fullness harmonizes with the spiralling scaffolding of the window grille.

The *contre-jour* effect casts Mme Pissarro's features into shade and outlines her profile, her cheek and her eyelid with threads of light, while her bust and hands are illuminated more broadly. The orange and salmon tones outside the window infiltrate the cooler hues of the interior and Mme Pissarro's dress.

Mme Pissarro is sewing. This not only follows pictorial convention but also probably arises from real domestic necessity. The needlework, cropped by the frame, is painted so thinly that the canvas twill identifies with the depicted fabric. Elsewhere paint builds up more heavily, often in small, nearly uniform touches aligned in flowing sweeps, which modulate the forms of her body.

Despite the close vantage point, Mme Pissarro appears oblivious of any intrusion. A certain factualness describes her heavy, no longer youthful features, gently softened by the indirect light.

In the late 1870s Pissarro concentrated almost exclusively on landscape. This portrait of Mme Pissarro signals a re-emergence of figure composition, which was to produce a series of peasant images during the following decade.

Camille Pissarro
Portrait of Mme Pissarro

Edouard Manet

In the Conservatory 1879

Manet submitted this painting to the Salon of 1879 along with an earlier painting of a woman and man boating (*Argenteuil*, 1874), bringing into contrast his prosperous merchant-class pair in their hothouse milieu with the working class couple on an outing. As in *The Balcony* (p. 48), specifically portrayed friends enact a more broadly staged composition. M. and Mme Guillemet, portrayed here, were the proprietors of a fashionable shop on the rue du Faubourg Saint-Honoré. Despite the name, Jules Guillemet seems not to have been a relation of Antoine Guillemet, the painter who posed for *The Balcony*.

The Guillemets are not at home, but pose in the conservatory attached to Manet's current studio, rented from the Swedish painter Otto Rosen. Another, less finished painting of Manet's wife Suzanne sites her in the same environment and in a corresponding attitude to Mme Guillemet, but adds white flowers as a background.

Although the fact that the couple are both wearing rings may emphasize a respectable relationship, the title of the painting, which leaves the models anonymous, led several critics, perhaps mindful of an incident in Zola's *La Curée*, to infer a seduction scene. The relationship of the figures seems inexplicably ambiguous. The gap between their nearly contiguous hands is like an unsaid but understood phrase. Mme Guillemet's yellow umbrella pointedly underlines the gesture. Yet she remains self absorbed, not acknowledging her companion who leans forward, head inclined towards her. Huysmans read the incomplete communication as flirtatious behaviour.

The unusually sharp focus and precision of details pleased critics. While Manet may have made some concession to taste in his draughtsmanship, he did not compromise his modernist rigour in the motif, whose depicted encounter remains enigmatic, or in the sun-bleached, nearly shadowless colouring. Blacks and greys serve as local colours, moderating the tang of vibrant green flecked with citrus yellow, coral and cobalt blue.

Mme Guillemet's fashionable attire has been precisely described. Her yellow hat, gloves and umbrella offset her grey dress, whose skirt spreads across the bench in a carefully arranged display of pleats. She was of American origin and was noted for her beauty and elegance. Several mutual friends remarked upon Jules Guillemet's resemblance to Manet. Given the related painting of Mme Manet, Guillemet's likeness to the painter prompts a reading of some more personal allusion.

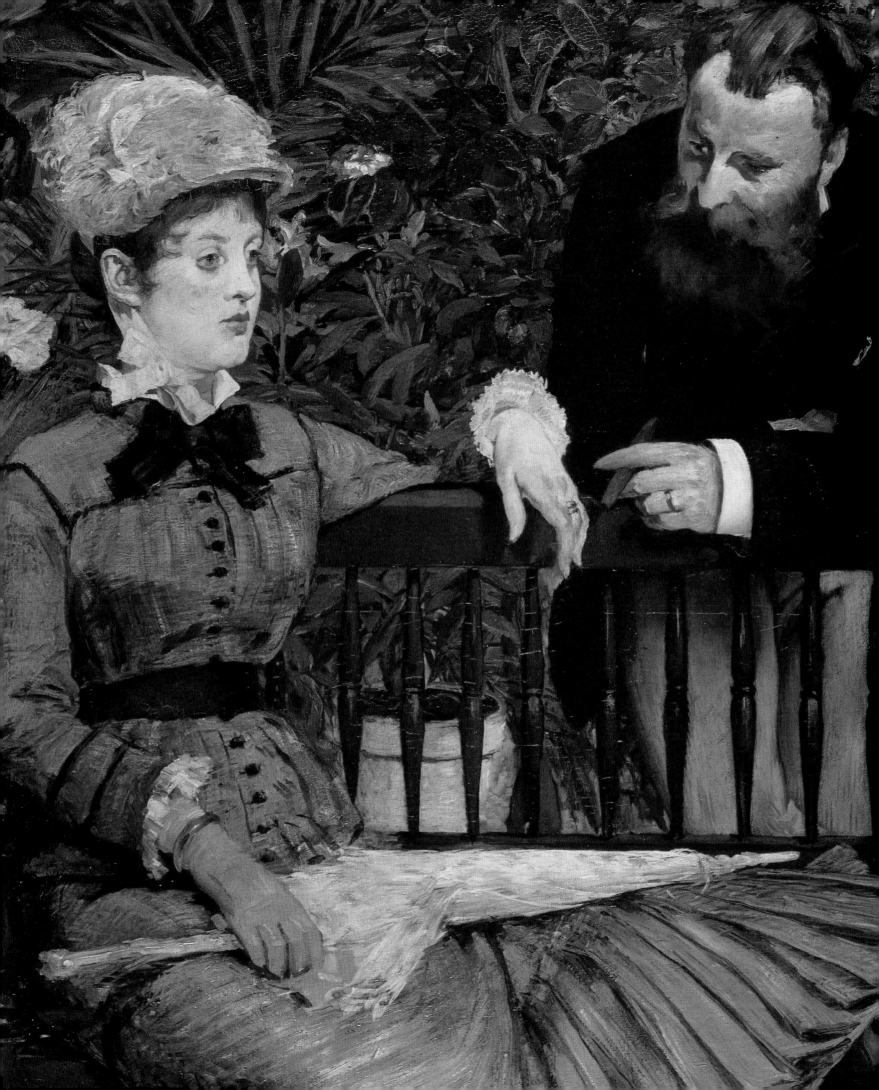

Mary Cassatt

Woman and Child Driving 1879

Rarely do men take part at all in Cassatt's paintings. Here, the
Cassatt family groom has been usurped from the driver's seat and is
relegated to a subordinate position, leaving the reins in control of
Cassatt's sister Lydia (1837–82). Although the features of Cassatt's
models are recorded with the knowledge gained from familiarity,
the title and the composition project more widely ranging meanings
onto the portraiture. Lydia is depicted not as one of the fashionable
demi-mondaines who frequented the Bois de Boulogne but as a
dignified woman concentrating on the task in hand. She came to
Paris with her parents in 1877 to join her elder sister, and served
frequently as a model until her death in 1882, after a life of illness.
In other paintings of the same year she is shown as a vivacious
young woman, but in this work her erect pose, her primly clothed
body, and the heavy hat over her brow lend her an air of almost
matronly maturity. The accompanying child is not a relation, but
Odile Fèvre, a niece of Degas. Like Lydia, she exhibits a poise and
gravity belying her youth.

The cropped, close-up view of the carriage presses its occupants
into foreground immediacy. The compact, inverted pyramid of
figures to the right decentres the pictorial weight. Degas also
exploited this kind of 'snapshot' framing, a compositional device
owing at least as much to Japanese prints and to modern pictorial
construction as to photography. In contrast to plein air
Impressionist painting, the landscape here provides no embracing
environment for the figures, who are illuminated by an even,
bleaching light. Cassatt painted few landscapes; like Degas, she
focussed on figures.

Although the woman and the little girl each inhabit separate
psychological worlds, one concentrating outwards and the other
withdrawn into privacy, they are united in a single, light form of
pastel colours – pinks, lavenders, roses – and are linked by the
diagonal of the back of the seat running behind Odile and picked
up again in Lydia's gloved arms. The framework of the carriage
excludes the male figure from the female realm. He is turned away
in profil perdu, but his skin colour borrows from theirs, while the
black of his uniform filters into details of their accessories. The dark
shapes of the groom and the rump of the horse bracket the two
female figures.

In Cassatt's more domestic groupings of women and children,
gestures bring out the bonds of maternity and family relationships.
This painting directs attention towards an elision of separately
articulated states of female experience, of childhood and maturity
and of passivity and activity.

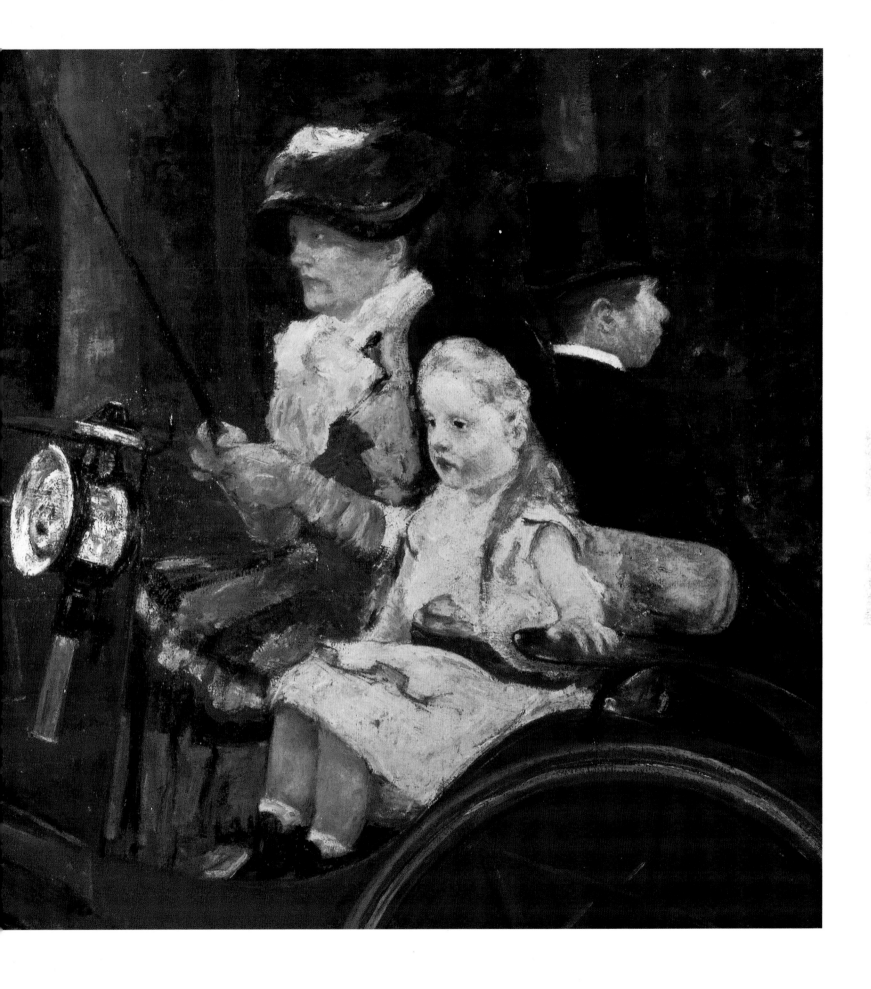

Edgar Degas

Ludovic Halévy and Albert Boulanger-Cavé 1879

Ludovic Halévy (1833–1908) and Albert Boulanger-Cavé are the dandified gentlemen posing backstage at the theatre. 'Myself, serious in a frivolous place', was how Halévy referred to the picture. The theatre was an integral part of the life of their social class, but both had an even deeper involvement. Boulanger-Cavé had served as Director of Censorship during the 1850s. Halévy, a dramatist and novelist, is now best known as the co-author with Henri Meilhac of numerous libretti for Offenbach's operettas and for Bizet's *opéra comique, Carmen*.

Boulanger-Cavé, more of a dilettante than Halévy, belonged to a wealthy family. As a young man he mingled in the entourages of both Delacroix and Ingres. Halévy's son Daniel later described his father's friend as a 'do-nothing Ariel'. Degas more admiringly called him 'the man of taste'.

Halévy had been a friend of Degas since their schooldays at the Lycée Louis-le-Grand, and they remained close until the Dreyfus case divided them in 1898. (Halévy, although raised a Catholic, belonged to a Jewish family.) Before turning to literature, Halévy had worked in the ministry of state in the Bonapartist regime. Several of his literary efforts drew upon Degas' collaboration, and a comedy written with Meilhac, *La Cigale*, 1877, satirized Impressionist painting. Far from being offended, Degas appreciated the humour and sketched a decor for a scene set in a studio.

Degas, a frequenter of the wings of the Opéra, as well as its auditorium and ballet studios, here sets his models against the simplified background of a wing, their black clothing contrasting with the high-keyed yellows, greens and blues. A foreground stage flat abruptly slices Boulanger-Cavé's body. Along with the slightly raised vantage point, it implicates the viewer in a voyeuristic intrusion. The two figures squeeze and shape the interval between them, while their feet interplay in a kind of choreography across the sloping floor. Halévy partly supports his weight on his furled umbrella, a stance which Degas investigated further in several depictions of Mary Cassatt (see p. 172). Not only does the pose offer the compositional introduction of an acute diagonal, but also lends a casually relaxed bearing to an upright posture.

Boulanger-Cavé appears more animated. His profile spikes outwards towards Halévy, whose more rippling outline, backward-leaning posture and lowered eyelids retract into self-containment. Like most of Degas' depicted encounters, the painting leaves undivulged the private circumstances of the occasion, forming a non-narrative slice to which the viewer has only partial access.

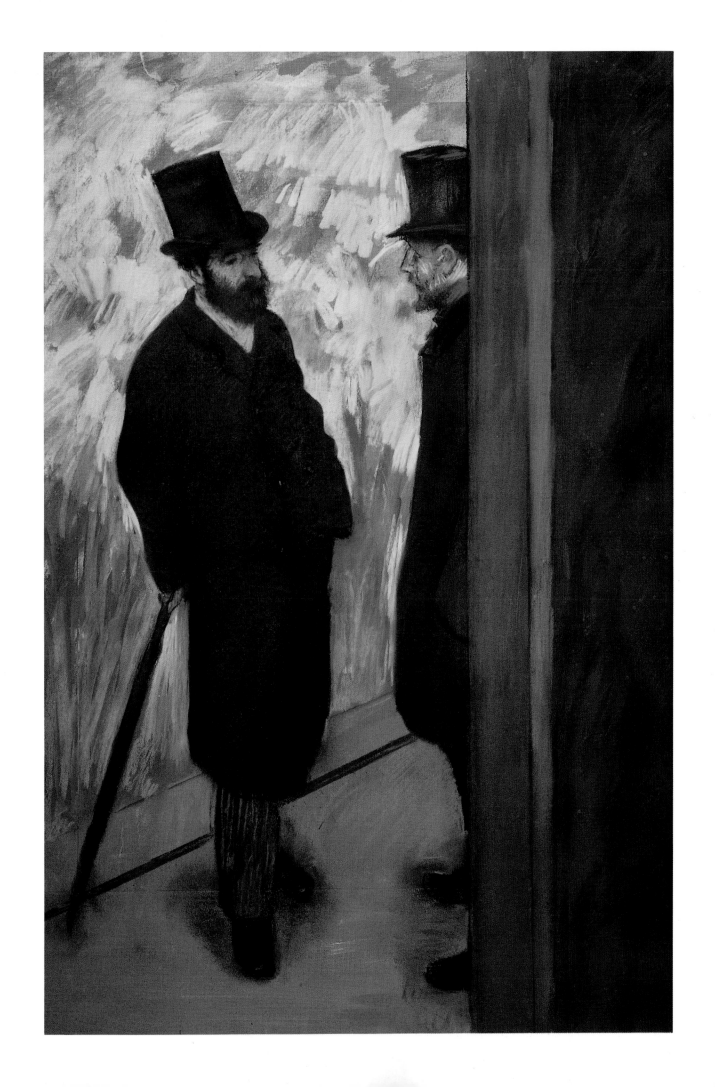

Edgar Degas

Portrait of Diego Martelli 1879

The overhead vantage point of this portrait makes the viewer a kind of voyeur into the privacy of Diego Martelli's room. Martelli (1838–96) himself, with folded arms and lowered eyelids, appears oblivious to any outside gaze. Although he wears shoes, the red-lined slippers lend a more casual note, while the disarray of papers and objects on the cloth-covered table suggests a temporary break from work.

Martelli, a Florentine writer and art critic, was a champion of the Macchiaioli painters whom Degas met at the Caffé Michelangiolo during his 1859 sojourn in Italy. The Macchiaioli had anticipated the Impressionists in their landscape paintings composed in simplified light-dark patches.

Originally a student of natural history, Martelli soon followed his more literary and artistic inclinations, which led him to found several art journals in the 1860s and 1870s. He had carried his political articulateness into action during the Risorgimento, fighting alongside Garibaldi.

In the 1870s Martelli made several visits to Paris. During his stay in 1878–79, serving as a correspondent for several Italian newspapers, he became an advocate of the Impressionists. He bought several of Pissarro's paintings but remained closest to Degas.

One of Martelli's friends described him as a putto, and Degas' revision of his belly and left thigh emphasizes his plump bulk, already squashed into rotundity by the foreshortening. This reworking, along with the slippers, the adjacent floor and the chair, may have been embarked upon as late as 1894. Degas was notorious for his reluctance to terminate work on a picture.

The strokes of colour, painted dryly in oil, are similar to Degas' handling of pastels. The vibrancy of the colours may also reflect his work in pastel. The emphasis on shaped colour patterns and the raised perspective recall Japanese prints.

The square format of this portrait, like that of Duranty (p. 154), also begun in 1879, exhibits Degas' fascination with challenging canvas proportions. The blue expanse of table and sofa pushes Martelli to the left. The distribution of papers on the work surface echoes the furniture's partial embrace of his figure, while Martelli's folded arms hug his body in a squared U shape. The sofa back curves upwards towards the inverted crescent depicted within the frame on the wall. Whereas Degas' portrait of Duranty captures the sitter in a network of oblique angles, his painting of Martelli depicts its model in an expansive, arc-shaped environment in accord with his physique and his personality.

Edgar Degas
Study for the Portrait of Diego Martelli

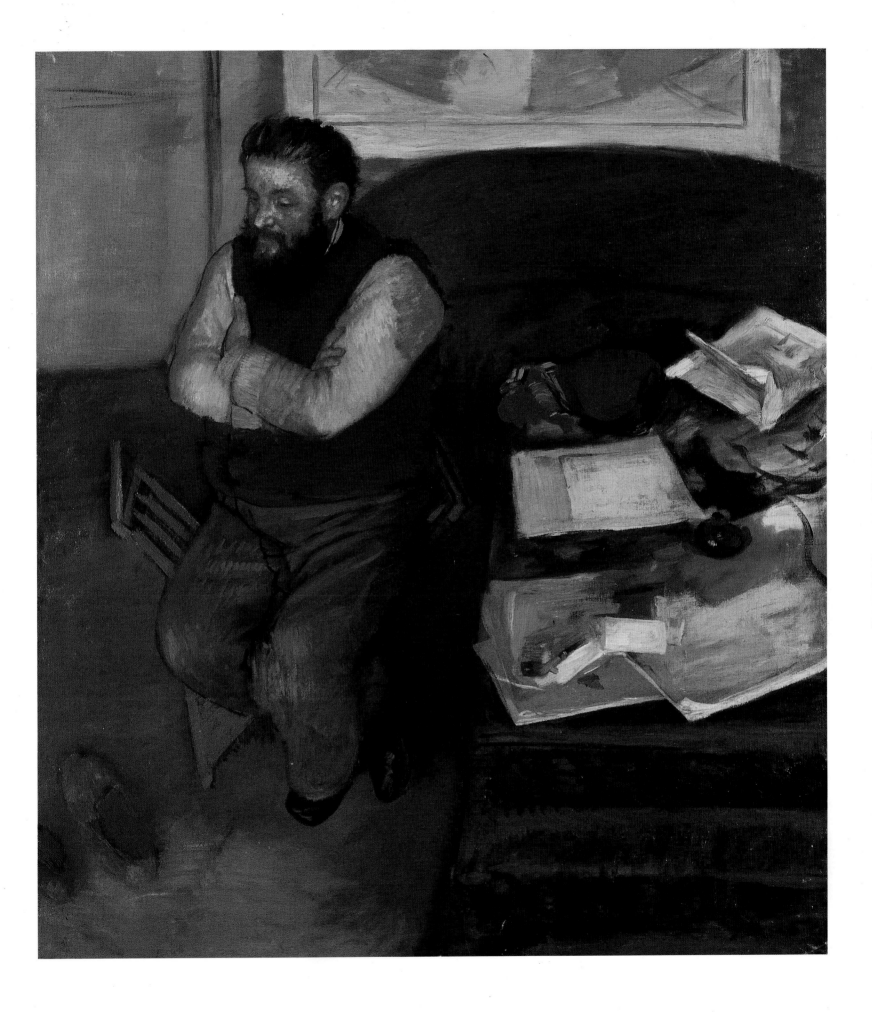

Edgar Degas

Portrait of Duranty 1879

Degas depicted Louis-Emile-Edmond Duranty (1833–80) in his study. Books on shelves and documents on the desk encase the Realist novelist and critic. The high vantage point further embeds Duranty in his library environment. The diagonal distribution of foreground and background elements zig-zags into a spatial coil around the figure, whose pose spirals centrifugally outward to interlace with his literary products. In *La Nouvelle Peinture* in 1876 Duranty had advocated a kind of portraiture in which the surroundings reveal the sitter's 'income, his class, his profession'. Of all the members of the Impressionist circle, it was Degas who had the closest sympathy with Duranty's theories.

Duranty's novels in the vein of Flaubert and Zola became overshadowed by these authors' more successful work. Later in life his disillusionment became more manifest in a personal aloofness and irony akin to Degas' own distanced manner.

Duranty frequented the Café Guerbois, where he probably met Degas in the mid 1860s, and later the Café de la Nouvelle Athènes, both social gathering places of Manet and the Impressionist generation. Like Zola, he favoured a kind of painting descriptive of contemporary life and had less regard for plein air landscape.

Degas' portrait is executed in a combination of distemper and pastel media – he was noted for his experimental approach to media. Its dryness lends itself to draughtsmanly precision, while the bloom of the pastel gives off a sheen suggesting reflected light. Parallel diagonal hatchings compound the shape of the jacket and model the vibrant skin of the head and hands. This concentrated, detailed observation brings the image of Duranty's figure into focus, in contrast to his more broadly sketched possessions, where the thinner pigment application allows the bare linen canvas to breathe through.

This is Degas' only portrait of a literary member of his social milieu. When it was shown in 1880, the critic and writer Joris Karl Huysmans praised the evocation of the character of 'this curious analyst . . . his slender, nervous fingers, his keen and mocking eye, his searching, piercing look, his expression of an English comedian'. The rather odd positioning of his left hand draws attention to his physiognomy. Two fingers press into the corner of his eye, and the other two form a knot to the side of the upward curving mouth. Degas' and Duranty's shared interest in pictorial psychology emerges in the sharply telling gestures and details. Sympathetic observation does not preclude a suggestion of irony, for the material signs of Duranty's profession here become claustrophobically overwhelming.

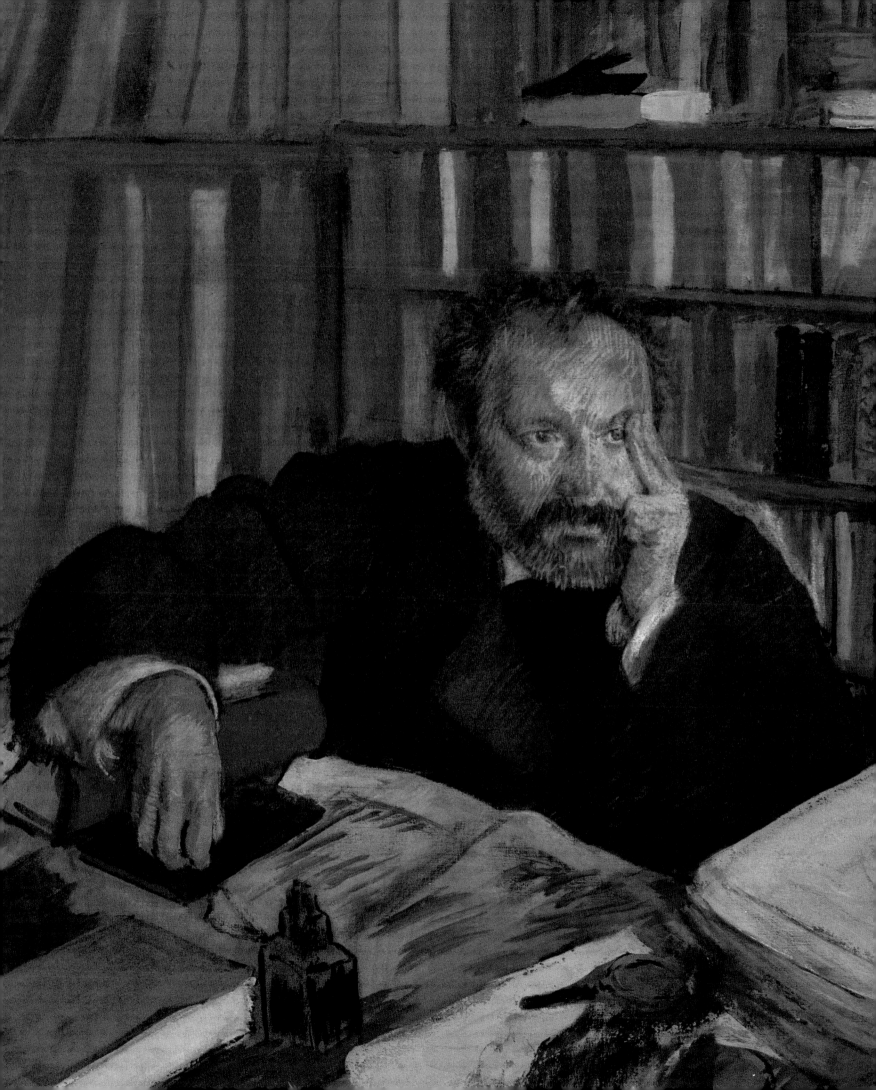

Edouard Manet

Emilie Ambre in the Role of Carmen 1879–80

Manet and Emilie Ambre (1854–98) met in the summer of 1879 at Bellevue, where the painter was undergoing hydrotherapy. Ambre had admired Manet for some time, and she did him the favour of taking the Mannheim version of his painting *The Execution of Maximilian*, 1868, to America, when she went on tour later that year. The painting was shown in New York and Boston but did not meet with success. Ambre's singing tour met with greater fortune, particularly in New Orleans where the visiting French troupe revived the city's dormant opera. She sang the role of Carmen in its New Orleans première.

Manet began this portrait of Ambre in her Carmen costume in the summer of 1879 but did not finish it until her return in 1880. Bizet's opera was given its première at the Opéra-Comique in 1875, not with Ambre but with Galli-Marié. Early critics reacted negatively, deeming its plot unsavoury for Opéra-Comique audiences, but it managed fifty performances in its first run. It then disappeared from the Paris repertoire until 1883, when it was revived with music transposed. Ambre, whose repertoire included the soprano roles of Violetta in Verdi's *La Traviata* and Manon in Massenet's opera, very likely required transpositions to sing this mezzo-soprano part; nevertheless, a music critic writing in 1885 spoke of her as an 'unforgettable' Carmen. In the nineteenth century, leading singers customarily had their own costumes. In this portrait Ambre's costume follows the model worn by the role's first creator.

While Carmen may have been a favourite role of Ambre's, its Spanish flavour fits in with Manet's revival of his earlier interest in Spanish motifs. In 1879 he painted at least three tambourines depicting Spanish dancers for the Spanish singer and guitarist Pagans (p. 68), and a pastel of a woman in a mantilla.

Ambre poses hands on hip with a fan jutting out below her elbow. Simplified shading and prominent brushstrokes give vivacity to her features. A sparkling mantilla frames her face, and the decoration on her bolero jacket gives occasion for the painterly brushwork outlining the forms of her upper torso, contrasted in the simplicity of her skirt. While the dark background evokes an amorphous space, a just visible table provides a prop for the model's stance.

Although relegated to opera's marginalia today, Ambre must have been a lively and cultivated woman. She wrote a novel, *Une diva*, published in 1885, whose melodramatic plot could itself serve as an operatic scenario. The heroine Yvonne Bertini utters a statement of female independence which echoes both Mérimée's novel and Halévy and Meilhac's libretto for *Carmen*: 'I will fall at a time which pleases me, never at a time which pleases others.'

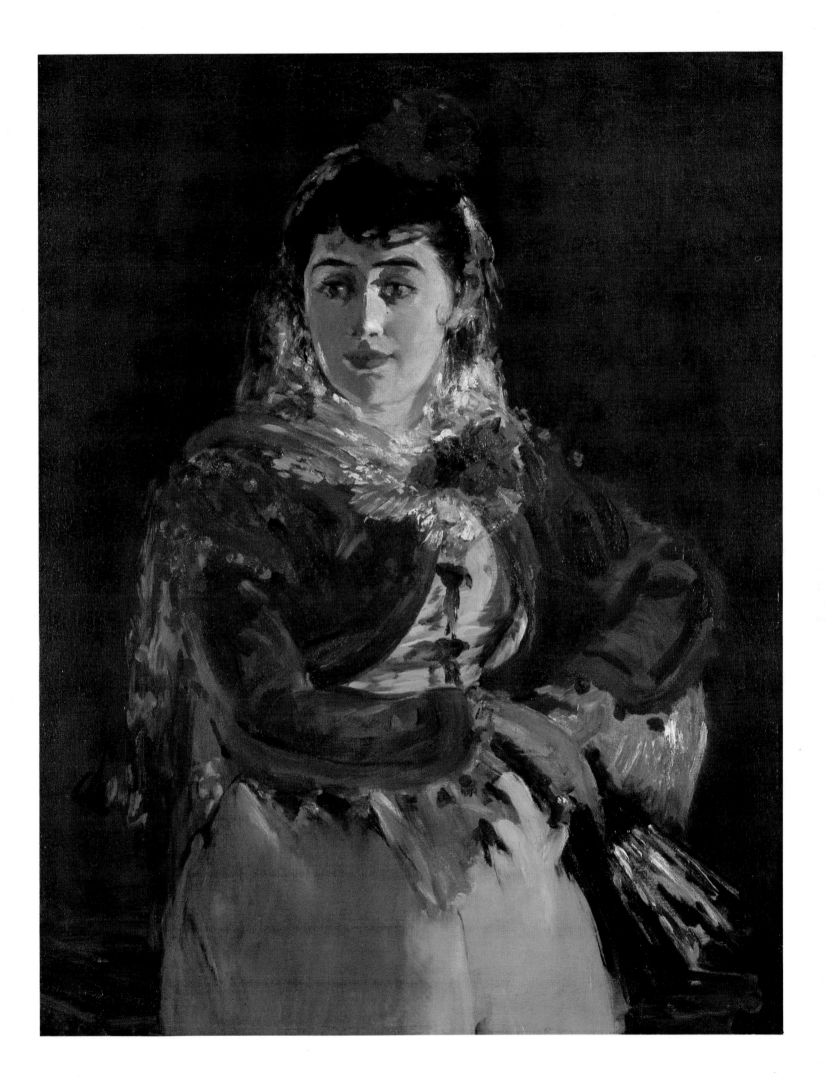

Claude Monet

Camille Monet on her Deathbed 1879

After a period of failing health following the birth of her second son Michel, Camille Monet died on 5 September 1879. In the months between Michel's birth and Camille's death Alice Hoschedé, who was to become Monet's second wife, and her children had moved in with the Monet family. Whatever the domestic situation was, Monet's later remarks to Clemenceau about this painting carry overtones of ambivalence: 'Finding myself at the deathbed of a woman who had been and still was very dear to me, I caught myself, with my eyes focused on her tragic temples, in the act of automatically searching for the succession, the arrangements of coloured gradations that death was imposing on her motionless face . . . in spite of myself, I was being involved by my reflexes in an unconscious process in which I was resuming the course of my daily life.'

Despite Monet's emphasis upon colour sensations in his remark, the portrait is one of the most extraordinarily haunting images to have been produced by an Impressionist painter. Brushstrokes scramble over and around the figure, occluding the upper torso and the withering flowers. The lower part of the painting scarcely registers any form at all, as the pigmented surface opens up over the primed ground. A veil of predominantly vertical brushwork renders a ghostly trace of her features, the most orderly part of the painting.

The head, indeed, occupies only a small area of the canvas, high within the blue-mauve mound of the deathbed. Blue overlays the face with a pallor, the features being barely traced on its elongated oval. Monet not only observes the visual effect of death upon Camille's person, but infuses the surroundings with the transpositions of his emotional experience.

The pale ochre ground, visible through the interstices of the open network of paint, bespeaks the haste of execution. Rarely did Monet cover his canvases so lightly. The yellow cast of the ground also serves as a kind of diffused light. The sheeting and the shapeless mass of Camille's body and flowers palely echo the darkened red blotches in the sombre blue background.

Monet appended a poignant postscript to Camille's life when he requested his friend Georges de Bellio to retrieve a pawned locket, the only souvenir she had been able to keep through the financial vicissitudes of the life she shared with the painter. 'I should like to tie it around her neck before she leaves forever', he wrote.

Paul Cézanne

Portrait of Louis Guillaume 1879–82

The age of Louis Guillaume, the son of friends of Mme Cézanne, is difficult to determine. The maturity in the set of the child's face may token the conflicts of early adolescence. The indistinct pattern on the wall to the right of his head could even be read as a form redolent with sexual allusions.

Guillaume's pose, slightly inclined off the vertical and displaced against the chair back, gives him a stiff, tense posture, while his face has a mask-like rigidity. Cézanne's slow, laborious method of painting rejected transient expressions and required strenuous sittings from his models.

A dark blue tonality pervades Louis Guillaume's clothes and the background. It invades the folds of his white neckerchief and models the deeply shaded left side of his face. Only the crimson lips and the paler pink patches on his skin contrast strikingly with the dominant sombreness.

The attention to modulation of form in Cézanne's portraits tends towards a distant expression of features. Personality is not so much brought out as constructed into the relationships of form. The bow of Guillaume's mouth is echoed in the curve of his right ear. The rounded X of his scarf seems to support his head on the plinth of his body. Its drooping corners play against the arched eyebrows and the inflections of his closely cropped hairline.

The two halves of the face contrast, almost as if belonging to two different viewpoints. The lit side broadens and flattens to a shallow relief, with the ear appended like a flap. The shaded side thins and buckles back to the dark oval ear which appears almost as an extension of the hair. The prominent, cast shadow of the nose creates a profile shape, superimposing the suggestion of a turned head onto the nearly full face. Louis Guillaume's visage becomes an elusively shifting portrayal. His unrevealing, nearly black eyes withdraw from contact.

Cézanne transformed his own anxieties over personal relationships into a kind of portraiture that yields its sitter's presence through what is left inexplicit. It gives more responsibility to the implications of visual arrangements. Instead of fixing an image it proposes multifaceted ambiguities.

These ambiguities may have been compounded by rapid changes in Cézanne's motif. Guillaume's appearance fuses attributes of a schoolboy with an already stoic resignation. The pedestal of his body shoots upwards. Cézanne travelled frequently during the probable years of this portrait's execution, from Aix to Paris, Medan, Pontoise and L'Estaque, and it is not known whether he was able to finish the painting uninterrupted. Even if work was continuous, the moment of dawning adolescence contains its own elusive contradictions.

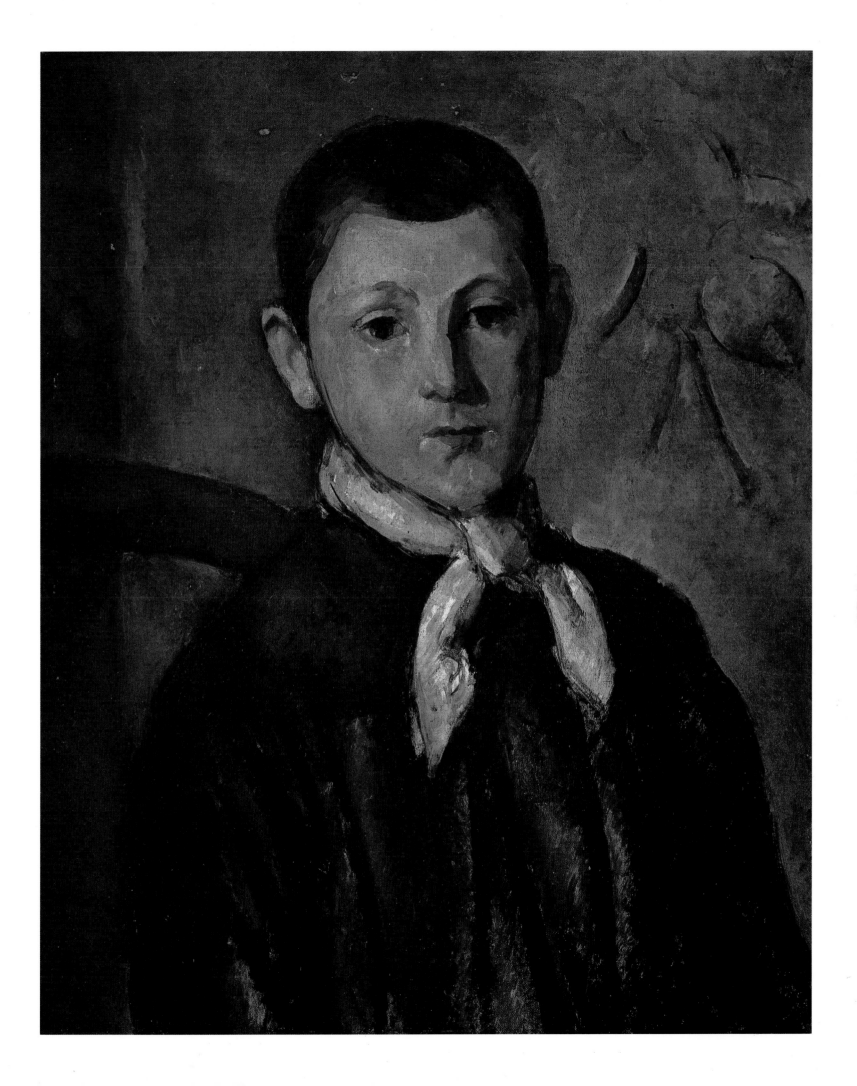

III

New Directions 1880–86

Camille Pissarro

La Mère Larchevêque 1880

Pissarro's slabbed, worked handling particularly suits his portrait of La Mère Larchevêque, lending her a rough-hewn vigour. The peasantry found a modest place in the paintings of some of the Impressionist circle, although only Pissarro devoted concerted effort to this type of model. Peasant imagery had a long precedent in the fine arts. Except for the more urbane Degas and Manet, few of the Impressionist associates confronted the depiction of the urban working class.

In the 1880s Pissarro's painting came to focus more closely on the human figure, after the dominance of landscape. By and large, the figures depict peasants, and they remain anonymous images of a class rather than individual personalities. The shift in motif emerges within Pissarro's visual formulation of his socialist and anarchist politics. These years also mark Pissarro's struggle to develop his technique, which one critic had discouragingly described as 'pasty, woolly, tormented'.

While such an inelegant paint application may congeal the surfaces of landscape, it contributes to the construction of the image of La Mère Larchevêque. The sitter, one of the few named peasants, was a neighbour of Pissarro in Pontoise. Unlike Pissarro's more youthful peasant girls and women, the middle-aged Mère Larchevêque has individuality. She displays neither the attractions of freshness nor the picturesqueness of old age. Like a simple declarative statement, she appears without sentimental or nostalgically ennobled overtones.

Seen from above, her heavy body spreads into a solid, lumpen mass. While the shoulders are rounded, the arms rest firmly on her thighs. Her face, turned in a three-quarters view, squints towards the light. The vantage point suggests the pressing down of an invisible weight, signalling perhaps that of physical labour.

The yellow scarf binding her hair harmonizes with the warm, weathered skin tones, the barest touches of red enlivening the blue, green and yellow triad. As if acknowledging the importance of the incidence of red, Pissarro used the hue for his signature, so pinning down the upper left-hand corner. Although the brushwork varies, from the strawlike strands modelling the face to the frayed smudges of dark green shadow on the left background, the overall effect is one of a surface toiled at, almost chiselled into the rolling relief of Mère Larchevêque's body.

While bourgeois professionals may require the identification tags of their occupations and class, the peasant type is almost instantly recognizable from the physique. Mère Larchevêque's body is earthbound, and her face broad and heavy featured, yet the slits of her eyes and tightened lips convey the canniness of experience.

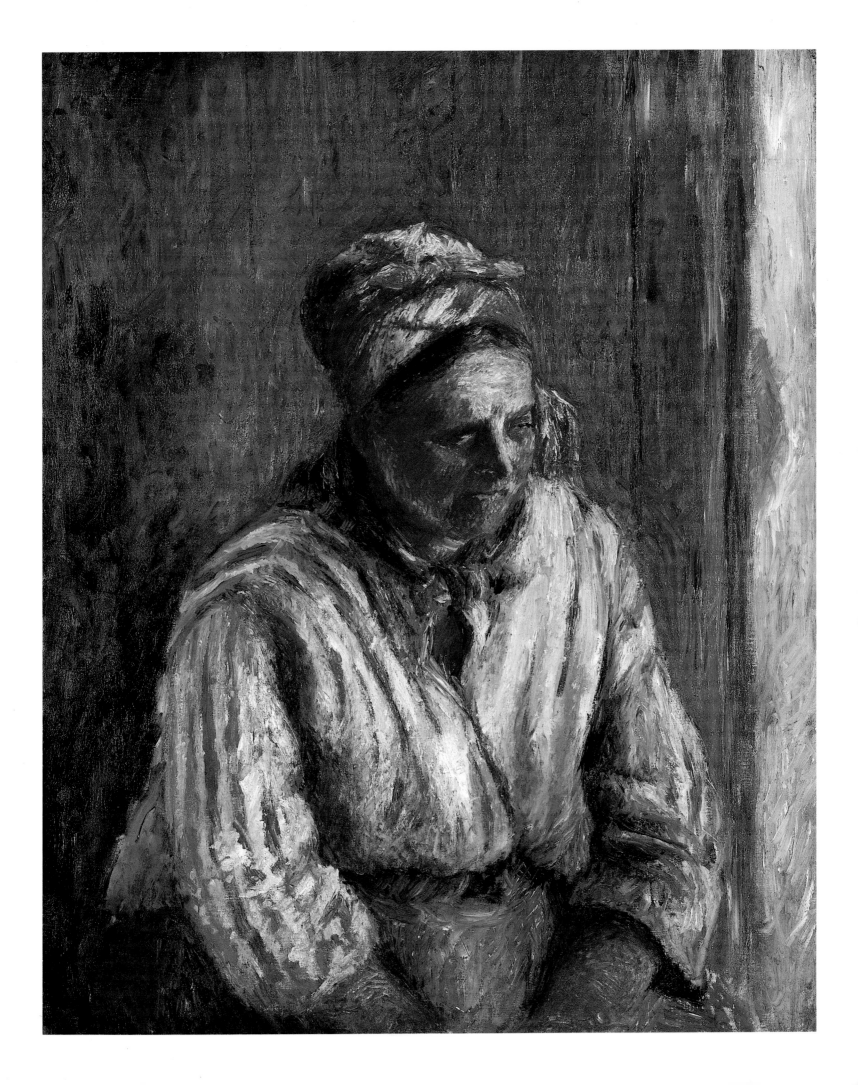

Edouard Manet

M. Pertuiset, Lionhunter 1880–81

Current sensibilities may find it difficult to take seriously Manet's portrait of Eugène Pertuiset. Indeed, it appears almost as much a caricature as its coeval parody in a Parisian satirical journal. As if posing amidst a scene arranged in a photographer's studio, Pertuiset kneels stiffly and self-consciously. Behind him his dead prey could be equally convincing as a stranded leviathan or a taxidermist's accident. The surroundings suggest a Parisian park rather than African grasslands.

The colouring, which has possibly become more subdued through time, appears deliberately anti-naturalistic. Although blue hues frequently render shadows in Impressionist landscape paintings, here the whole environment is suffused with the tonality of a seascape dappled with rosier ripples of light. The painterly handling may enliven the surface, like more familiar Impressionist facture, but the various textures – directional strands, scumblings and smears – have a laboured, rather than spontaneous look.

M. Pertuiset, seen frontally, and his lion are sandwiched between a rising background, observed from a higher vantage point, and a foreground tree trunk, which cuts the surface design into unequal portions. Such compositional devices, familiar in Japanese prints, form two spatial compartments: the left-hand sliver containing the lion's head and the more generous right-hand portion accommodating Pertuiset himself. A drawing of the same motif, probably executed after the painting, suppresses the lower tree trunk and the lion's head, allowing Pertuiset to advance nearer the picture plane. In the painting, Manet's signature and the date appear on the tree trunk as if carved into the bark, not only presenting a witty autograph but also further unsettling the conventional relationships of picture surface and pictorial space.

Eugène Pertuiset, a friend of Manet, was an adventurer, game hunter and occasional painter. A colourful personage and raconteur, he was already a well known figure during the Second Empire. An anecdote related by Manet's friend Antonin Proust describes Pertuiset's failed attempt to present a lion skin to the Emperor, an occasion which may well have lingered in Manet's memory many years later when he came to paint this portrait.

The painting is one of Manet's largest works. Its ambitious scale and the pictorial traditions of the game hunter motif associate it with heroic imagery. Along with its 1881 Salon companion, a portrait of the politician Henri Rochefort, it earned Manet a second class medal. Yet here, aggressive heroism is subject to gentle mockery, and Pertuiset's seriousness deflated like the lion pelt. Probably commissioned by its sitter, it was one of nine paintings by Manet in his collection. One might wonder whether Pertuiset accepted or overlooked its droll qualities.

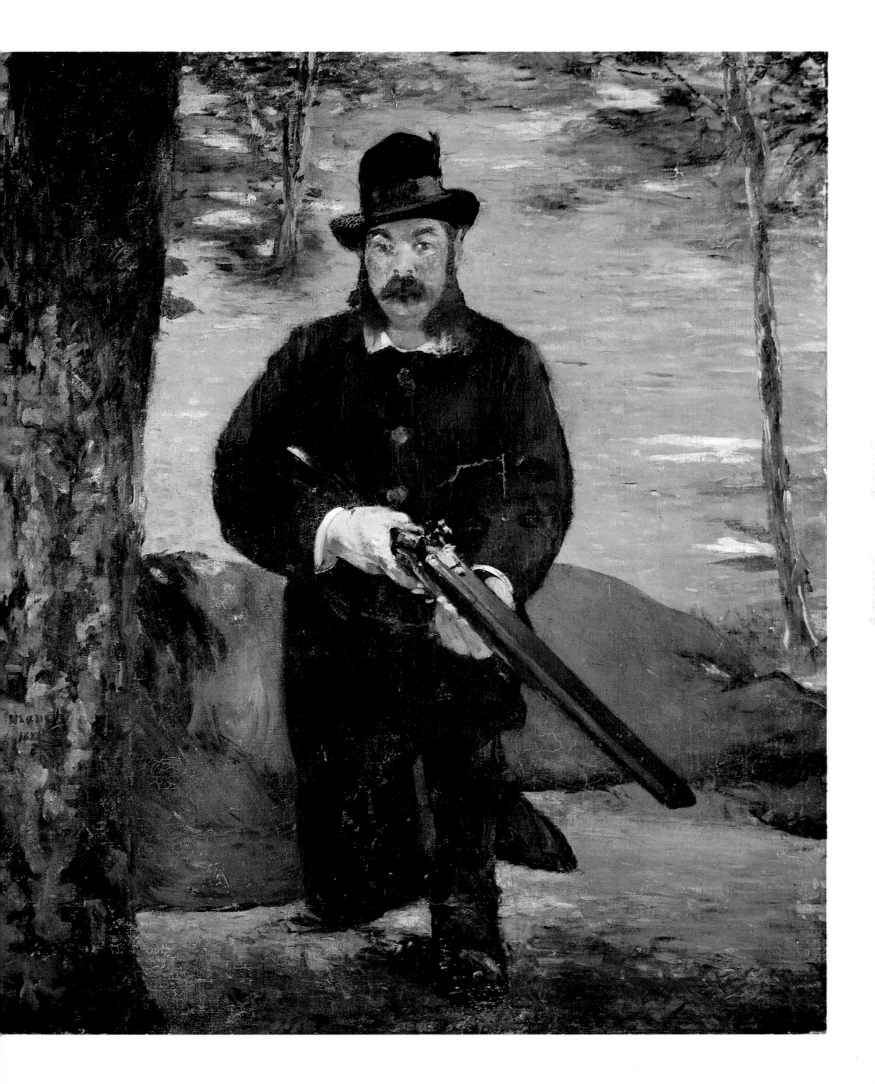

Camille Pissarro

Portrait of Félix Pissarro 1881

Pissarro's son Félix-Camille (1874–97) grew up to continue the family's artistic dynasty and to share his father's anarchist sympathies. Before his untimely death he became a painter, engraver and caricaturist under the pseudonym of Jean Roch, earning posthumous praise from the writer Octave Mirbeau as a gifted, imaginative and original artist. Born in the year of the first Impressionist exhibition, shortly after the death of his sister Jeanne (depicted on p. 85) he was seven years old at the time his father painted this portrait.

Mirbeau remarked upon Félix's 'silent attitude'. Whether or not this behaviour was characteristic of his childhood, he is depicted as subdued. The pose turns him inward, slumped down in the chair, arms folded across his chest. His wide, blue-grey eyes glance sideways from his solemn face. To read in a look of anxiety would be overinterpretation, but this portrait presents a slightly disquieting aspect compared to the more stereotyped images of childhood in Renoir's paintings. Pissarro seems to have broken with idealizing conventions in his portrayal of his own numerous progeny.

Unlike the light-filled, open-air paintings of peasants, which Pissarro was painting concurrently at Pontoise, the hues of this portrait are muted. The diffuse light supplies the bare hint of a shadow in the darkened area behind the chair. Against a softly flecked green wallpaper a dull red tam-o-shanter and the bright pink knot of Félix's neckerchief enliven the brown figure. While a kind of woven, hatched contouring brushes in the tunic, smaller variations of light mauve and olive green model the face. Longer strokes render the texture of Félix's hair. Like the vocabulary of brushstrokes, which are varied descriptively within an overall tactile surface, colour comes across as localized. Although each area contains flecks of colour contrasts, particular hues predominate.

The pose and setting appear deceptively simple, but Pissarro has arranged the curls of the hair, the curve of shoulder and back in a sequence of rhythms against the bentwood of the chair. The spotted wallpaper reinforces the prominence of the eyes. The strands of hair on the left incorporate streaks of the background green, while on the right they approach the reddish colouring of the wood.

Félix, known affectionately to his family as Titi, was encouraged in his artistic vocation by his father before he died of tuberculosis in London at the age of twenty-three. His father's letters commented upon the subtlety and finesse of his work: 'He was an artist!' the elder Pissarro exclaimed after his death.

Claude Monet

Le Père Paul 1882

Monet arrived in Pourville in February 1882, where he stayed at a hotel-restaurant called *A la Renommée des Galettes*. The proprietor Paul Graff (1823–93) was known as Le Père Paul. 'I am at the place of worthy people very happy to have a pensionnaire, who dance attendance on me', wrote Monet. 'The countryside is very beautiful . . . One could not be closer to the sea than I am, on the beach itself, and the waves beat on the foot of the house.' According to Monet Père Paul was 'an excellent chef'; his speciality, *galettes* (griddle cakes), gave the restaurant its name.

Probably in recognition of the Graffs' hospitality, Monet painted Père and Mère Paul's portraits, which the couple came to own. He also made the famous *galettes* the subject of a still-life. The portrait of Père Paul, to which Monet referred a year later as a 'curious sketch', is rendered with loose, sweeping brushstrokes, which thin out towards the lower corners, emphasizing an oval composition. Such an isolation of a bust-length figure was common in Monet's occasional portraiture in the 1880s, not only in the pendant of Mme Graff but also in his own later self-portrait (p. 184). The device concentrates the focus on the head and facial expression.

Père Paul wears the uniform of his trade, his chef's cap flopping slightly to the left, directing the compositional flow down towards the summarily indicated, curving folds of his white jacket. The bristling beard on his face carries a crescent-like swing from his lapels through to the hat. Paul Graff's face crunches and wrinkles with his sixty years, yet his sternly concentrated expression suggests pride and force of character. The downward turned corners of his mouth connect with the beard, which thrusts outwards from his jutting chin. Even his costume seems pervaded with a life of its own.

Strong gestural brushwork scores and models his face and clothing, while contrastingly random marks supply an atmospheric background. The brushstrokes absorb and transform Monet's concern with the effect of light, giving off as well as reflecting illumination. The white of Père Paul's garb against the dark of his beard gives a value contrast while accommodating colour modulation.

The images of Père Paul and his wife belong to the small group of portraits of people outside Monet's intimate circle (see also the portrait of Poly on p. 183) which depict a more stolid, less urban character. In all three works, Monet has kneaded his models' visages into near physiognomic exaggeration. The greater social and personal distance of these sitters perhaps encouraged his youthful beginnings as a caricaturist to re-emerge, yet sympathy overcomes satire, producing an alternative to Pissarro's contemporary dignification of the peasant.

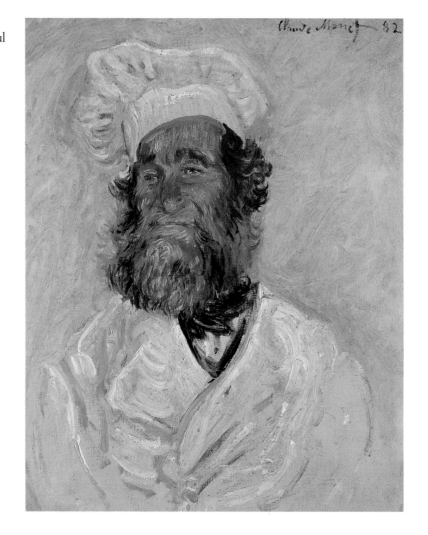

Claude Monet

Mme Paul 1882

Monet's portrait of Mme Paul, Eugénie Graff (d.1891) is a kind of double portrait of owner and dog, a little griffon, which Jean-Pierre Hoschedé (Monet's step-son) remembered as gentle and obliging. In the comparative juxtaposition of their visages it is the dog who regards the viewer, Mme Paul's eyes being deflected to the left.

The mobile flow of brushstrokes serves to model Mme Paul's features and to describe the dog's silken hair. A constriction of the strands of paint just above both button noses binds the facial features into intersecting triangles. Mme Paul's smile contrasts with the dog's more serious expression — a parallel that begs the pathetic fallacy. The flop of the dog's ears and Mme Paul's hat, the dog's curling neck hair and her neckerchief, reinforce the analogy of human and canine appearance.

Rapidly diffusing towards the framing edges of the canvas, Monet's paint application confers an oval format on the bust-length pose. Not only does Mme Paul's figure evaporate in the lower corners, but its artificial truncation is defined by Monet's signature set at an angle below her right shoulder. The axis formed by the nodes of the two heads swings the oval off centre, suggesting a kind of active rotation, a feature that is also present in the circuit of drawn brushstrokes in Paul Graff's portrait. Here, the shorter strands of paint seem to be established by the given motif of the dog's fur.

While the colour of Père Paul's portrait emphasizes the contrasting values of hues, in that of Mme Paul a pervasive blue tonality affiliates the work with Monet's other portraits from the mid 1880s. Wife and husband are also differentiated by their facial expressions, he presenting a sterner concentration, while she exhibits a milder, almost sentimentalized appearance. Such distinctions derive not just from the depiction of appearances but from the traditions of gender portrayal. Whereas Père Paul's image constructs a more individual character, Mme Graff's conforms to a typology of elderly women.

Representations of youth occur frequently in the Impressionist repertoire, but portraits of older women, other than relatives, become almost a special occurrence. Pissarro's *Mère Larchevêque* (p. 162) illustrates his involvement with peasant imagery. Like Cassatt's Mrs Riddle (p.174), a woman of a different social class, Monet's Mère Paul was occasioned by gratitude and friendship. The Graffs had been particularly genial hosts to Monet in 1882. Here, the lively and vital plasticity of the paint transforms the usually more sedate appearance of age.

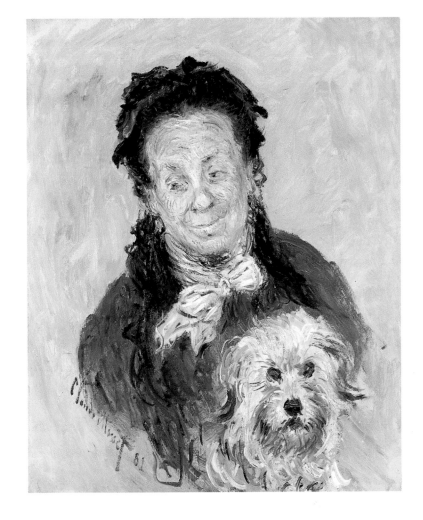

Gustave Caillebotte

Portrait of Henri Cordier 1883

Henri Cordier (1849–1925) bends over a desk piled with papers. It has been suggested that he is correcting proofs of his major work the *Biblioteca Sinica*, published from 1878 to 1895, a bibliographic dictionary of works relative to the Chinese empire; however, the painting itself gives no such clue. During the period of this project Cordier had also embarked on a new project, the *Revue d'Extrême-Orient*. The portrait simply presents Cordier as a writer at work in his study. In this respect it bears comparison with Degas' portrait of Duranty (p. 154), but while Duranty appears isolated in his environment, the figure of Cordier is exposed to a close-up scrutiny.

Cordier had been born to French parents in New Orleans, where his father was a banker, but he was educated in France and spent the years 1867–69 in England. In 1869 he departed for the orient where his father had business connections, and did not return to France until 1876. From 1877 he served as a member of a Chinese Government commission. When the commission ended in 1883, the year of this portrait, Cordier continued to live and travel in Europe. He had begun the first of his prolific writings about the orient in 1873 and recognition of his scholarly achievements came with his election to the Institute in 1908. In addition to his literary efforts, he taught the history, geography and law of the Far East at the Ecole des Langues Orientales.

Caillebotte probably undertook this work out of friendship rather than in response to a commission. The portrait concentrates on an image of the scholar and bibliophile at work, his head, hands and manuscript in clustered proximity. His body, somewhat awkwardly formed and foreshortened, is turned away from the viewer, his head in profile, his eyes lowered to his manuscript. The horizontal format brackets him with his books and writing materials, which closely compact against the figure. Whether or not the interior of his office on the rue de Rivoli was actually so claustrophobic, Cordier's cramped pose accentuates the spatial density, simultaneously suggesting the intensity of his application to his task.

The work is painted loosely with varying degrees of finish. Although browns predominate, their variety participates, along with the red, blue and white pigments, in a range of hue. The dense saturation of colour is contrasted with the startling lightness of Cordier's papers, skin and shirt. Despite the presence of a lamp on the desk, light seems to come from outside the painting, striking evenly across the profile of the eminent Sinologist.

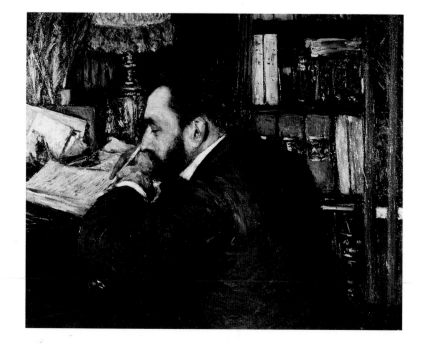

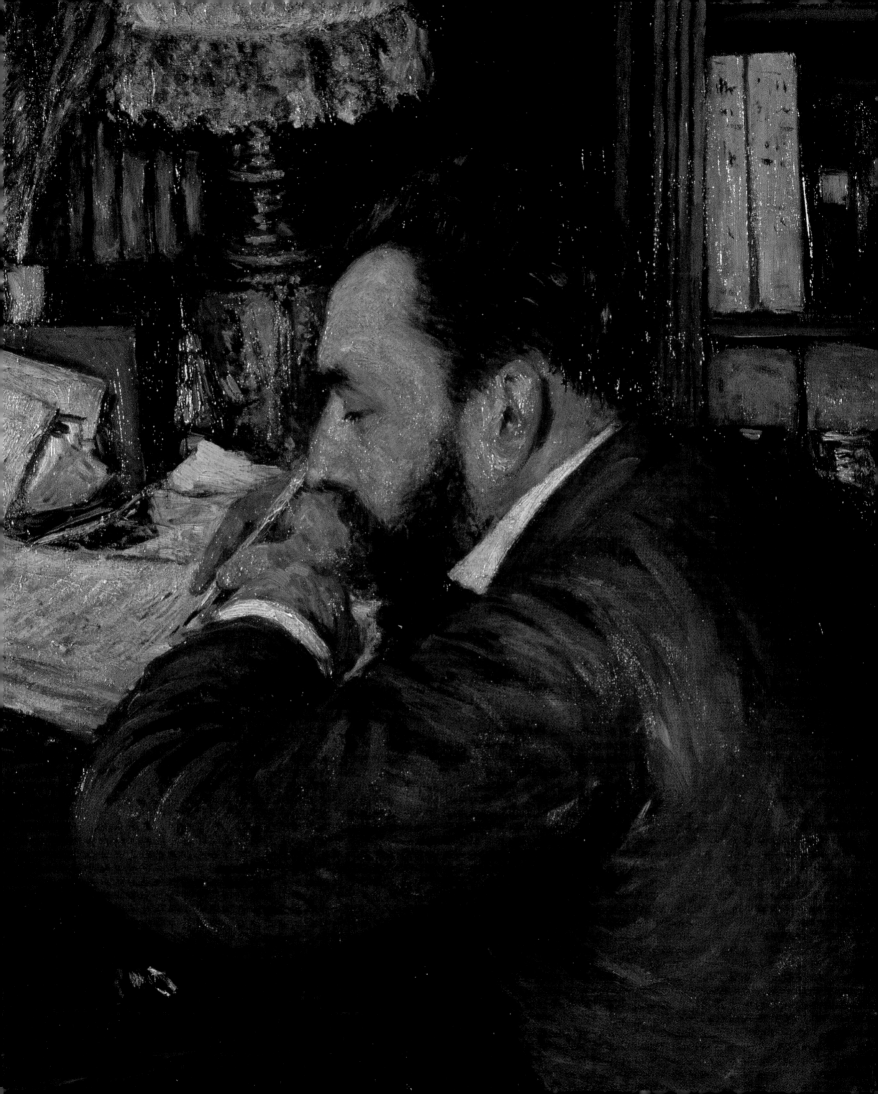

Edgar Degas

Portrait of Mary Cassatt c. 1880–84

Degas and Cassatt met in 1877, though they had known and admired each other's work before their personal introduction. They soon developed a lasting, if occasionally troubled, friendship. Although attempts have been made to impute greater intimacy to their relationship, bachelor and spinster they remained. Their artistic contact, however, became mutually fruitful.

Cassatt posed several times for Degas, even occasionally serving as a model for his more anonymous scenes at the milliner's. Her fashion sense appealed to him, and in this portrait details such as her hat, cuffs and yellow gloves are tellingly brought out. Later in life Cassatt found the work distressing, though perhaps for more personal than pictorial reasons. She wrote to the dealer Durand-Ruel: 'It has some qualities as a work of art but it is so painful and represents me as such a repugnant person that I would not want anyone to know that I posed for it.'

She sits leaning forward in an attitude that recalls Degas' depiction of his father in the double portrait with Pagans (p. 68). Although her facial expression appears introspective, the set of her head and the tension of her posture suggest attentiveness rather than relaxation. The three cards fanned out in her hands may be photographs or small prints; their monochromatic images are too blurred to give more information. Prints of some kind are also distributed on the table to the right, partially overpainted by the reworking of the background.

This painterly white background begins to obliterate the more environmental, furnished space, detaching and silhouetting the figure. Since the painting remains unfinished, its uncharacteristic isolation of the sitter may simply have been preparatory to a spatial restructuring. As it stands, the gestures of the pose bear a concentrated focus. The slant of the head produces an asymmetry of features, and its strongly defined outline warps Cassatt's jaw. The expression of her mouth reads ambiguously, while the intense hue of her eyes contrasts with their blurred depiction. A bright yellow accent provided by the corner of a ribbon behind her head brings out their luminous blue.

Unfurling beneath her chin, the russet bow sets off Cassatt's head continuing the vertical thrust of her thin face. The hiatus of her black gown intervenes between the head and the other focus of concentration – her hands inclining diagonally on her lap.

As in Manet's portrait of Eva Gonzalès (p. 74), contradictions emerge in this image of a professional woman, though here less pointedly. Although Cassatt is depicted as a woman of fashion rather than as a practising painter, the seriousness of her demeanour superimposes no flattery. The images displayed in her hands signal artistic interest, and their juxtaposition with her head associates intellect with taste.

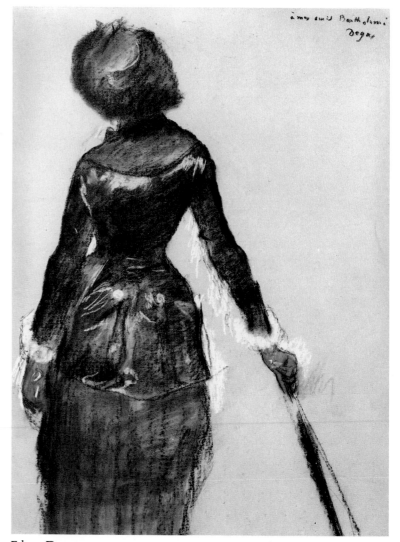

Edgar Degas
Mary Cassatt in the Louvre

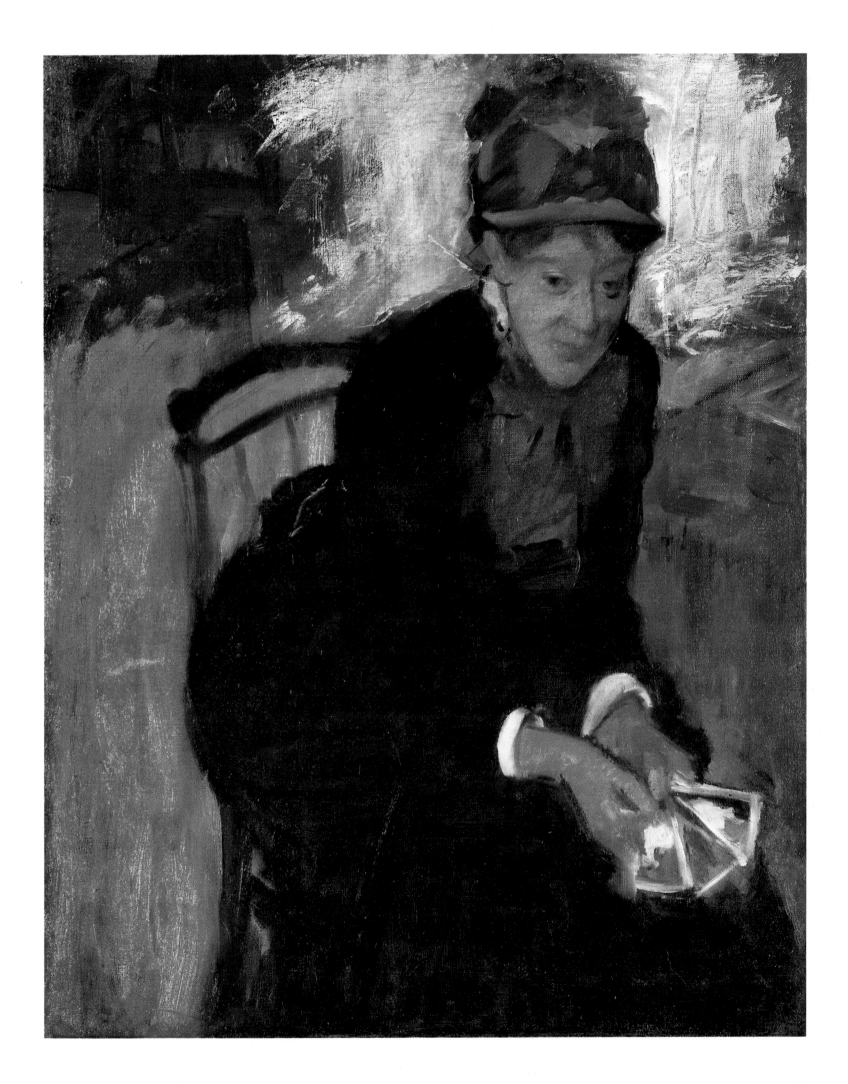

Mary Cassatt

Lady at the Tea Table 1883–85

According to Cassatt's mother, the portrait of Mrs Riddle was undertaken in return for the Riddles' generosity and hospitality to the Cassatt family during a recent visit to England. Mrs Robert Moore Riddle, née Mary Johnston Dickinson, was a cousin of Mrs Cassatt. After two years of work the portrait did not meet with satisfaction from Annie Scott, Mrs Riddle's daughter, who considered the nose to be too large. Cassatt's mother in fact had expressed reservations about the Riddles' taste – 'they are not very artistic in their likes and dislikes of pictures' – but both Degas and the painter Jean-François Raffaelli had praised the portrait's 'distinction', and Mrs Cassatt noted hopefully that 'Annie goes in for that kind of thing'.

Distinguished manners and refined breeding are manifest in Mrs Riddle's erect bearing, her discreetly appropriate black and white attire, and above all in the china tea service. Cassatt referred to it as 'a most lovely *old* Japanese tea and coffee set'. Although the set had been a gift from the Riddles to the Cassatts, it is tempting to call this painting a portrait of tea service and owner. Mrs Riddle has been sandwiched between the china and a gold framed picture close behind. Her rings and poised hand link the teapot and her body, while the lace ribbons of her cap seem to conduct the china blue to her eyes.

Cassatt has produced a portrait of an older woman that is sympathetically perceptive both to the dignity that accords with status and to the material possessions that signify such status to a woman of the upper middle class. Afternoon tea was one of the few social rituals available for a woman of this class within the restricted codes of behaviour. Cassatt's portrait evokes monumental dignity without the flattery, sentiment or picturesque quality so often imposed on the depiction of older women.

The precisely drawn silhouette and the interlocking of the figure with its environment align Cassatt's work with that of her colleague Degas, while the rich blacks and the impastoed flickering figures in the lace, together with the detailed foreground still-life, suggest an affinity with Manet's recently shown *Bar at the Folies-Bergère*, 1881–82. Although the opposition of black and white forms the structure of the composition, cobalt blue and accents of gold shimmer throughout, enlivening the formal austerity. A duller green, seen in the fragment of framed painting behind, escapes to the foremost lower edge in Cassatt's signature.

So disappointed was Cassatt in the portrait's reception by the unappreciative Riddles that she put it away for years. Only in 1914 was it exhibited through the efforts of Mrs Havemeyer, a more discerning American friend (see p. 132).

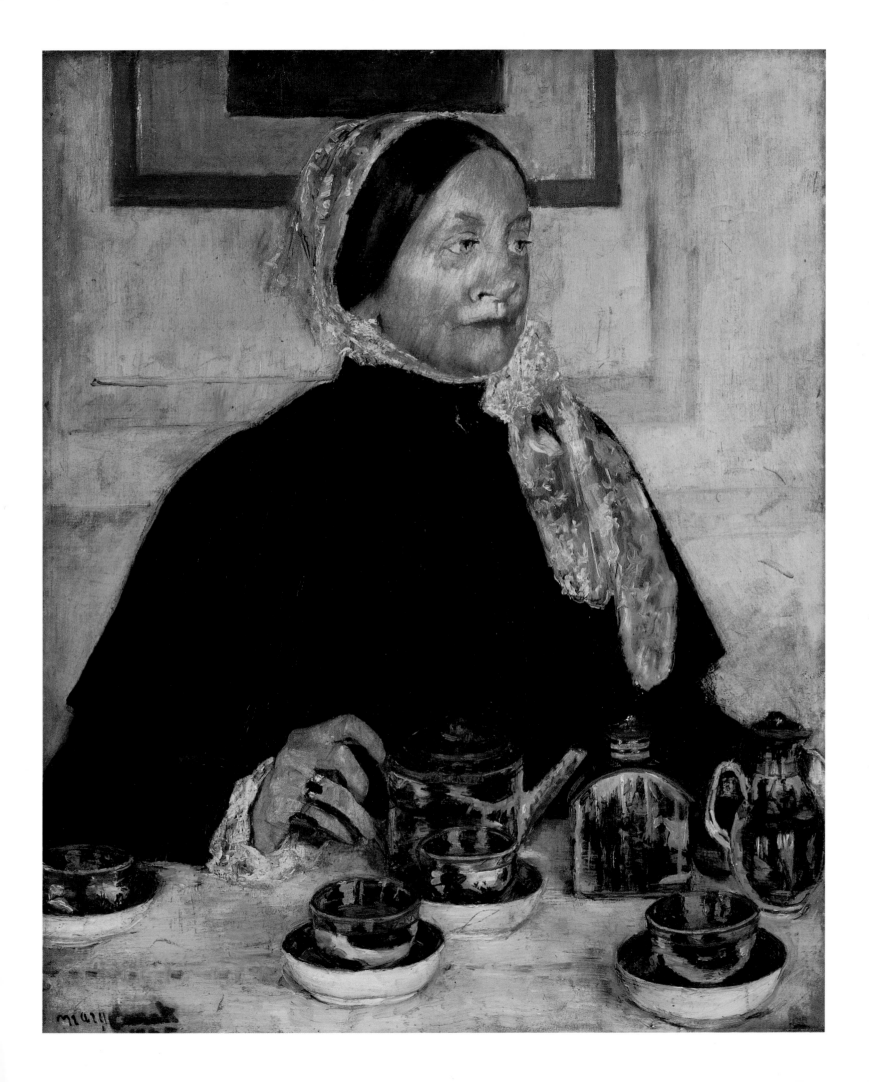

Mary Cassatt

Portrait of Alexander Cassatt and his Son 1884

The tradition of dynastic portraiture depicting fathers and sons hardly surfaces in Impressionist painting. Male portraiture is equally rare in Cassatt's oeuvre. This double portrait is an observant portrayal of the filial bond between Cassatt's brother Alexander Johnston Cassatt (1839–1906) and his son Robert. Alexander's matter of fact announcement to his wife of the sitting is hardly an adequate preparation for the astonishing relationship composed in this painting. 'Mary has commenced portraits of Robert and me together', he wrote, 'Rob sitting on the arm of my chair. I hope it will be a success this time.'

Alexander Cassatt had been a vice president of the Pennsylvania Railroad, but he resigned in 1882, subsequently devoting his time to racehorse stockfarming. He and his son visited Paris late in 1884, and both of them posed separately for several other works done by Cassatt at this time.

Black clothing unites the two figures into a single shape. Robert's hands on his own knee and his father's shoulder reinforce the parallel lines extended in Alexander's arms. Echoes and transpositions of family likeness bond the contiguous faces, their hair merges and their dark eyes are adjusted a fraction out of line. The elder Cassatt's rusty moustache seems a mellowing of his eleven-year-old son's more vibrantly red lips, while his complexion is cast in riper tones against the child's pale skin. Physically symbiotic, the two generations are joined in shared activity, not attending to each other but mutually absorbed in the newspaper.

The summarily sketched, light-washed interior silhouettes the figure group. The floral fabric of the armchair, repeated in the curtains, holds together the foreground and background. Whether because of the chair's comfort or its decorative potential, Cassatt favoured this piece of furniture for several of her sitters (see also p. 133). The table in the background subtly reinforces the rectilinear structuring of the masculine poses. Its ambiguous positioning allows the space to close up onto a surface organization.

Despite the placing of the curtained window behind the heads of the sitters, its potential for a *contre-jour* effect is not exploited. Rather, an even, almost shadowless illumination falls over the two figures and their environment. Modelling does not interrupt the delineation of features or infiltrate the flattened mass of dark bodies.

Although Cassatt concentrated almost single-mindedly on maternal or women's relationships in her group portraits, this painting presents a distinctive image of male kinship and masculine solidarity.

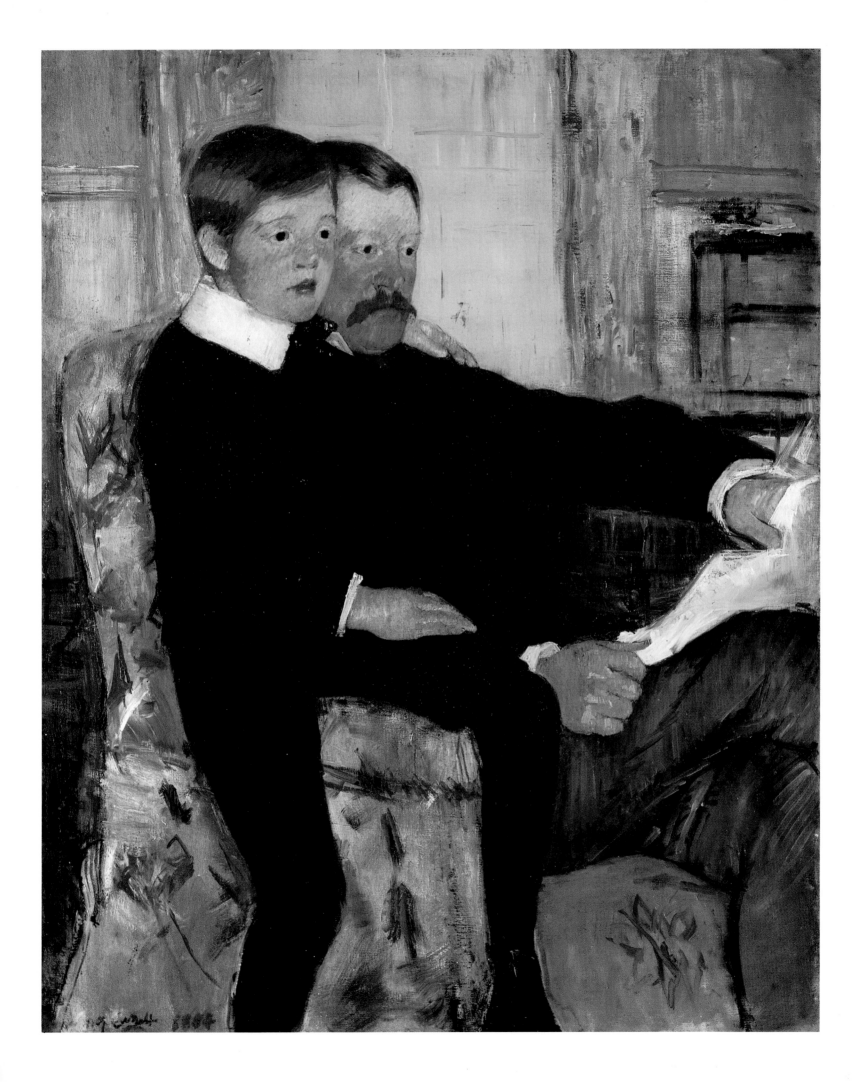

Pierre-Auguste Renoir

Children's Afternoon at Wargemont 1884

Renoir's quiet, studied painting seems to contradict Jacques-Emile Blanche's reminiscence of 'the Berard girls, unruly savages who refused to learn to write or spell, their hair wind-tossed, slip[ping] away into the fields to milk the cows.' Marguerite (aged ten) is absorbed in her book, while Lucie (aged four) patiently holds her doll on the lap of her sister Marthe (aged fourteen), who concentrates on her sewing. During the 1880s Renoir made long visits to the Berard estate at Wargemont near Dieppe and portrayed the Berard children in several paintings.

Paul Berard, a diplomat and banker, became one of Renoir's most important patrons during this period. In 1900, when Renoir was awarded the Légion d'honneur, he requested that Berard make the presentation.

Renoir's depiction of children, particularly little girls, frequently tends towards a chocolate-box sweetness, but here he portrayed the Berard children with a seriousness that amounts almost to severity. The sharp delineation and fresco-like whitened colouring accompany a frieze-like composition. Marguerite lounges in an inclined diagonal, but the other two girls pose in a tightly blocked group. The doll seems to comment on their stylized features and stiffly held postures.

A blue-green scale offsetting a red-yellow range almost bisects the picture into two zones, though contrasting colour accents infiltrate each area, blue spreading more insistently into the warmer, right half. The compositional organization also differentiates the two halves of the painting. In the more spacious left-hand side, recessive diagonals intersect with angles that direct a planar flow. To the right, the denser furnishings, patterns and population set up a scaffold of horizontals and verticals. The even illumination, suppression of shadows and narrowing of colour contrasts, however, unify these oppositions. The creamy paint strokes have an overall consistency, though brushmarks lightly model and texture the surfaces.

A generalization of features, perhaps partly supplied by family resemblance, makes the three girls into types suggestive of stages of maturation. The youngest holds a toy, while the middle child reads. The eldest, distinguished by the colour and style of her dress and by her plaited hair, is an adolescent already practising the domestic task of a woman. The doll on her lap implies future maternity. For the youngest the doll is a plaything designed to develop a gender role; for the eldest it appears as a sign of not quite completed maturation into that role.

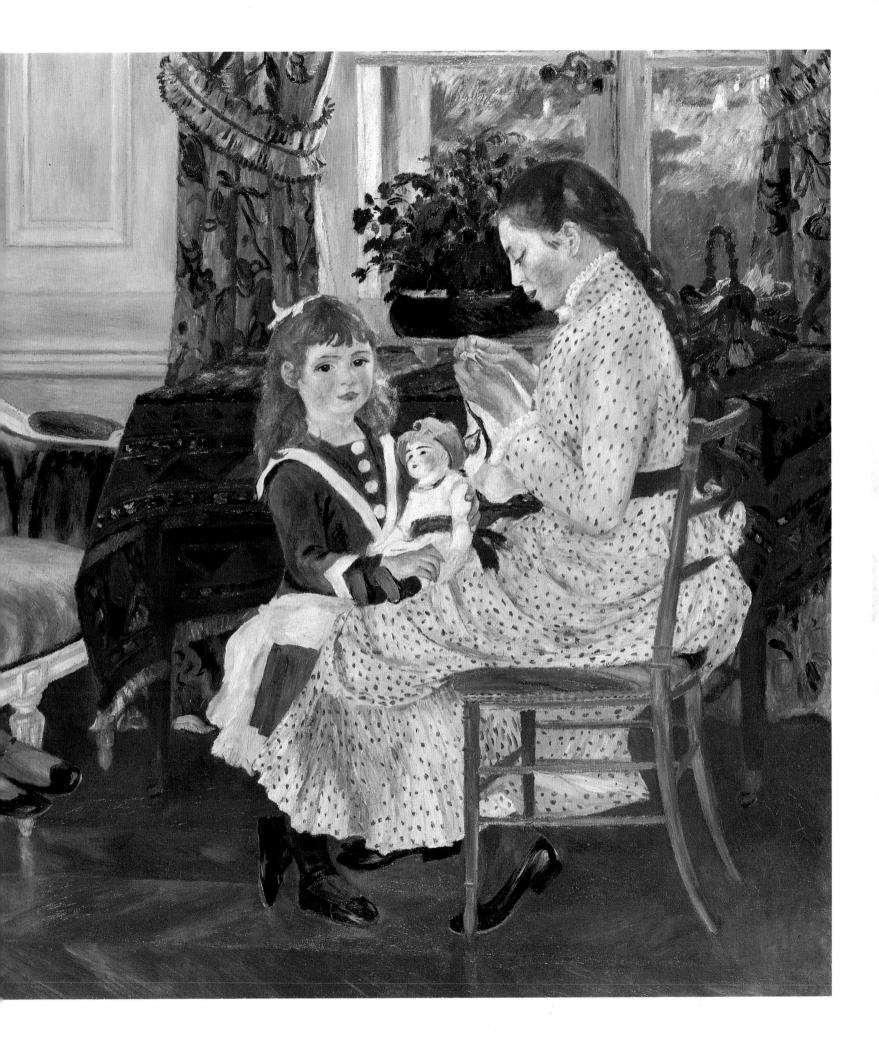

Paul Cézanne

Self-portrait with Palette 1885–87

Among the painters associated with Impressionism Paul Cézanne (1839–1906) portrayed his own features with greatest frequency. Over thirty self-portraits are known. Here, the paraphernalia of his profession actively contribute to the formation of an image of his person.

His easel, displaying the back of a stretched canvas, and his palette set up a barricade whose near rectilinearity acknowledges the framing edges of the painting. Within the compressed space between this foreground and the background Cézanne's figure adjusts to the angular matrix. His palette supplants the concealed elbow and forearm. As if separated from the hand beneath, his thumb – the only part of his body to venture forward – breaks across the indented corner of the palette. Palette, thumb, brushes, and depicted canvas form a sequence which overlaps and breaks sufficiently to ease the slightly inward turn of Cézanne's body.

Cézanne's facial features appear as self-protective as his physical surroundings. His heavy beard bounds his rectangular face, masking his jaw. The direction of his eyes eludes any attempt to read a fixed gaze. Does he look outwards, towards his own reflection in a mirror, does he glance at his canvas, or does the lack of focus suggest detachment from momentary concerns?

Cézanne had last shown with the Impressionists in 1877. Unlike more spontaneous portraits by many of his former colleagues, Cézanne's self-portrait organizes the planes of head and body into facets compounded out of smaller, carefully adjusted strokes of paint. Each facet modulates planar inflections into a sense of bulk independent of illumination from a directional light source. The touches of red and yellow pigment on the palette accent the otherwise restricted range of hue.

Drawing appears to incise the edges of larger planes into the picture's surface, but outlines are frequently broken, opening a passage from one space to another. Drawing, too, delineates echoes between, say, the curve of an ear, the outline of an eye socket and brow, and a curl of unruly hair. Coiling and reversing back upon itself, a linear script imposes a Baroque-like scroll onto the facial features.

Cézanne, the son of a banker in Aix-en-Provence, had been destined by his father to study law. His commitment to painting brought about one of several clashes with parental authority. In 1861, joining his friend the aspiring novelist and critic Emile Zola in Paris, he entered the Académie Suisse, an open studio for life drawing. At Suisse's he met Pissarro and Guillaumin. Discouragement and retreats to Aix followed his first Paris venture, but his father's sparingly allocated support enabled him to persevere. His thickly impastoed early paintings, often depicting violent subjects, awkwardly executed, display a tension between Romantic, dramatic emotionalism and a more Courbet-like dogged Realism.

In 1872 he joined Pissarro in Pontoise. The friendship and close artistic association brought about a freshening of his palette and a more obvious imposition of order upon his pictorial composition. Through Pissarro's advocacy Cézanne was included in the first Impressionist exhibition of 1874, but he showed only once more, three years later.

Paul Cézanne
Self-Portrait and Apple

The events of Cézanne's personal life in the mid 1880s contrast in their turbulence with the deliberate structuring of this self-portrait. Suggestions of a mysterious romantic attachment are hinted at in his correspondence with Zola in 1885. In the spring of 1886, at last with parental approval, he married Hortense Fiquet, mother of his fourteen-year-old son Paul. His father died that autumn, leaving him with a considerable fortune. That year also saw the publication of Zola's novel *L'Oeuvre*, which precipitated a rupture of the long personal and artistic relationship between the writer and painter.

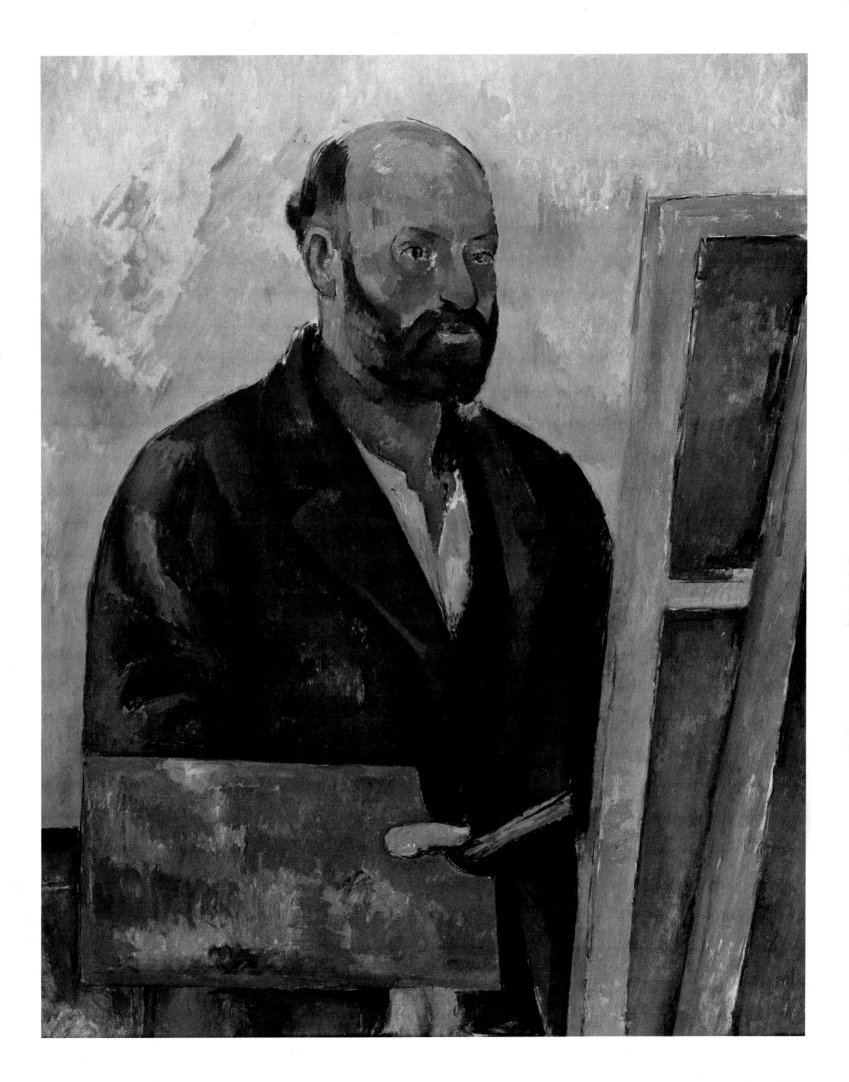

Claude Monet

Portrait of Poly, Fisherman at Belle-Isle 1886

Monet spent several months in the autumn of 1886 at Belle-Isle, off the Breton coast. It is intriguing to note that at the moment of his growing reputation he painted both his own self-portrait in artisan's clothing (p.184) and this portrait of a local fisherman. Rarely did he depict peasant types, and portraiture as a whole became an increasingly rare motif for him in the 1880s.

The fisherman, known as Poly, is depicted in the same palette of blues as the self-portrait. Perhaps the hue of the clothing serves to bring out the similarity, but also in both works a lighter keyed blue infuses the amorphous background. Both figures are crowned with a hat, and both turn slightly to the right.

Poly, however, sits in a chair, his body inclined at ease against the chair back, his head cocked alertly. Only the brim of his hat lightly shades his ruddy complexion. He gazes intently at the viewer with a lopsided expression, pulling his lips. The face variously lends itself to ambiguous readings of amusement, pride, ironic detachment and weariness, perhaps not incompatible expressions for a fisherman discovering himself in the role of artist's model.

Separate strokes of red, contrasting with green round the eyes, model the face. The beard flares out in longer strands of darkened green, purple and blue, while choppier marks pick up the same hues in the eyebrows. The varied brushwork lends liveliness to his visage. The viewpoint, from below eye-level, emphasizes Poly's nearly circular eye sockets hooded by partly lowered lids, which impart a quizzical expression. The sympathetic depiction and the enigmatic characterization only just preserve the image from caricature.

Textural variety enlivens the entire surface of the painting. The blue sweater seems knit in a crisscross hatching with flecks of mauve and orange borrowed from Poly's face and background. Less regular dabs of paint scuffle in the background, which varies subtly from a pale lavender tinge on the left to a dense green shading on the right. A mauve halation silhouettes Poly's left arm. Parallel, ordered brushmarks compound the shape of the hat, while the neckerchief is drawn in a more plastic pull of paint. Although textured all over, the paint application divides into local areas which are allocated particular graphic marks.

This vitality of pictorial handwriting asserts itself more prominently than in Monet's contemporary self-portrait. Without exactly imposing a personality on Poly, it contributes to an image of a weathered and lively individual.

Claude Monet

Self-portrait 1886

It was in 1886 that the last Impressionist exhibition took place.
Claude-Oscar Monet (1840–1926), whose work has often been
taken as a paradigm of Impressionism, did not exhibit with his
colleagues in their final group show, possibly registering his protest
over the inclusion of the pointillist Seurat. His work was selling at
relatively high prices, but rather than presenting an image of
material success, he depicted himself in his familar blue painter's
jacket and beret.

The son of a shopkeeper in Le Havre, Monet became well known
locally as a caricaturist while still in his teens. Despite this early
inclination, his painting came to focus on landscape, with fewer and
fewer portraits in later life. Like several of his Impressionist
colleagues, he worked at the Académie Suisse and in the studio of
Gleyre in the early 1860s. Early Salon success was followed by
rejection, and he withdrew from the offical system, apart from a
single entry in 1880. It was his *Impression, Sunrise*, 1873, singled
out by a critic at the first Impressionist exhibition, that baptized the
somewhat unwieldily titled Société anonyme des artistes peintres,
sculpteurs, graveurs with the name that adhered. By 1883 he had
moved to his final home at Giverny, but he continued to travel
fairly extensively – in the year of this self-portrait journeying to
Haarlem and working at Belle-Isle. At this time his work also
gained an international showing, both in Brussels and New York.

Following a trip to the Mediterranean in 1884, his landscape
palette had taken on a more iridescent colour. In this self-portrait
the greater, shadowed portion of his skin flickers with carmine red
and mauve, while the beard and clothing pick up traces of lime and
avocado green, modulating the painting's overall blue key.
Although this standard head-and-shoulders format does not include
brushes or other obvious emblems of a painter, his painting attire
signals his profession, and his intently staring eyes produce an
image of concentration familiar in artists' self-portraits.

The paint surface thins to bare canvas in the corners below his
shoulders, and the deeper blue aura surrounding his head reinforces
the central focus of the painted image. Its halo effect should not be
overlooked. Earlier nineteenth century bohemianism had done much
to establish a romanticization of the martyrdoms suffered in the
cause of artistic dedication, and many of Monet's contemporaries
portrayed themselves with such saintly vestiges. Despite the
justification of Monet's complaints of poverty in his early career, his
life-style did not accord with destitution.

This rare depiction of his own visage came at a time when
Monet had already gained a measure of financial success. In such
circumstances, the apparently ingenuous, straightforward self-
presentation belies a careful construction of an artistic persona.

Edouard Manet
Portrait of Claude Monet

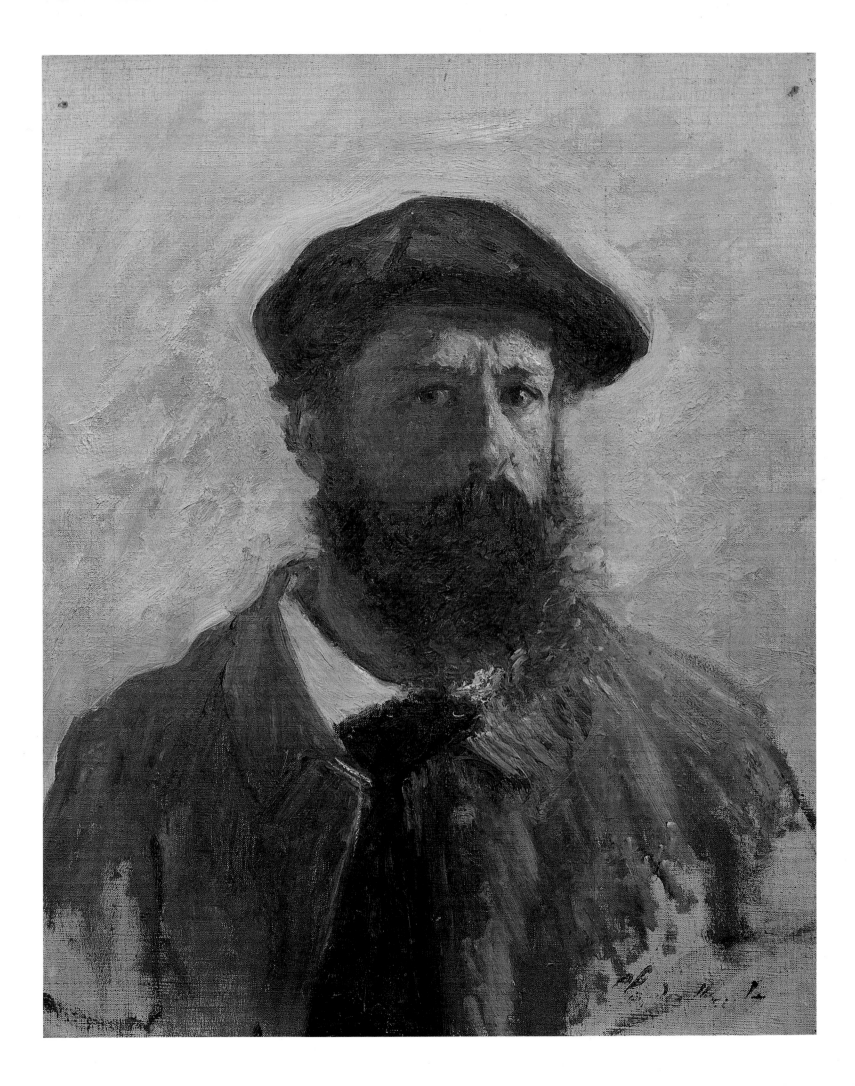

Gustave Caillebotte

Le Père Magloire Stretched Out in a Wood 1884

For many years this painting was assumed to be a portrait of Caillebotte's fellow Impressionist Monet. The fashion for beards does not assist the identification of male sitters, especially in the case of small scale figures, a problem multiplied in Bazille's painting of his studio (p.72). Caillebotte and Monet both worked in Etretat in the summer of 1884, and possibly the blue blouse adopted by Monet for his painter's uniform encouraged the attribution of this model to Monet.

Recently, the depicted person has acquired a more plausible identity as Magloire Paulin (1850–*c.* 1915). Known as Père Magloire, he was a gardener at Etretat. Caillebotte included him wearing his blue smock and cap in several other paintings of Etretat.

Etretat was a favourite landscape site for a number of the Impressionists. Caillebotte normally preferred to stay in the environs of Paris, but he visited Normandy during the early 1880s for the cruises of the yacht club Cercle de la Voile de Paris. Paintings executed in Etretat in the summer of 1884 mark his return to motifs of the figure set in the open air after a lapse of several years.

A long tradition of figures reclining in landscapes precedes this portrait. While the female figure, usually presented nude, affirms an identification with nature, male figures, more often clothed, suggest an attitude of contemplation, melancholy or reverie.

Père Magloire stretches out diagonally, his body intersecting the shadows of the trees and countering their direction; they fall forward while Magloire's body inclines into the painting's depth. The *contre-jour* effect and the foreshortening of his figure consolidate his shadowed shape, while the loosely hanging smock obscures the articulation of his body. The high horizon adds spatial ambiguity, suggesting both a grassy slope and a raised viewpoint. The conflicting readings and the stress on the pattern of trees and shadows collapse the space of the landscape against the relatively small foreground figure.

Père Magloire's blue smock contrasts with the yellowed grass, seemingly burned by the light. His shadowed face brings a spot of ruddiness to the centre of the composition.

Despite the apparently simple pretext of the motif, the painting remains slightly puzzling. Nature may be an appropriate environment for a gardener, but these surroundings show little evidence of a gardener's labour. The relationship between this man who domesticates nature and nature itself is proposed as one of intervention, contrast and counterpoint.

Edgar Degas

Portrait of Mlle Hélène Rouart 1886

Degas had earlier portrayed Hélène Rouart as a child seated on her father Henri's lap. Now a young woman, she appears confined within the ambience of his art collection and furnishings, his overwhelming presence implied in the vacant large armchair. Degas had become close to his former schoolfellow Henri Rouart after their reacquaintance during the Franco-Prussian War, and he had begun a series of portraits of the entire Rouart family, a project left incomplete after the death of Mme Rouart in 1886 (see also p. 126).

This portrait of Hélène also remains unfinished, although its evidence of rethinking was hardly unusual for Degas. The ground colour of the canvas shows through the thinly applied paint, while incisive delineations rework Hélène's pose.

The cool blue of her dress contrasts with the dominant, warm tonality produced by the golds, rose pinks and terra cottas. Inspired by Hélène's striking Titian hair and colouring, Degas had once expressed a desire to begin a portrait of her in Venice.

Henri Rouart's collection assembled works of ancient art, old masters and modern painting from Corot to the Impressionists. Three wooden Egyptian funerary statues stand in a case to the left, and part of a Chinese Ch'ing silk hanging forms the upper border of the painting. On the right hangs Corot's seascape of *Naples and the Castello dell'Ovo*. The pose in several earlier sketches of Hélène devolves from a Hellenistic Tanagra figurine, likening her to yet another object in the Rouart collection. Given the fact that most works of art depicted in Degas' paintings are unidentifiable or appear to have been invented, it is tempting to speculate on the significance of these objects specifically selected from Rouart's vast collection.

In 1886 her mother died and Hélène married the engineer Eugène Marin. The year must have been an emotionally turbulent time for the twenty-three-year-old woman. The unevenness of her features imparts ambiguity to Hélène Rouart's withdrawn expression. The more distant eye seems larger and without a pupil, and the farther corner of her mouth inclines downwards. Even the hands seem mismatched. The chair conceals one thumb, and the little finger on her right hand disappears.

Degas often constructed the personality of the sitter through the environment. He also depicted girls and young women with sympathetic penetration but without flattery. The claustrophobically confining space and the enigmatic expression on Hélène's face bring out the circumscribed conditions of a middle-class woman's life, in which convention accorded her the status of commodity rather than of an assertive personality.

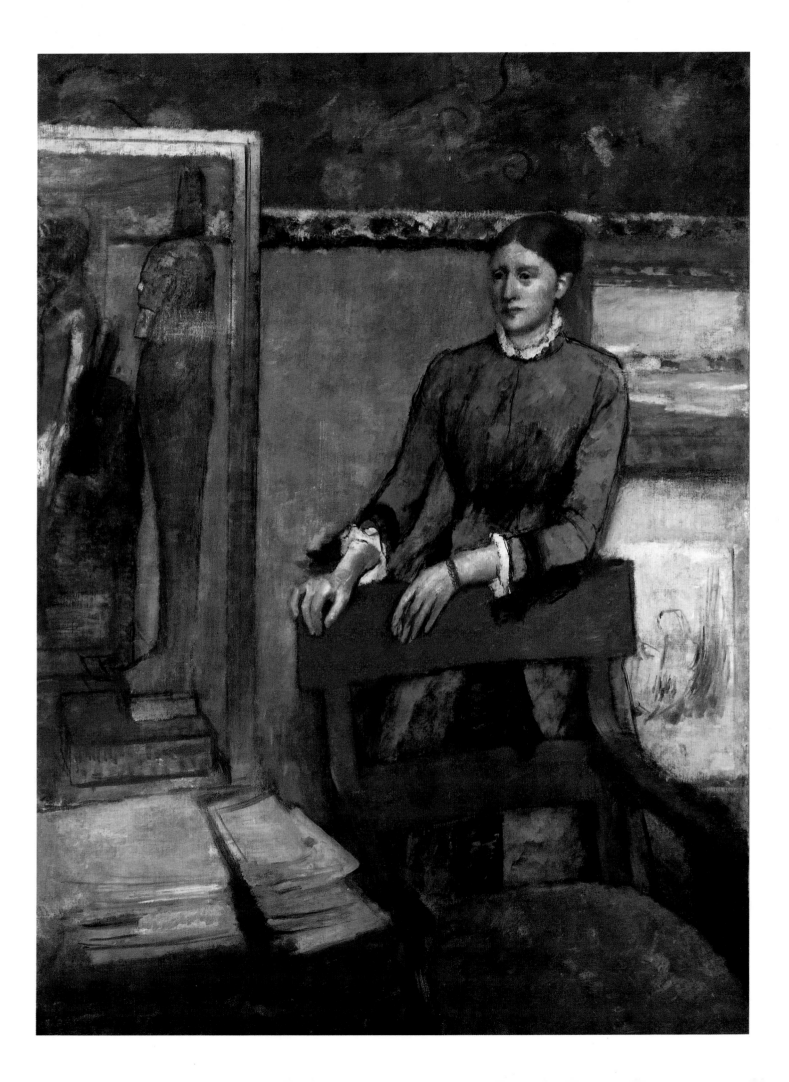

Paul Gauguin

Clovis 1886

In June 1885 Gauguin parted from his wife and four of his five children in Copenhagen, the home of Mme Gauguin, and returned to Paris with his son Clovis. Clovis was the third child of Paul and Mette Gauguin, born in 1879 while his father was still an amateur painter. Both father and son suffered hardship in the spring of 1886. Clovis fell seriously ill, and Gauguin was forced to take a job as a bill poster to support the two of them. Even so, he managed to exhibit nineteen paintings and a wood relief in the final Impressionist show in May-June of that year. Leaving Clovis in a pension, Gauguin departed for Pont-Aven in Brittany during the summer.

Clovis, about six or seven years old at the time of this portrait, clutches a book that seems overwhelmingly large for his childish figure. His hands, one turned down and the other up, grip the book's edges to support its weight. His wan face looks up from his reading. His large eyes, turned in awareness towards the viewer, his flattened nose and his mouth twisted upwards as if in an effort to smile, impart a melancholic, almost Pierrot-like expression to his features, emphasized by his close cropped cap of hair.

His body turns at an angle against the horizontal back of the chair, while the book, whose illuminated edge forms a right-angled V, thusts inwards, tightly confining his body. Part of a handle or fastening on the cupboard to the right juts inward arrestingly towards the intersection of the book and his leg. A basket of flowers on top of this piece of furniture completes the simple interior decoration. The bulbous blooms contrast with Clovis's hollowed cheek shaded into his angular face, against which his ear sticks out like a flange.

While descriptive of Clovis's appearance, naturalism gives way to a stylization weighted towards the evocation of a less tangible statement. Colour has been simplified into local hues. The reduction of modelling turns shading into shape, as on the page of the book, or into a significant patch, as in the telling darkening along Clovis's cheek and jaw. Even the fruit-like forms of the flowers and the half-cross of the furniture attachment seem loaded signs, although they elude precise meaning.

The brushwork still retains the vestigial brokenness of Impressionist facture, even while the composition adopts a more static construction. Only Clovis's right eyelid, blurred as if capturing a blink, hints at the passing moment.

As in Pissarro's portraits of his children (pp. 84, 166), as well as some of Monet's depictions of his son Jean (p. 100), Gauguin's portrait of Clovis brings out solemnity and troubled care in the image of childhood.

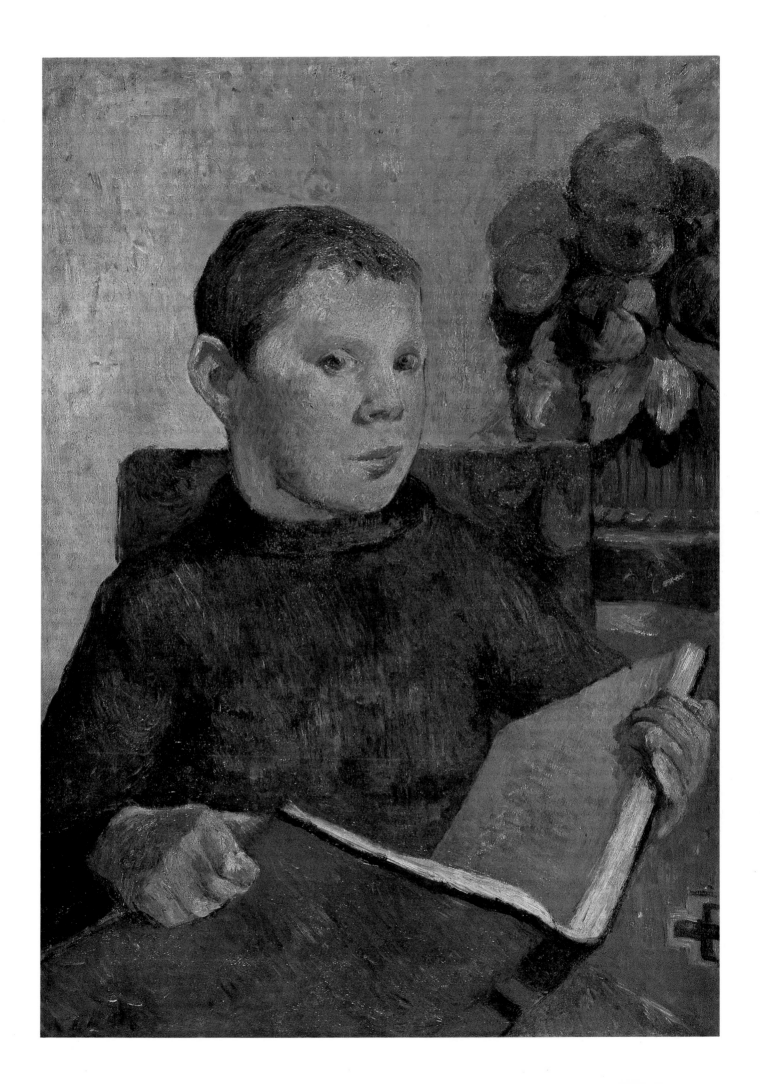

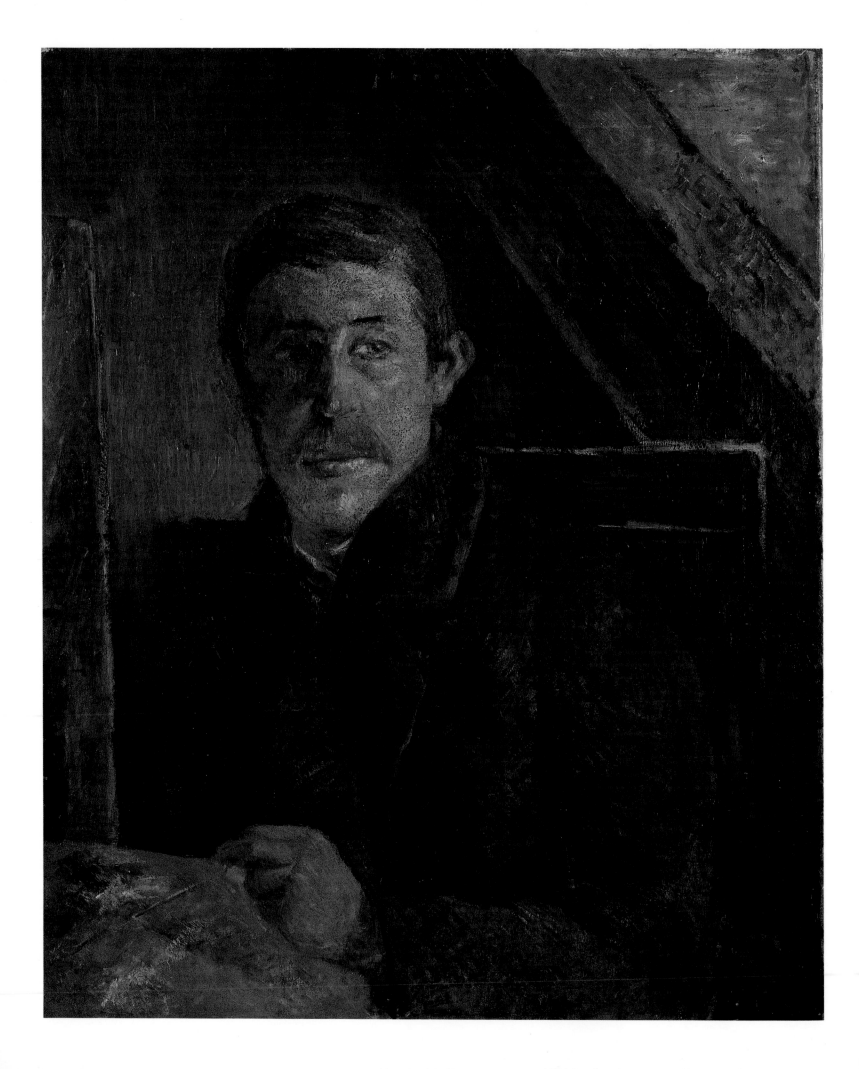

Paul Gauguin

Self-portrait in Front of an Easel 1883/1884–85

Paul Gauguin (1843–1903) is more commonly associated with the Post-Impressionist generation, but he participated in the Impressionist exhibition of 1879 and all the four subsequent exhibitions. His first profession had been banking and stockbroking, which had enabled him to build up a collection of Impressionist paintings. Even as an amateur painter Gauguin had seen one of his landscapes accepted to the 1876 Salon, but, committing himself to a more independent stance in the later 1870s and early 1880s, he worked alongside Pissarro and Cézanne. The financial slump of 1883 triggered Gauguin's change of life-style. Having left his job on the stock exchange, he began to devote himself full time to his painting.

Although the date of this self-portrait is not securely established, it proclaims a self-image as an artist. The eyes are swivelled in intense focus, and the lines of the full lips set his mouth in an expression of concentration. He is seated at his easel holding his painter's tools, the somewhat ambiguous conjunction of left hand, palette and brush suggesting a mirror image. The artist's implements on the left and the chair back to the right tightly box in his figure. The rear wall, just revealing a propped-up canvas behind his shoulder, compresses the space to a shallow slice, which presses forward against the frontal border of his arm and tilted palette. The diagonal rafters, cutting off the upper right-hand corner, evoke the romantic image of an artist's garret, with light entering from a skylight or dormer window.

The self-confidence of Gauguin's visage may support the proposals for the earlier date of the painting, before financial difficulties became apparent; however, the environment evokes the Copenhagen attic allocated to Gauguin by his in-laws during his 1884–85 residence there. In an attempt to reduce his expenditures he briefly moved to his wife's home, working as the Scandinavian representative of a French canvas manufacturer.

The brushmarks, differentiated into separately textured surfaces, share the Impressionists' broken touch. The flecked colour, particularly the alliance of blues, oranges and yellows in the stretcher, palette and skin, likewise manifest an Impressionist concern with the vibrancy of light-dappled surfaces. Hindsight makes the compartmentalization of surface pattern, the thick line edging his jacket, and the weighty hues seem a foretaste of his later Breton work.

Gauguin's later self-portraits construct a more symbolically loaded artistic and personal image. Here, observation prevails, although appearance already is charged with evocative resonance.

Bibliography

Ambre, Emilie, *Une diva*, Paris, 1885.

Berhaut, Marie, *Caillebotte: sa vie et son oeuvre. Catalogue raisonné des peintures et pastels*, Paris, 1978.

Boggs, Jean Sutherland, *Portraits by Degas*, Berkeley and Los Angeles, 1962.

Boston, Museum of Fine Arts, *Monet Unveiled: a New Look at Boston's Paintings*, cat. by Alexandra Murphy, Lucretia Giese, Elizabeth Jones, Boston, 1977.

Breeskin, Adelyn D., *Mary Cassatt: a Catalogue Raisonné of the Oils, Pastels, Watercolours, and Drawings*, Washington, 1970.

Brettell, Richard R., and Suzanne Folds McCullagh, *Degas in the Art Institute of Chicago*, New York, 1984.

Cabanne, Pierre, *Edgar Degas*, trans. Michel Lee Landau, Paris and New York, 1958.

Callen, Anthea, *Techniques of the Impressionists*, London, 1982.

Chicago, Art Institute, *Frédéric Bazille and Early Impressionism*, cat. by J. Patrice Marandel and Francois Daulte, Chicago, 1978.

Clark, T.J., *The Painting of Modern Life: Paris in the Art of Manet and His Followers*, London, New York, 1984.

Daulte, François, *Frédéric Bazille et son temps*, Geneva, 1952.

——, *Auguste Renoir: Catalogue Raisonné de l'oeuvre peint. I, Figures, 1860–1890*, Lausanne, 1971.

Dunlop, Ian, *Degas*, London, New York, 1979.

Edinburgh, Edinburgh International Festival, *Degas 1879*, cat. by Ronald Pickvance, Edinburgh, 1979.

Goldwater, Robert, *Gauguin*, New York, 1984, London, 1985.

Gordon, Dillian, *Edgar Degas: Hélène Rouart in Her Father's Study*, London, 1984.

Gordon, Robert, and Andrew Forge, *Monet*, New York, 1983.

Grey, Christopher, *Armand Guillaumin*, Chester (CT), 1972.

Guérin, Marcel (ed.), *Degas Letters*, Oxford, 1947, Santa Monica (CA).

Houston, Museum of Fine Arts, *Gustave Caillebotte, a Retrospective Exhibition*, cat. by J. Kirk Varnedoe and Thomas P. Lee, Houston, 1976.

Isaacson, Joel, *Observation and Reflection: Claude Monet*, Oxford, 1978.

London, Hayward Gallery, Arts Council of Great Britain, *Pissarro*, cat. by John Rewald, Richard Brettell, Françoise Cachin, Janine Bailly-Herzberg, Christopher Lloyd, Anne Distel, Barbara Stern Shapiro and Martha Ward, London, 1980.

——, *Renoir*, cat. by John House, Anne Distel, Lawrence Gowing, London, 1985.

London, National Gallery, *Manet at Work*, cat. by Michael Wilson, London, 1983.

Matthews, Nancy Mowll (ed.), *Cassatt and Her Circle: Selected Letters*, New York, 1984.

Mayne, Jonathan, *Degas' Ballet Scene from 'Robert le Diable'*, London, 1969, Boston, 1984.

McMullen, Roy, *Degas: His Life, Times and Work*, London, 1985.

Paris, Bibliothèque Nationale, Théâtre National de L'Opéra de Paris, Association pour le Rayonnement de L'Opéra de Paris, *Robert Le Diable*, cat. by Martine Kahane, Paris, 1985.

Paris, Grand Palais, *Centenaire de l'impressionnisme*, cat. by René Huyghe, Hélène Adhémar, Anthony M. Clark, Anne Dayez, Michel Hoog and Charles Moffett, Paris, 1974.

——, *Hommage à Claude Monet (1840–1926)*, cat. by Hélène Adhémar, André Masson, Gaston Bachelard, Michel Hoog, Anne Distel and Sylvie Gache, Paris, 1980.

——, *Manet 1832–1883*, cat. by Françoise Cachin, Charles S. Moffett, Michel Melot, Juliet Wilson Bareau, Paris, New York, 1983, London, 1984.

Paris, Orangerie des Tuileries, *Degas: Oeuvres du Musée du Louvre, peintures, pastels, dessins, sculptures*, cat. by H. Adhémar, Michèle Oliver and Geneviève Monnier, Paris, 1969.

Philadelphia, Philadelphia Museum of Art, *Edouard Manet 1832–1883*, cat. by Anne Coffin Hanson, Philadelphia, 1966.

Pollock, Griselda, *Mary Cassatt*, London, New York, 1980.

Reff, Theodore, *Degas: The Artist's Mind*, London, New York, 1976.

——, *Manet and Modern Paris*, Chicago and London, 1982.

——, 'Pissarro's Portrait of Cézanne', *Burlington Magazine*, CIX, 776, London, 1967, pp. 627–33.

Rewald, John, *Camille Pissarro*, London, New York, 1963.

—— (ed.), *Paul Cézanne: Letters*, Oxford, 1976, New York, 1984.

—— (ed.), *Camille Pissarro, Letters to his Son Lucien*, London and Henley, 1980, Layton (UT), 1981.

——, *The History of Impressionism*, London, New York, 1980.

Rome, Accademia di Francia a Roma, *Degas e L'Italia*, cat. by Henri Loyrette, Rome, 1984.

Rouart, Denis (ed.), *The Correspondence of Berthe Morisot with Her Family and Her Friends*, trans. Betty W. Hubbard, London, 1959.

——, and Daniel Wildenstein, *Edouard Manet: Catalogue Raisonné*, 2 vols, Lausanne and Paris, 1975.

Schapiro, Meyer, *Paul Cézanne*, London, New York, 1953.

Serret, G., and D. Fabiani, *Armand Guillaumin 1841–1927*, Paris, 1971.

Tucker, Paul Hayes, *Monet at Argenteuil*, New Haven and London, 1982.

Washington, National Gallery of Art, *Mary Cassatt 1844–1926*, cat. by Adelyn D. Breeskin, Washington, 1970.

White, Barbara Ehrlich, *Renoir: His Life, Art, and Letters*, New York, 1984.

Wildenstein, Daniel, *Claude Monet: biographie et catalogue raisonné*, vol. I: 1840–81, Lausanne and Paris, 1974.

Wildenstein, Georges, *Gauguin*, Paris, 1964.

List of Illustrations

Ballet Scene from 'Robert le Diable', 1876
Oil on canvas, $29\frac{1}{2} \times 32$ (74.9 × 81.3)
Victoria and Albert Museum, London. 123

L'Absinthe, 1876
Oil on canvas, $36\frac{1}{4} \times 26\frac{3}{4}$ (92 × 68)
Musée d'Orsay, Paris (Galeries du Jeu de
Paume). Photo Giraudon. 20

Henri Rouart in front of his Factory, c. 1877
Oil on canvas, $25\frac{5}{8} \times 19\frac{5}{8}$ (65 × 50.4)
Museum of Art, Carnegie Institute, Pittsburgh
(acquired through the generosity of the Sarah
Mellon Scaife Family). 127

Study for Singer with Glove
Charcoal with white highlights on grey paper,
$18\frac{3}{4} \times 12\frac{1}{4}$ (47.5 × 31)
Musée du Louvre, Paris (Cabinet des
Dessins). 142

Singer with Glove, 1878
Pastel and liquid medium on canvas, $21 \times 16\frac{1}{4}$
(52.8 × 41.3)
Courtesy of the Harvard University Art
Museums, the Fogg Art Museum (Bequest:
Collection of Maurice Wertheim, Class of
1906). 143

The Stock Exchange, c. 1879
Oil on canvas, $39\frac{1}{2} \times 32\frac{1}{4}$ (100.3 × 81.9)
Musée d'Orsay, Paris (Galeries du Jeu de
Paume). Photo Giraudon. 8

Mlle La La at the Cirque Fernando, Paris, 1879
Oil on canvas, $46 \times 30\frac{1}{2}$ (117 × 77.5)
National Gallery, London. 20

Study for the Portrait of Diego Martelli
Black chalk heightened with white chalk, $17\frac{3}{4} \times 11\frac{1}{4}$ (45 × 28.6)
Courtesy of the Harvard University Art
Museums, the Fogg Art Museum (Bequest of
Meta and Paul J. Sachs). 152

Portrait of Diego Martelli, 1879
Oil on canvas, $42\frac{1}{2} \times 39\frac{1}{2}$ (108 × 100.3)
National Galleries of Scotland, Edinburgh. 153

Ludovic Halévy and Albert Boulanger-Cavé, 1879
Pastel and tempera, $31 \times 21\frac{1}{2}$ (78.7 × 54.6)
Musée du Louvre, Paris (Cabinet des Dessins).
Photo Réunion des Musées Nationaux,
Paris. 151

Portrait of Duranty, 1879
Pastel and tempera on canvas, $39\frac{1}{2} \times 39\frac{1}{2}$
(100.3 × 100.3)
Glasgow Museums and Art Galleries, the Burrell
Collection. 155

Mary Cassatt in the Louvre, 1880
Pastel on grey paper, $25 \times 19\frac{1}{4}$ (63.5 × 48.9)
Private Collection. 172

Portrait of Mary Cassatt, c. 1880–84
Oil on canvas, $28\frac{1}{4} \times 22\frac{3}{4}$ (72.4 × 57.8)
National Portrait Gallery, Smithsonian
Institution, Washington DC. 173

Portrait of Mlle Hélène Rouart, 1886
Oil on canvas, $63\frac{3}{8} \times 47\frac{1}{2}$ (161 × 120.7)
National Gallery, London. 189

GAUGUIN, Paul (1848–1903)

Portrait of Mette Gauguin, 1878
Oil on canvas, $45\frac{5}{8} \times 31\frac{7}{8}$ (116 × 81)
E. G. Bührle Collection, Zürich. 135

Self-portrait in Front of an Easel, 1883/1884–5
Oil on canvas, $25\frac{5}{8} \times 21\frac{5}{8}$ (65 × 54.9)
Private Collection, Switzerland. 192

Clovis, 1886
Oil on canvas, $22 \times 15\frac{3}{4}$ (55.9 × 40)
Collection of the Newark Museum, New Jersey
(Gift of Mrs L. B. Wescott 1960). 191

GOGH, Vincent van (1853–90)

Père Tanguy, 1887
Oil on canvas, $25\frac{1}{2} \times 20$ (65.8 × 50.8)
Stavros S. Niarchos Collection. 28

GUILLAUMIN, Armand (1841–1927)

Portrait of Camille Pissarro Painting a Blind,
c. 1868
Oil on canvas, $18\frac{1}{4} \times 15$ (46.1 × 38.1)
Musée Municipal, Limoges. 59

Pissarro's Friend Martinez in Guillaumin's Studio,
1878
Oil on canvas, 35×29 (88.9 × 73.7)
From the Collection of Mr and Mrs Paul Mellon,
Upperville, Virginia. 13

Self-portrait, 1878
Oil on canvas, $23\frac{5}{8} \times 19\frac{5}{8}$ (60 × 49.8)
National Museum Vincent van Gogh,
Amsterdam. 131

MANET, Edouard (1832–83)

Mme Manet at the Piano, 1867–68
Oil on canvas, 15×18 (38.1 × 45.7)
Musée d'Orsay, Paris (Galeries du Jeu de
Paume). Photo Réunion des Musées Nationaux,
Paris. 56

Portrait of Zola, 1868
Oil on canvas, $57\frac{1}{2} \times 45$ (146 × 114.3)
Musée d'Orsay, Paris (Galeries du Jeu de
Paume). Photo Bulloz. 17

The Balcony, 1868–69
Oil on canvas, $66\frac{1}{2} \times 49\frac{1}{4}$ (168.9 × 125.1)
Musée d'Orsay, Paris (Galeries du Jeu de
Paume). Photo Réunion des Musées Nationaux,
Paris. 49

At the Café, 1869
Pen and ink, $11\frac{5}{8} \times 15\frac{1}{2}$ (29.5 × 39.4)
Courtesy of the Harvard University Art
Museums, the Fogg Art Museum (Bequest of
Meta and Paul J. Sachs). 12

Portrait of Eva Gonzalès, 1869–70
Oil on canvas, $75\frac{1}{4} \times 52\frac{1}{2}$ (191.1 × 133.4)
National Gallery, London. 75

Repose (Portrait of Berthe Morisot), 1870
Oil on canvas, $61 \times 44\frac{1}{2}$ (155 × 113)
Museum of Art, Rhode Island School of Design,
Providence (Bequest of Edith Stuyvesant
Vanderbilt Gerry). 51

Woman with the Fans, 1873–74
Oil on canvas, $44\frac{1}{2} \times 65\frac{1}{2}$ (113 × 166.4)
Musée d'Orsay, Paris (Galeries du Jeu de
Paume). Photo Réunion des Musées Nationaux,
Paris. 89

Portrait of Claude Monet, c. 1874
Brush and Indian ink, $6\frac{3}{4} \times 5\frac{3}{8}$ (17.2 × 13.7)
Musée Marmottan, Paris. 184

Mme Manet on a Blue Sofa, 1874
Pastel on paper, mounted on cloth, $25\frac{1}{2} \times 24$
(64.8 × 61)
Musée du Louvre, Paris (Cabinet des Dessins).
Photo Réunion des Musées Nationaux,
Paris. 96

Monet Working on his Boat in Argenteuil, 1874
Oil on canvas, $32 \times 39\frac{1}{4}$ (81.3 × 99.7)
Bayerische Stadtsgemäldesammlungen, Munich.
Photo Artothek. 93

The Artist (Portrait of Marcellin Desboutin), 1875
Oil on canvas, $75\frac{5}{8} \times 50\frac{3}{8}$ (192 × 128)
Museu de Arte, São Paulo. Photo
Giraudon. 105

Portrait of Stéphane Mallarmé, 1876
Oil on canvas, $10\frac{5}{8} \times 14\frac{1}{8}$ (26.9 × 35.9)
Musée d'Orsay, Paris (Galeries du Jeu de
Paume). Photo Réunion des Musées Nationaux,
Paris. 117

Portrait of Faure as Hamlet, 1877
Oil on canvas, $76\frac{3}{8} \times 51\frac{5}{8}$ (194 × 131)
Folkwang Museum, Essen. 121

In the Conservatory, 1879
Oil on canvas, $45\frac{1}{4} \times 59$ (114.9 × 149.9)
Nationalgalerie, Staatliche Museen Preussischer
Kulturbesitz, Berlin. 147

Portrait of Clemenceau, 1879–80
Oil on canvas, $37 \times 29\frac{1}{4}$ (94 × 74.3)
Musée d'Orsay, Paris (Galeries du Jeu de
Paume). Photo Giraudon. 26

Emilie Ambre in the Role of Carmen, 1879–80
Oil on canvas, 36×29 (91.4 × 73.7)
Philadelphia Museum of Art (Given by Edgar
Scott). 157

M. Pertuiset, Lionhunter, 1880–81
Oil on canvas, $59 \times 66\frac{7}{8}$ (150 × 170)
Museu de Arte, São Paulo. Photo
Giraudon. 165

Portrait of Henri Rochefort, 1881
Oil on canvas, $32 \times 26\frac{1}{4}$ (81.3 × 168.9)
Hamburger Kunsthalle, Hamburg. 16

MONET, Claude (1840–1926)

Le Déjeuner sur l'herbe, 1866
Oil on canvas, $51\frac{1}{8} \times 71\frac{1}{4}$ (130 × 181)
Pushkin Museum, Moscow. 6

Woman in the Green Dress (Camille), 1866
Oil on canvas, $89\frac{3}{4} \times 58\frac{5}{8}$ (228 × 149)
Kunsthalle, Bremen. 15

Portrait of Mme Gaudibert, 1868
Oil on canvas, $85\frac{3}{8} \times 54\frac{1}{2}$ (217 × 138.5)
Musée d'Orsay, Paris (Galeries du Jeu de
Paume). Photo Réunion des Musées Nationaux,
Paris. 53

The Luncheon, 1868
Oil on canvas, $90\frac{1}{2} \times 59$ (230 × 150)
Städelsches Kunstinstitut, Frankfurt. 43

Portrait of Camille Monet, 1868–69
Red chalk, $11\frac{1}{4} \times 8\frac{1}{4}$ (28.6 × 21)
Private Collection. 112

L'Hôtel des Roches Noires, Trouville 1870
Oil on canvas, $31\frac{1}{2} \times 21\frac{5}{8}$ (80 × 55)
Musée d'Orsay, Paris (Galeries du Jeu de
Paume). 9

Impression, Sunrise, 1873
Oil on canvas, $18\frac{7}{8} \times 24\frac{3}{4}$ (48 × 63)
Musée Marmottan, Paris. 7

The Luncheon, 1873
Oil on canvas, $63 \times 78\frac{3}{4}$ (160 × 200)
Musée d'Orsay, Paris (Galeries du Jeu de
Paume). Photo Giraudon. 23

A Corner of an Apartment, 1875
Oil on canvas, $31\frac{1}{2} \times 23\frac{5}{8}$ (80 × 60)
Musée d'Orsay, Paris (Galeries du Jeu de
Paume). Photo Réunion des Musées Nationaux,
Paris. 101

Camille Monet and a Child in a Garden, 1875
Oil on canvas, $21\frac{3}{4} \times 25\frac{1}{2}$ (55.3 × 64.7)
Courtesy Museum of Fine Arts, Boston
(Anonymous Gift in Memory of Mr and Mrs
Edwin S. Webster). 103

La Japonaise, 1875–76
Oil on canvas, $91\frac{1}{4} \times 56$ (231.6 × 142.3)
Courtesy Museum of Fine Arts, Boston (1951
Purchase Fund). 113

Alice Hoschedé, 1878
Oil on canvas, $18\frac{1}{8} \times 15$ (46.1 × 38)
Musée des Beaux-Arts, Rouen. Photo
Giraudon. 22

Camille Monet on her Deathbed, 1879
Oil on canvas, $35\frac{3}{8} \times 26\frac{3}{4}$ (90 × 68)
Musée d'Orsay, Paris (Galeries du Jeu de
Paume). Photo Réunion des Musées Nationaux,
Paris. 159

Le Père Paul, 1882
Oil on canvas, $25\frac{1}{4} \times 20$ (64 × 51)
Kunsthistorisches Museum, Neue Galerie,
Vienna. 168

Mme Paul, 1882
Oil on canvas, $25\frac{1}{4} \times 21\frac{1}{2}$ (65.4 × 54.6)
Courtesy of the Harvard University Art
Museums, the Fogg Art Museum (Gift of the
Wertheim Fund, Inc.). 169

Self-portrait, 1886
Oil on canvas, $22 \times 18\frac{1}{2}$ (55.9 × 47)
Private Collection. 185

Portrait of Poly, Fisherman at Belle-Isle, 1886
Oil on canvas, $29\frac{1}{8} \times 20\frac{7}{8}$ (74 × 53)
Musée Marmottan, Paris. 183

MORISOT, Berthe (1841–95)

Mother and Sister of the Artist, 1870
Oil on canvas, $39\frac{1}{2} \times 32\frac{1}{4}$ (101 × 81.8)
National Gallery of Art, Washington DC
(Chester Dale Collection). 67

Portrait of Mme Pontillon, 1871
Pastel, $32 \times 25\frac{1}{4}$ (81.3 × 64.1)
Musée du Louvre, Paris (Cabinet des Dessins).
Photo Giraudon. 77

The Cradle, 1872
Oil on canvas, $21\frac{1}{2} \times 18$ (54.6 × 45.7)
Musée d'Orsay, Paris (Galeries du Jeu de
Paume). 25

Portrait of Mme Hubard, 1874
Oil on canvas, $19\frac{7}{8} \times 31\frac{7}{8}$ (50.5 × 81)
Ordrupgaardsamlingen, Copenhagen. 99

PISSARRO, Camille (1830–1903)

Portrait of Minette Standing, c. 1872–73
Oil on canvas, 18×14 (45.7 × 35.6)
Wadsworth Atheneum, Hartford (The Ella Gallup
Sumner and Mary Catlin Sumner
Collection). 85

Self-portrait, 1873
Oil on canvas, $22 \times 18\frac{1}{4}$ (55.9 × 46.4)
Musée d'Orsay, Paris (Galeries du Jeu de
Paume). Photo Réunion des Musées Nationaux,
Paris. 83

Portrait of Cézanne, c. 1874
Oil on canvas, $28\frac{3}{4} \times 23\frac{1}{2}$ (73 × 59.7)
From a Private Collection. 107

Portrait of Cézanne, c. 1874
Pencil, $7\frac{3}{4} \times 4\frac{1}{2}$ (19.6 × 11.3)
Musée du Louvre, Paris (Cabinet des Dessins).
Photo Réunion des Musées Nationaux,
Paris. 106

Portrait of Mme Pissarro, 1875–78
Pencil, $9\frac{3}{4} \times 5\frac{7}{8}$ (24.8 × 14.9)
Private Collection. Photo Sotheby Parke Bernet,
London. 144

Portrait of Mme Pissarro Sewing near a Window,
1878–79
Oil on canvas, $21\frac{1}{4} \times 17\frac{3}{4}$ (54 × 45)
Ashmolean Museum, Oxford. 145

La Mère Larchevêque, 1880
Oil on canvas, $28\frac{3}{4} \times 23\frac{5}{8}$ (73 × 59.9)
Metropolitan Museum of Art, New York. 163

Portrait of Félix Pissarro, 1881
Oil on canvas, $21\frac{1}{4} \times 18\frac{1}{8}$ (54 × 46)
Tate Gallery, London. 167

RENOIR, Pierre-Auguste (1841–1919)

Cabaret of Mère Antony, 1866
Oil on canvas, $76\frac{3}{8} \times 51\frac{1}{2}$ (194 × 131)
Nationalmuseum, Stockholm. 45

Lise with a Parasol, 1867
Oil on canvas, $71\frac{1}{2} \times 44\frac{1}{2}$ (181.6 × 113)
Folkwang Museum, Essen. 10

Portrait of Frédéric Bazille, 1867
Oil on canvas, $41\frac{7}{8} \times 29\frac{1}{4}$ (106.3 × 74.3)
Musée d'Orsay, Paris (Galeries du Jeu de
Paume). Photo Réunion des Musées Nationaux,
Paris. 39

The Engaged Couple (The Sisley Family), c. 1868
Oil on canvas, $41\frac{3}{4} \times 29\frac{1}{8}$ (106 × 74)
Wallraf-Richartz Museum, Cologne. 55

Mme Clementine Stora in Algerian Dress (Algerian Woman), 1870
Oil on canvas, $33 \times 23\frac{1}{2}$ (83.8 × 59.7)
The Fine Arts Museum of San Francisco (Gift of

Mr and Mrs Prentice Cobb Hale in Honor of
Thomas Carr Howe Jr.). 87

Mme Monet Reading 'Le Figaro', 1872/74
Oil on canvas, $21 \times 28\frac{1}{4}$ (53.3 × 71.8)
Calouste Gulbenkian Foundation, Lisbon. 95

Claude Monet Smoking his Pipe, 1872
Oil on canvas, $24\frac{1}{4} \times 19\frac{3}{4}$ (61.6 × 50.2)
From the Collection of Mr and Mrs Paul Mellon,
Upperville, Virginia. 18

Monet Painting in his Garden at Argenteuil, 1873
Oil on canvas, $19\frac{3}{4} \times 42$ (50.2 × 106.7)
Wadsworth Atheneum, Hartford (Bequest of
Anne Parrish Titzell). 91

*Mme Monet and her Son in their Garden at
Argenteuil*, 1874
Oil on canvas, $20 \times 26\frac{1}{2}$ (50.8 × 67.3)
National Gallery of Art, Washington DC (Ailsa
Mellon Bruce Collection). 22

Portrait of Sisley, 1874
Oil on canvas, $25\frac{5}{8} \times 21\frac{1}{4}$ (65.2 × 54)
Art Institute of Chicago (LL Coburn Memorial
Collection). 111

M. Fournaise, 1875
Oil on canvas, $22 \times 18\frac{1}{2}$ (55.9 × 47)
Sterling and Francine Clark Art Institute,
Williamstown, Massachusetts. 109

Self-portrait, c. 1875/c. 1879
Oil on canvas, $15\frac{1}{2} \times 12\frac{1}{2}$ (39.4 × 31.8)
Sterling and Francine Clark Art Institute,
Williamstown, Massachusetts. 119

Mme Chocquet, 1875
Oil on canvas, $28\frac{3}{4} \times 23\frac{3}{8}$ (73 × 59.3)
Staatsgalerie, Stuttgart. 16

Victor Chocquet, 1875–76
Oil on canvas, $18 \times 14\frac{1}{4}$ (45.7 × 36.2)
Courtesy of the Harvard University Art
Museums, the Fogg Art Museum (Grenville L.
Winthrop Bequest). 141

Portrait of Mme Georges Charpentier, 1876–77
Oil on canvas, $18\frac{1}{8} \times 15$ (46 × 38)
Musée d'Orsay, Paris (Galeries du Jeu de
Paume). Photo Réunion des Musées Nationaux,
Paris. 27

Portrait of Mme Charpentier and her Children,
1878
Oil on canvas, $60\frac{5}{8} \times 74\frac{3}{4}$ (154 × 190)
Metropolitan Museum of Art, New York (Wolfe
Fund, 1907, Catherine Lorillard Wolfe
Collection). 137

The Boating Party, 1880–81
Oil on canvas, 51×68 (129.5 × 172.7)
Phillips Collection, Washington DC. 14

Children's Afternoon at Wargemont, 1884
Oil on canvas, 50×68.1 (127 × 173)
Nationalgalerie, Staatliche Museen, Preussischer
Kulturbesitz, Berlin. 179

WINTERHALTER, Franz-Xaver (1806–73)

The Empress Eugénie and her Maids of Honour,
1855
Oil on canvas, $118\frac{1}{8} \times 165\frac{3}{8}$ (300 × 420)
Musée National du Château de Compiègne.
Photo Giraudon. 6

INDEX